Fra Angelico

Gabriele Bartz

Guido di Piero, known as

Fra Angelico

ca. 1395–1455

1 (frontispiece)
Madonna delle ombre (detail ill. 99), ca. 1450
Fresco and tempera, 193 x 273 cm
Museo di San Marco, Florence

© 1998 Könemann Verlagsgesellschaft mbH
Bonner Str. 126, D-50968 Köln

Art Director: Peter Feierabend
Project Manager and Editor: Sally Bald
Assistant: Susanne Hergarden
German Editor: Ute E. Hammer
Assistant: Jeannette Fentroß
Translation from the German: Christine Varley
Contributing Editor: Michael Scuffil
Production Director: Detlev Schaper
Assistant: Nicola Leurs
Layout: Marc Wnuck
Typesetting: Greiner & Reichel, Cologne
Reproductions: Omniascanners, Milan
Printing and Binding: Neue Stalling, Oldenburg
Printed in Germany

ISBN 3-8290-0246-7
10 9 8 7 6 5 4 3 2 1

Contents

The Artist Friar Who Strove for the Light of Redemption
6

Inset: "To portray spiritual and holy things, a man must have a holy and pious mind"
(Vasari's Life of Fra Angelico)
8

From the Litany with Saints to the Aristotelian Unities of Time and Space:
Fra Angelico's Pictures of the Madonna with Saints
14

Inset: The Altarpiece at Fiesole and its Re-working: Assessment and Differences
18

Inset: The Linaiuoli Tabernacle of 1433:
Fra Angelico's Relationship to the Sculptors and Architects of his Time
24

Inset: Italy and the North:
The Lamentation over the Dead Christ and its Influence on Rogier van der Weyden
46

The Altarpieces with Religious "Stories"
48

The Frescoes in San Marco: Strict Observance and the Sensation of Light
64

Cappella Niccolina for Nicholas V
94

The Armadio degli Argenti: Narration in Miniature
102

Glossary
116

Selected Bibliography
119

Photographic Credits
119

THE ARTIST FRIAR WHO STROVE FOR THE LIGHT OF REDEMPTION

Georg Wilhelm Friedrich Hegel said of Fra Angelico's work that it was "unsurpassed in the solemn depth of its conception". This is praise indeed for the inner greatness of the religious artist, coming as it does from a Protestant philosopher on the threshold of modern thought.

The life of Fra Giovanni da Fiesole, actually Guido(lino) di Piero (born around 1395 in Vicchio di Mugello, died in Rome in 1455) is the stuff of legend. "Angelic" was how he came to be known soon after his death; the name "Beato" was a comment on his painting and not a reference to his beatification, which happened only recently.

Of the three famous friar artists of the first half of the 15th century, Fra Angelico was destined to play a special role. Unlike the older Don Lorenzo Monaco, he experienced the revolutionary innovations of the very early Renaissance and was greatly influenced by them; unlike the Carmelite friar, Fra Lippo Lippi, who left his order, Fra Angelico remained true to his. He was a Dominican, and a mendicant, so, not being part of a closed order, he was free to meet and talk to others in the city. He was active at the same time as the architect Filippo Brunelleschi (1337–1446), the sculptor Donatello (1386–1466), and the painter Masaccio (1401–ca. 1428) were changing the face of the visual arts in the 1420s. In 1420–1422 he entered the convent of San Domenico in Fiesole with his brother Benedetto, a scribe. It was here that he produced his first conventual decoration which consisted of the altarpiece for the high altar (ill. 18), the *Annunciation*, now in the Prado (ill. 59), the *Coronation of the Virgin*, now in the Musée du Louvre (ill. 70), as well as the fresco of the Crucifixion on the wall of the chapter room, and other frescoes depicting the Madonna (ills. 15, 16).

From payment records dated 1423, for a work that has since been lost, in which he is named as *frate Giovanni, de' frati di San Domenicho da fiesole*, we may conclude that he had already undergone his novitiate since novices were not allowed other activities than those required for their spiritual preparation. As well as gaining recognition as a painter, Fra Angelico must have commanded respect in his convent because he was appointed Vicario for the first time in Fiesole from 1432/33, a post he was to hold frequently in later years.

The 1430's were destined for work in Florentine churches. In 1432, the Servite Brothers from Brescia commissioned an Annunciation that is probably lost. The painter carried out the following commissions for the Dominicans in Cortona: the *Cortona Triptych* (ill. 21) and an *Annunciation* panel (ills. 66, 68), as well as the one remaining fresco. There is evidence that Fra Angelico was in Cortona in 1438; he was a witness at the signing of Giovanni di Tommaso di Cecco's will. From 1438, he was at work on his most important commission, the altarpiece for the high altar (ill. 47), and the frescoes for the convent of San Marco in Florence (ills. 79–108).

In July 1445 Fra Angelico was summoned by Eugenius IV to Rome, where he painted frescoes in the chapel of Santissimo Sacramento which was later demolished under Pope Paul III. For Eugenius' successor, Nicholas V, he painted the frescoes of St. Stephen and St. Lawrence between 1447 and 1449 with the assistance of Benozzo Gozzoli (1420–1497), in the Cappella Niccolina in the Vatican, named after the Pope who commissioned the frescoes (ills. 109–116). Fra Angelico was also commissioned to paint the walls of a study that no longer exists. In the summer of 1447, he began work on the frescoes in the Cappella di San Brizio (ill. 10), in the cathedral at Orvieto. These were completed by Luca Signorelli, but not until the turn of the century. From 1450–1452 he returned to his old convent in Fiesole as Prior, before going for one last time to Rome, where he died on 18 February 1455. He is buried in Santa Maria sopra Minerva, where his grave has always drawn worshippers. After his beatification by Pope John Paul II in 1984, the headstone was placed on a plinth and surrounded by a bronze grille with floral motifs (ill. 2). His feast day is 18 February, the day of his death.

The small Dominican convent in Fiesole, which Guido di Piero entered, was founded in 1406 by Giovanni Dominici and was occupied by Observants. This was a voluntary movement within the order, observing the Rule in a particularly strict manner, harking back to the founder, St. Dominic. The conventual order had gradually come to lay more emphasis on learning while the Observants were concerned with preaching and saving souls. The life of

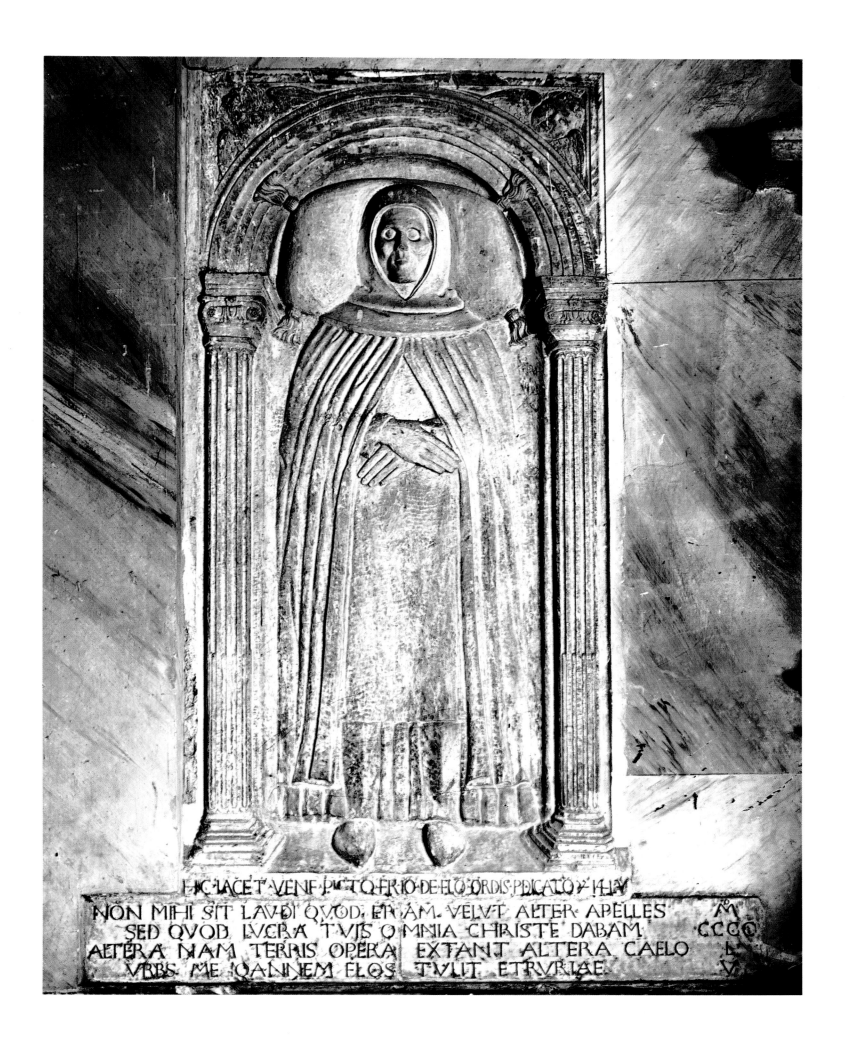

HIC IACET VENE P̄ TQ FR IO DE FLO ORDIS P̄DICATO M̄ IHV

NON MIHI SIT LAVDI QVOD ERAM VELVT ALTER APELLES M̄
SED QVOD LVCRA TVIS OMNIA CHRISTE DABAM CCCC
ALTERA NAM TERRIS OPERA EXTANT ALTERA CAELO L
VRBS ME IOANNEM FLOS TVLIT ETRVRIAE V

"TO PORTRAY SPIRITUAL AND HOLY THINGS, A MAN MUST HAVE A HOLY AND PIOUS MIND" (VASARI'S LIFE OF FRA ANGELICO)

When Giorgio Vasari (1511–1574) published his "Lives of the Artists" ("Vita de'più eccellenti architetti, pittori et scultori italiani") in 1550, Fra Angelico had already become something of a legend. Just ten years after his death, Fra Domenico da Corella called him an "Angelic Painter", (Angelico). This sobriquet has more or less replaced his baptismal name, as well as the one he assumed on his admission to the order. Sometime later, in a poem, Giovanni Santi called him the "Friar, who strove for the Light of Redemption". His epitaph (ill. 2), which was most likely composed by the humanist Lorenzo Valla, extols the piety of the man Fra Angelico before his abilities as an artist. The exhortation in that epitaph that he not be called a second Apelles was, incidentally, the first time since Antiquity that the famous classical painter had been compared to another artist.

With this in mind, it is no wonder that Vasari, inspired by anecdotes about Fra Angelico's piety from aged monks of San Marco who could never have known him, came to lay emphasis on the manner and character of the man, when writing his Life of the artist friar. The fact too that Fra Angelico depicted only religious subjects in his work lends credence to this view. For Vasari, it was essential for the monk himself to be humble and modest, for his saints to have the look of real saints.

It is said of the painter that he never improved on a work of art, because God had willed it to be thus. This was meant to show that the artist's greatness lay in his gift of divine inspiration. This, and the story of how Fra Angelico never began work without praying, and could never paint a crucifix without tears coursing down his cheeks, all contributed to make a portrait for 19th century commentators of a pious friar who painted pictures of divinely inspired simplicity, quite unaware of the new artistic trends around him.

Vasari also set Fra Angelico's birth date too early (1387); not until 1955 was it proved that this was wrong, and that a date much later in the 1390's was nearer the truth. Supposing him to be older, the 19th century commentators regarded him as the last medieval painter before the start of the Italian Renaissance. If the date had been true, he would have been 42 years old when he completed the altarpiece of St. Peter Martyr, the *San Pietro Martire Triptych* (ill. 11) in 1492.

The great biographer's Life of Fra Angelico, in its comparison of the artist's way of life and habits with those of a saint, has had a protracted influence on art historical accounts of him. The originality of his artistic talent has thus been overlooked, and the view of it distorted by this lyrical interpretation.

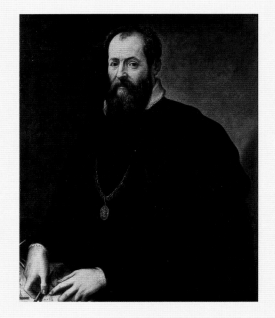

3 (above) Giorgio Vasari
Self-portrait, 1566–1568
Oil on wood, 100.5 x 80 cm
Galleria degli Uffizi, Florence

Vasari portrays himself in the dignified posture of a stylish courtier. His chain carries the coat-of-arms of Pope Pius V. By contrast, the drawing implements which represent the symbols of his work as an artist, appear rather modest.

4, 5 (below, left and right) Giorgio Vasari
Fra Angelico
Woodcuts from Vasari: "Lives of the most excellent Painters, Sculptors and Architects", 2. Ed., 1568

In the woodcut reproduced here Giorgio Vasari from Arezzo is described as a painter and architect. Vasari gives the artist whom we know as Fra Angelico the name by which he was known in his monastic Order: Fra Angelico da Fiesole. He also gives his baptismal name, Guido.

the Observants was marked by communal prayer and offices, yet they were allowed to follow other pursuits. Antonino Pierozzi, who was later canonized, and was Bishop of Florence from 1446, had been Prior at Fiesole from 1423, and had put the Observant Dominicans into the older convent of San Marco in Florence. In 1445 he signed the Act of Separation of the two Observant convents in Fiesole and Florence, together with his brother friars, amongst whom was Fra Giovanni. The independent convent of San Marco was thereby founded.

In 1417 when he was still a layman by the name of Guido di Piero, the painter was proposed for membership in the Compagnia di San Niccolò by the illuminator Battista di Biaggio Sanguini (1393–1451). But it is not known if the artist started out as an illuminator, and there is no mention in the source material of his teachers. A record of payment for work from 1418 for an altarpiece, now lost, for the church of Santo Stefano al Ponte in Florence, indicates that Fra Angelico was an apprentice of Ambrogio di Baldese, to whom the commission originally went. For the *Deposition* for the Strozzi family that is now in the Museo di San Marco, he used a panel (ill. 74) on which Lorenzo Monaco (ca. 1370–1423/1424) had previously painted the pictures in the spaces beneath the finials. There are stylistic similarities too, in his early work which suggest that Fra Angelico was trained by Ambrogio di Baldese.

The works of his contemporary, Masaccio, whose originality substantially enriched the art of his time in Florence, are of great importance for Fra Angelico's early period. Gentile da Fabriano (1360/70–1427), not a native of Florence, must have been an example, too, for the young artist while he was there. William Hood believes the Sienese artist, Sassetta (1392–1450), to have been an important source of inspiration for the way the young artist developed his use of light through the luminescent effects of color.

Since there is a reference to an illuminator, as well as a mention of Angelico's brother, Benedetto, as a scribe in Battista di Biaggo Sanguini's document of 1417, researchers have made an exception in looking also for works on parchment. The initials in the missal ms. 558, which probably came from San Domenico in Fiesole, and is now in the Museo di San Marco, are authenticated works by Fra Angelico.

There are discreet indications of the locality of each figure worked into the golden ground of the initial "R" of the *Annunciation to the Virgin* (ill. 6). The Mother of God is sitting on a field of green, and the clouds beneath the angel's feet define the heavenly sphere. An unusual feature is the deep sky blue around the figure of God the Father which dominates the golden ground completely. In order to depict the *Glorification of Saint Dominic* (ill. 7) the ruling for the music has clearly been erased before being painted upon. Despite the poor condition of the manuscript, one can still see how skillfully Fra Angelico worked on parchment, and how he made use of it to portray subtle gradations of white.

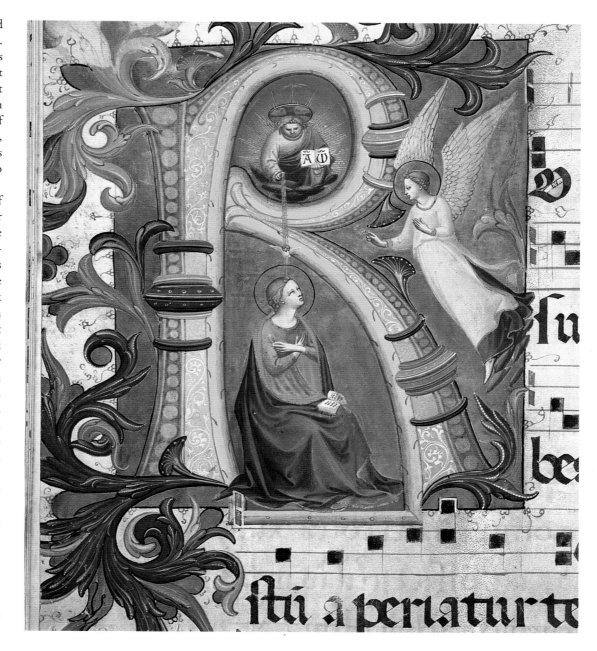

Although the missal is not dated, it is commonly held that Fra Angelico developed progressively from illuminator to creator of monumental altarpieces and frescoes. He was able to make use of his illumination techniques in later work in miniature form. A particular example of this is one of the four reliquaries (ill. 8) commissioned by Fra Giovanni Masi before 1434 for Santa Maria Novella which depicts the *Adoration of the Magi*, and the *Annunciation* on the upper half. Such a sharp division between scenes is usually found only in illuminations. The decorative effects seen here outweigh the narrative quality of the paintings.

Belonging to the Observant Dominicans as he did, Guido di Piero received many commissions from that community at the start of his career, even if it was individual patrons, rather than the convents themselves, who paid for the paintings in the end. The *Linaiuoli Tabernacle* and the *Deposition* made for the Strozzi Chapel in Santa Trinità show that the painter

6 *The Annunciation to the Virgin*
Parchment, 7 x 7 cm (initial), 47.5 x 35 cm (page size)
Missal, ms. 558, fol. 33v.
Museo di San Marco, Florence

In the initial "R" the Virgin sits with her arms crossed over her breast. She is looking up at the angel hovering on the right of the initial. God the Father leans down from above. A ray of light emanates from his hand and a dove flies through it to the Virgin who is to be the Mother of God.

7 (left) *The Glorification of Saint Dominic*
Parchment, 47.5 x 35 cm (page size)
Missal, ms. 558, fol. 67v.
Museo di San Marco, Florence

The page is almost completely covered with decoration; the small figures fill every available space, so that the letter "I" is hardly recognizable with all the surrounding medallions. As well as various saints portrayed in half-length portraits, the meeting of St. Francis and St. Dominic is represented. *The Glorification of Saint Dominic* does not fit completely onto the page and is cut off from the top of the initial.

occupied a leading role in Florence after Masaccio's death. Cosimo de' Medici was undoubtedly the artist-friar's most important patron. After all it was he who gave the church and convent of San Marco, which had formerly belonged to the Sylvestrine Brothers, to the Observant Dominicans of Fiesole. In 1438 he commissioned the architect, Michelozzo (1396–1472), to make extensive additions to the church and convent buildings. He also commissioned Fra Angelico with the making of the altarpiece for the high altar (ill. 47) and the decoration of the convent walls. During the periodic residences of the papal court in Florence, and during the period from 1439–1443, when a Council was held there, Fra Angelico would have become acquainted with Eugenius IV. He summoned the painter to Rome where Fra Angelico also worked for his successor, Nicholas V, after Eugenius' death. On his return to Florence, Fra

Angelico made the panels for the *Armadio degli Argenti*, a cabinet for precious votive offerings in Santissima Annunziata in Florence. The work had been commissioned by Piero de' Medici. This list alone, incomplete as it is, is enough to refute the legend of the reclusive monk. Fra Angelico was an artist obviously in great demand, and much occupied during his time.

The image of a painter-monk conjures up the romantic idea of an artist painting in the stillness of his monastery. However, Fra Angelico's success must soon have made a large workshop necessary. There is evidence of assistants by the time of the San Marco decoration at the latest, the most prominent being Benozzo Gozzoli. The works of Zanobi Strozzi, a panel painter and miniaturist, are also mentioned in connection with Fra Angelico. Source material shows the latter was responsible for the supervision of the choral books

8 (opposite) *Annunciation and Adoration of the Magi*, before 1434
Tempera on panel, 84 x 50 cm (as a whole),
42 x 25 cm (picture)
Museo di San Marco, Florence

Gabriel and the Virgin seem transported into a supernatural sphere by the gold of the floor and the background. The dove and the vase of lilies are hardly recognizable. The gold hems on the robes of the three Kings and their entourage in the lower part is the same as the gold ground. This reliquary together with another three ordered by Fra Giovanni Masi for Santa Maria Novella in Florence, is not only similar in size to a manuscript illumination but also has a comparable pictorial structure. It must have been completed before 1434 when Giovanni Masi died.

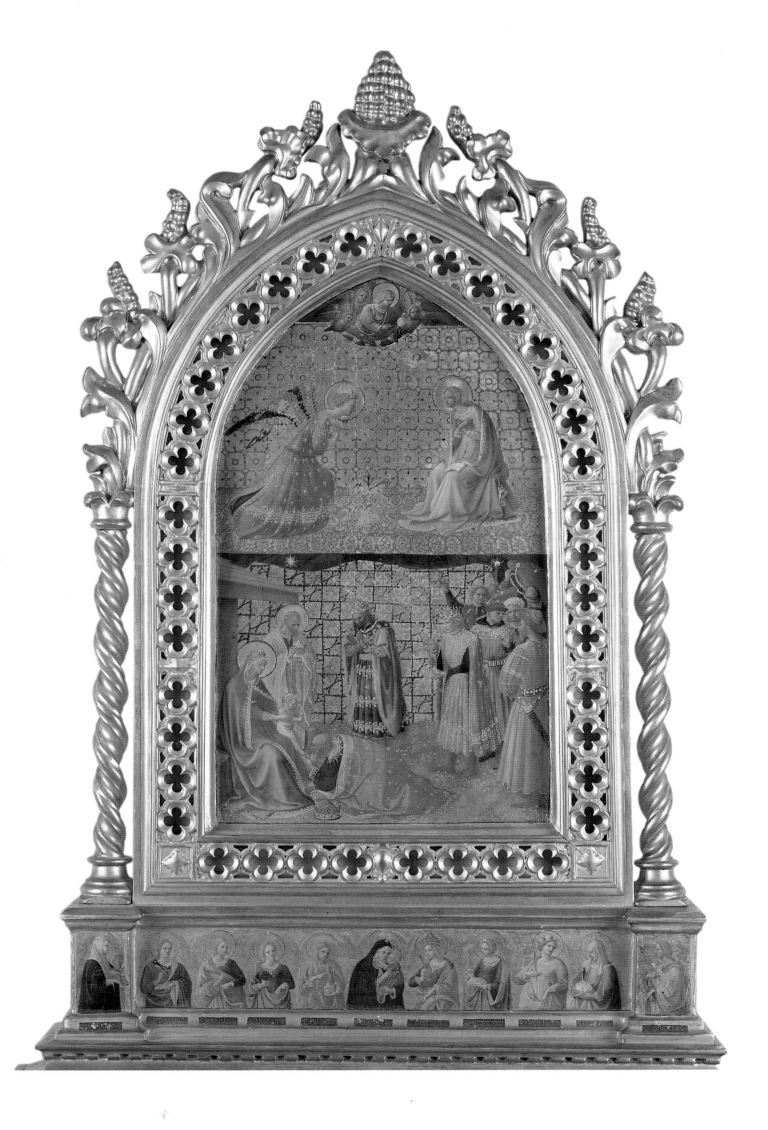

9 (left) *San Marco Altarpiece: San Cosmas* (detail ill. 47), ca. 1439–1442

The decoration of the convent of San Marco, begun probably in 1439, was the high point of Fra Angelico's creative work. This altarpiece for the high altar was made in the rectangular form. The predella shows narrative scenes from the lives of the two Medici patron saints, Cosmas and Damian. Whilst Damian turns towards the Virgin Mary to pray, Cosmas looks straight towards the viewer to call upon him to worship.

Strozzi illuminated from 1446 to 1454 at Cosimo de' Medici's behest.

Differences in style are noticeable in both of the side panels of the *Cortona Triptych* (ill. 21), implying the work of more than one hand, even before the work at San Marco. It seems pointless, though, to attribute whole works in Fra Angelico's style to his assistants. They were, indeed, entrusted with painting many of the frescoes, for example, but the designs were the master's own.

In 1447 Fra Angelico agreed to spend the next three summers in Orvieto and to decorate the San Brizio chapel in the cathedral with frescoes. But he did not resume work the following year. The frescoes in the vault with *Christ in Majesty Surrounded by Angels and the Sixteen Prophets* (ill. 10), were begun by him. He took it so much for granted that some of the work would be done by assistants that he approved the inclusion of four of them, mentioned by name, among them Benozzo Gozzoli, in the Orvieto contract.

The works that are dated in the archival material and have not been lost belong to a later period, beginning in 1429 with the altarpiece for the convent of San Pietro Martire in Florence. Lack of documentary evidence means the master's early work cannot be identified with certainty. There is mention of an altarpiece for Santo Stefano al Ponte in Florence in a payment record from 1418, but the work is lost. The Saint Jerome panel in Princeton, New Jersey (The Art Museum, Princeton University), dated 1424 by the coat of arms, is only attributed to Fra Angelico. In 1433 there came a commission from the linen-makers' guild (Arte dei Linaiuoli) for the great Tabernacle; the setting was built to Ghiberti's design. In 1436 the *Lamentation over the Dead Christ* (ill. 75) was ordered by Sebastiano Benintendi for Santa Maria della Croce al Tempio and the final payment for it was made by the end of the year. In 1437 Fra Angelico painted the altarpiece for the Guidalotti chapel in Perugia.

10 (opposite) *Christ in Majesty Surrounded by Angels and the Sixteen Prophets*, 1447
Fresco
Cappella di San Brizio, Cathedral, Orvieto

It is not known why Fra Angelico did not return to Orvieto: his work there consists of only two paintings in the vaulted roof. Benozzo Gozzoli, who was probably Fra Angelico's apprentice, must have assisted him here. The work was continued by other hands and completed by Luca Signorelli.

From the Litany with Saints to the Aristotelian Unities of Time and Space: Fra Angelico's Pictures of the Madonna with Saints

11 *San Pietro Martire Triptych*, 1428/29
Tempera on panel, 137 x 168 cm
Museo di San Marco, Florence

The seated Madonna dominates the central panel. On the side panels in smaller dimension, there are, on the left the founder of the order, St. Dominic, holding a lily and John the Baptist in a long hairshirt, carrying a staff, and on the right St. Peter Martyr and the theologian, Thomas Aquinas. Although the central panel has traditional Gothic finials, a rounded arch encloses the whole altarpiece above. In the spaces between the finials, there are pictures of St. Peter Martyr preaching, and of his death. The lunettes above the arches show the Annunciation.

The form and structure of Fra Angelico's earliest dated work, the altarpiece for San Pietro Martire in Florence, finished probably in 1429 (ill. 11), are rooted in the Trecento. Decorative altarpieces usually had a Madonna, enthroned, as the central picture, with several panels depicting saints, standing against a gold pattern. In Italian altarpieces there were no interchangeable panels for different use on special feast days and ordinary days, as in northern Europe. The choice of saints depended on the place, and the wishes of the patrons. The saint to whom the altar was dedicated could, therefore, be just as prominent as the patron saint bearing the name of the patron himself. Monastic altarpieces depicted the most important saints of the order while others, older patron saints, for example, are often to be found in miniature on pilasters. Polyptychs have to be seen almost as a litany: the Madonna and Child are at the center, and the saints symbolically address their invocations to her.

The altarpiece for the nuns of San Pietro Martire (ill. 11) is in this tradition. In the central arch the Virgin is enthroned with the Child standing on her lap, forming the blessing. Both are richly adorned, and the heavy folds of the garments are edged with gold. The Virgin is holding a golden vessel, as though the figure were from an Adoration. The Virgin, even though she is seated, towers above the adjacent saints. To the left are St. Dominic, the founder of the order, and St. John the Baptist, and on the right the Dominicans, St. Peter Martyr and St. Thomas Aquinas. The arch, with twisted columns on either side, creates a separate space for the Virgin. Yet the figures are all standing on the same colorful marble pavement, which ends with a step aligned with the frontal plane, creating a sense of distance.

The gold ground is used to decorative effect, with the black-patterned gold brocade covering the Virgin's throne serving to highlight the pierced discs of the haloes which are of the same material as the plain gold ground. Spatial effects are created in various ways; the saints are turned towards the Virgin and those next to her are set back slightly. Both the carpet, which spreads out from the central picture onto the side panels, and God the Father, whose gaze includes the Virgin of the

Annunciation in the rosette of the next arch as well as the Madonna herself, unify the separate pictorial elements.

Polyptychs are usually surmounted by a single pointed finial, but here there are three, all joined with a rounded arch, the spaces between being filled with narrative scenes. Each small space is skillfully used to depict a town scene and a landscape alternately. The lush foliage at the side edges creates an air of mystery.

An altarpiece like this would usually have a predella below the main panels on which more saints, in half-length portraits, and less often in narrative scenes, are depicted. The unusual arrangement has perhaps resulted from the complementary scenes being moved upward, as it were, instead of filling a predella. It has been suggested by Baldini among others that a predella in the Courtauld Institute in London belonged to this altarpiece. It has four half-length portraits of saints and a Man of Sorrows, mourned by the Virgin and Saint John. If these truly did belong to the San Pietro Martire altarpiece, one would have here an example of the narrative scene given equal status to the traditional form with attendant saints.

The *Madonna and Child*, now in the Museo di San Marco, from the Certosa del Galuzzo (ills. 12–14) was probably created in a similar context but its provenance is not known. It is modelled largely on the same pattern, but the panels are taller and this dimension gives the Virgin and Child a more graceful appearance than the figures in the San Pietro Martire altarpiece. The Virgin's mantle falls in loose billowing folds and further emphasizes the contours of the seated figure. The head-dress falls in airy folds onto the marble throne but the connection between the two is not clearly defined. It is apparent that the artist had difficulty in clarifying the spatial relation between the head-dress and the throne, but this is balanced by the decisive execution of the marble step, with its fine profiling, which thrusts boldly into the foreground and is completed with another step below. The colors, apart from the Virgin's obligatory blue, are gentle tones ranging from yellow to bright red, which enlivens the flesh tone. The finial has a *Gnadenstuhl* painted directly onto the gold ground, anticipating the death on the cross, and redemption.

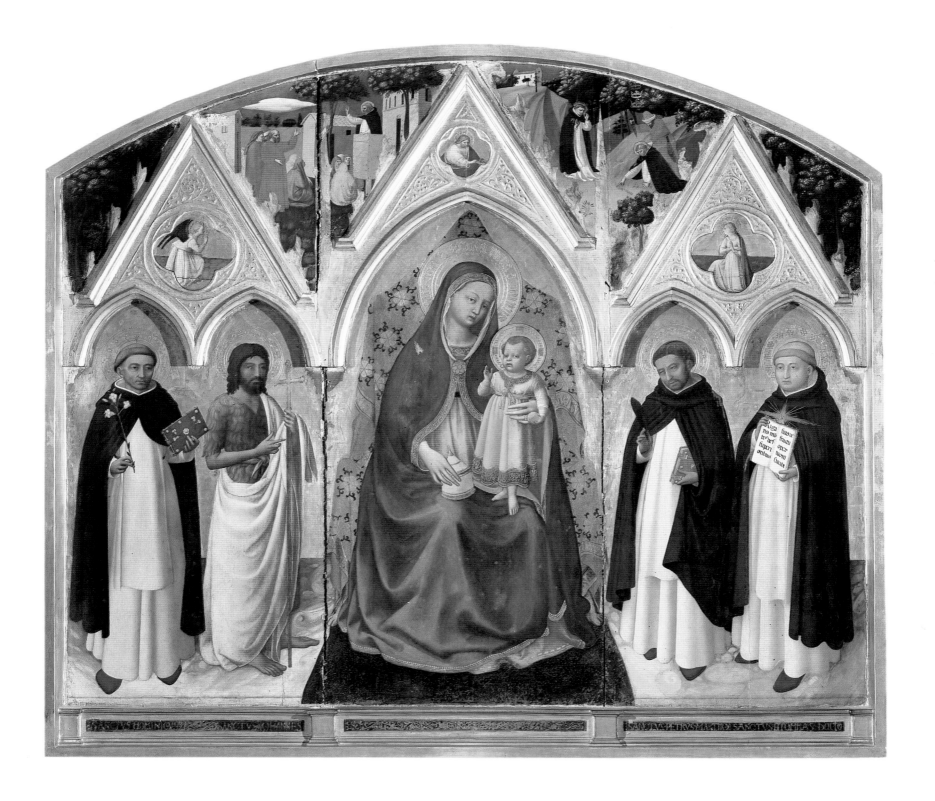

12, 14 (above, left and right) *Certosa del Galluzzo Triptych,* 1428–1430, side panels with attendant saints
Tempera on panel, 170 x 79 cm (each panel)
Museo di San Marco, Florence

Because of their bad condition, the panels with Saints Jerome (?), John the Baptist, Francis of Assisi and Onuphrius (?) cannot be assessed. They are believed to be connected with the seated Madonna (ill. 13), also in San Marco, and come from the Certosa del Galluzzo.

13 (above, center) *Certosa del Galluzzo Triptych:*
Madonna and Child, 1428–1430
Tempera on panel, 189 x 81 cm
Museo di San Marco, Florence

Originally belonging to a triptych, this Madonna shows all the qualities of Fra Angelico's early style. Building on the luminescent effect of the gold ground, he uses pale colors. Distinct spatial effects are also created by the loose folds of the gold brocade behind the throne, the volume given to the figures and the jutting marble step.

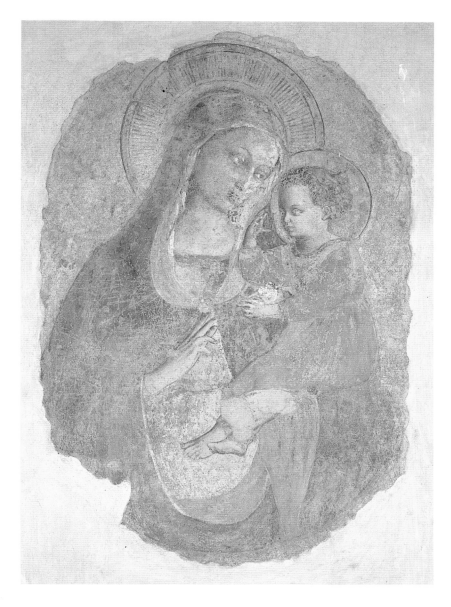

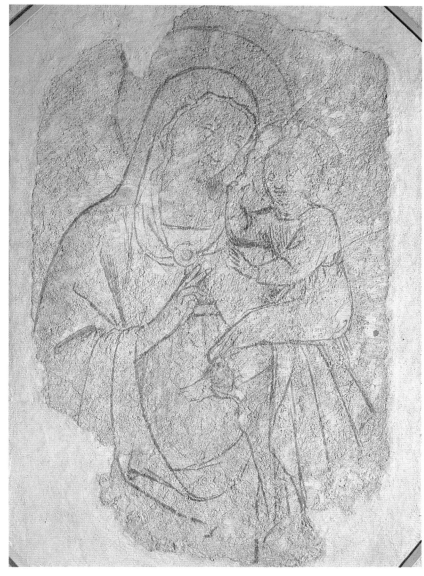

15 *Madonna and Child*, ca. 1435
Fresco, 116 x 75 cm
San Domenico, Fiesole

No longer in its original place and in lamentable
condition, this Madonna is of interest because it is Fra
Angelico's first convent decoration together with the
Crucifixion in the chapter room. It is probably from a
larger piece, a Madonna with Saints.

16 *Madonna and Child*, ca. 1435
Sinopia, 116 x 75 cm
San Domenico, Fiesole

This cartoon was exposed during the 1960 restoration
and lends an impression of Fra Angelico's technique in
preparing his frescoes. The folds are applied with
astonishingly meticulous care. The head of the Child is
drawn frontally, unlike in the actual fresco.

THE ALTARPIECE AT FIESOLE AND ITS RE-WORKING: ASSESSMENT AND DIFFERENCES

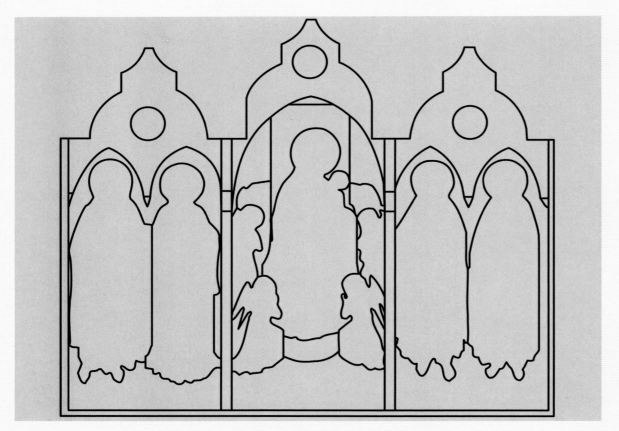

17 Reconstruction of the *Fiesole Triptych*

The panel would originally have been divided into three. The Madonna and angels were in the central panel with two saints on either side panel. The original, presumably Gothic, finial arch would have been just above their heads. The gold ground and the cloth covering the throne behind the Virgin would have defined the background.

The Madonna, surrounded by Angels, and Saints Thomas Aquinas, Barnabas, Dominic and Peter Martyr, (ill. 18) is an exceptional case in the history of altarpieces. Conceived for the Dominican convent in Fiesole (ill. 17), as a traditional three-part triptych with three crowning finials and a gold ground that allowed for no spatial effects, it was modernized, so to speak, by Lorenzo di Credi (1459–1537) in 1501. The originally pointed panels were transformed into a unifying rectangle and decorated with a landscape scene as a background.

The work was created during the rebuilding of the convent in Fiesole, which was financed by a bequest from the will of the Florentine merchant, Barnaba degli Agli. This is the reason that St. Barnabas figures on the panel with the three great Dominicans. His portrayal, however, is not specific because he was rarely depicted, and his iconography was not established. Indeed, he can only be identified because the patron's name is known.

Fra Angelico's altarpiece was obviously held in great esteem by the Dominicans of Fiesole since they took the trouble, more than two generations later, to commission a re-working by the High Renaissance painter, Lorenzo di Credi, a contemporary and associate of Leonardo. Fra Angelico had fitted the figures into the rigid scheme of the triptych in a way that made movement and spatial relationships possible. Freed from the constraints of the late Gothic setting and the captivating, but distracting, splendor of the gold ground, after Lorenzo's adaptation the saints appear in a simple Renaissance architectural setting. The

pilasters form a niche for the Virgin, and the two great open spaces behind the saints on either side reveal a landscape.

There was a predella belonging to this triptych with the Risen Christ surrounded by rows of angels and adoring saints which is in the National Gallery in London. At the edge, iconographically the least important place, there is a row of Dominican nuns and friars. Their faces have individual features and the figures are named. The pilasters were decorated with standing saints (Mark and Matthew, now in the Musée Condé in Chantilly, and Nicholas and Michael in a private collection). The pictures have been replaced by others on the pilaster panels, and by 19th century copies on the predella.

It is hard to decide without a technical investigation what remains of Fra Angelico's conception, apart from the figures and the tiled pavement. The throne must have had a step, and its arms, overlapping the row of angels, can still be seen. The central group of figures, though, is so close to the saints that separating them by columns could not have been done without much undesirable overlapping. To separate the upper area from the action, Lorenzo di Credi, a master of perspectival effect, placed a hexagonal canopy over the Virgin, which is fixed at an unseen point. The landscape terminates behind at the saints' eye-level, and above it is an area of sky that would have been unthinkably large for Fra Angelico.

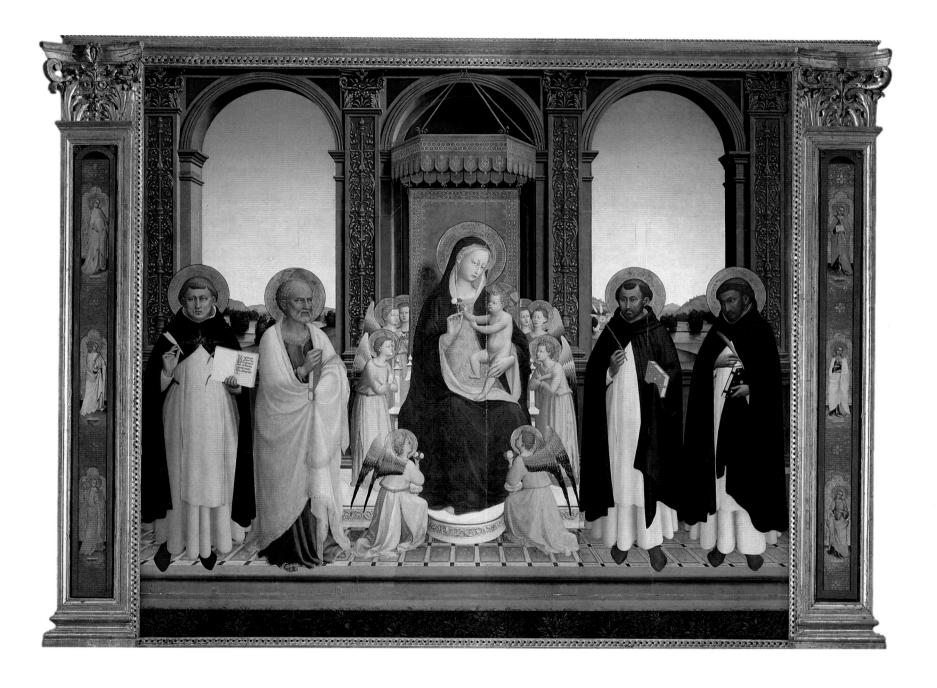

If the Madonna of the Certosa del Galuzzo (ill. 13) with its gentle elegance is the work of a Fra Angelico still rooted in the Gothic form, then the small panel with the Virgin in Frankfurt (ill. 19), demonstrates a new aspect of his creativity. The central group of the Fiesole altarpiece (ill. 18) is repeated in a considerably reduced format, which is the why most research suggests a date about 1429 as well. Not only the small format however, but also the grouping of the figures, creates different effects.

The first striking feature is that the seated Frankfurt Virgin seems to be of the same scale as the adoring attendant angels. The Mother of God looks out forlornly from her Gothic throne towards the right.

Jesus is well observed, and is portrayed with a round belly and chubby arms, somewhat recalling Masaccio. The angels encircle the throne in a wide arc. Every possible turn and position of the body is represented, from rear-view, to profile, to three-quarter view. Spatial development is lacking, though, in the way the angels are set down, for the group, ascending harmoniously, is not definably connected with the ground since their feet are not touching the steps of the throne.

The charming picture of the *Madonna and Angels and the Saints Dominic and Catherine* in the Vatican (ill. 20), which is even smaller than the little Frankfurt panel (ill. 19), is a further example of how to depict celestial "reality". The Virgin is sitting with the half-naked

18 *Fiesole Triptych*, 1424–1430
Adapted by Lorenzo di Credi in 1501
Tempera on panel, 212 x 237 cm
San Domenico, Fiesole

The picture was in the convent church on the high altar where Vasari (1568) saw it with the ciborium. The Child is naked and is turned towards his Mother attentively, holding a rose. His halo with a red cross seems to hover over his head while the haloes of the others are disc-like. There is an equal relation in size between the Saints (on the left, Thomas Aquinas and Barnabas, and on the right, Peter Martyr and Dominic) and the Madonna.

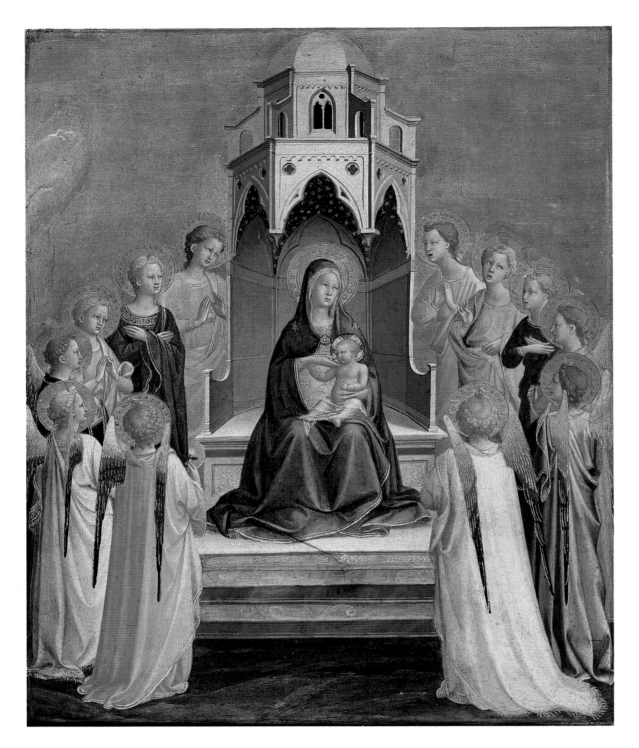

19 *Madonna Surrounded by Angels*, ca. 1429
Tempera on panel, 37 x 28 cm
Städelsches Kunstinstitut, Frankfurt am Main

In larger altarpieces the physical presence of the Madonna
is predominant, but here in a smaller format, it can be
overlooked. The Virgin is only slightly larger than the
angels who surround her in a wide circle. The Gothic
throne architecture is thus able to open out upwards and
the red stripes connect the Virgin's eye level with that of
the angels so that the opening up of the perspectives takes
on a formal structural function.

Christ-child who is gently stroking her cheek, in front
of a gold ground strewn with a pattern of etched flowers
into which her halo seems to recede and form a hollow.
The girlish angels at her side are clearly of a different
scale and have the effect of enlarging the seated figure.
The two saints in the foreground represent yet another,
third, and different scale. They are kneeling, and are
even smaller than the angels in front of the marble step,
which defines the area where the Virgin sits. To some
extent this is a *Sacra Conversazione*, were it not for the
fact that Fra Angelico stopped short of making the
bodies of the saints the same size as the Virgin. She is,
however, the focus of their prayers even though

Dominic, looking at the onlooker, deflects attention
from the Virgin at first. The saints, though not authentic
witnesses in the life of Christ, are brought into the
portrait so that the onlooker may use them as an
inspirational example and a means of meditation. This
feature, used here tentatively in the small Vatican panel,
was later to be brought to perfection in the frescoes of
San Marco (ills. 80–108). Because of its size the Vatican
panel is dated close to the reliquaries in Santa Maria
Novella which were commissioned by Giovanni Masi in
1434 (ills. 8, 31, 69). The *Perugia Triptych*, which
hitherto has been thought to date from 1437, must
presumably, because of its use of light, the way the gold

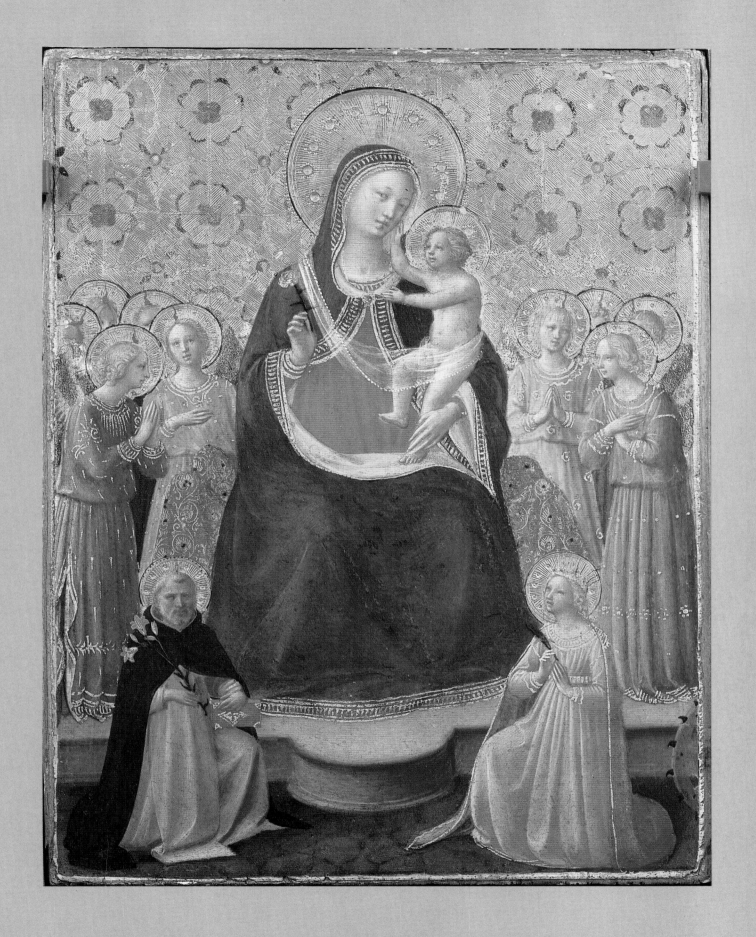

20 *Madonna with Angels and the Saints Dominic and*
Catherine, ca. 1437
Tempera on panel, 23 x 18 cm
Vaticano, Pinacoteca Apostolica Vaticana, Rome

This Madonna picture is Fra Angelico's smallest
altarpiece. The artist's affinity for miniatures is again
evident. The gold work gives the painting a very
sumptuous effect. The illumination, which comes only
from the left, gives the composition astonishing depth.

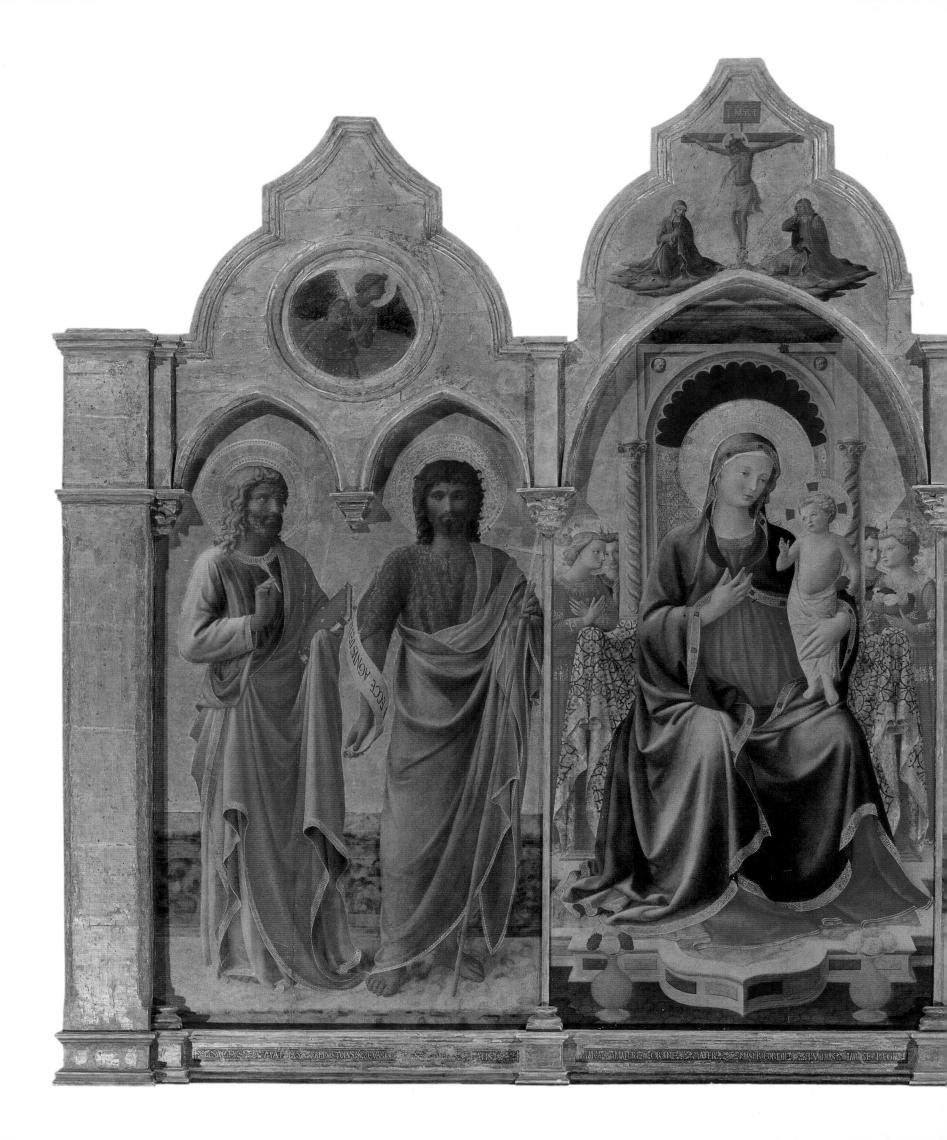

21 *Cortona Triptych*, ca. 1430–1436
Panel transferred to canvas, 218 x 240 cm
Museo Diocesano, Cortona

The Virgin is sitting with the Child on a throne covered
with a gold brocade cloth, shaped above like a stone
niche. The perspective is emphasized by the frame which
overlaps the picture, and by the angels standing behind
the throne. Two vases of roses in front of the throne create
spatial effects. The side panels form a counterpoint with
John the Evangelist and John the Baptist on the left and
St. Mark and Mary Magdalene on the right. Although
there is a stone seat behind their marble step, the
connection with the middle ground is not successful. The
areas on which the figures are standing are also differently
colored. The altarpiece was probably commissioned by
Giovanni di Tommaso di Cecco.

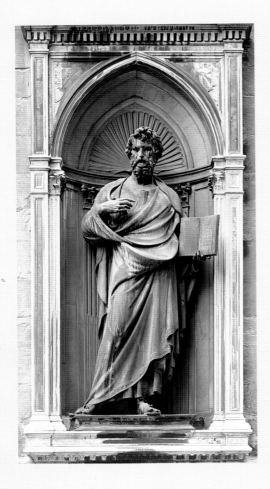

22 Lorenzo Ghiberti
St. Matthew, 1419–1422
Bronze, 270 cm
Or San Michele, Florence

The guilds had gained the right to decorate the niches between the columns with their patron saints. Between 1413 and 1416, Ghiberti made the statue of John the Baptist, the first larger than life-size statue of the Early Renaissance, for the powerful Arte dei Mercanti di Calimala. The influential Arte del Cambio, the money changers' guild, commissioned the sculptor to make the statue of *St. Matthew*. The figure is so big that it does not fit into its niche; the foot is overlapping the plinth and the book is overlapping the space the niche provides.

This monumental work, made for the linen-makers' guild the "Linaiuoli" (ills. 23–28, 30), required Fra Angelico to collaborate with one of the most important Florentine sculptors, Lorenzo Ghiberti (ca. 1378–1455). Source material shows that a carpenter was commissioned on 29th October 1432 to make a wooden model of the tabernacle's marble architecture which was finally executed by Ghiberti's assistants, Jacopo di Bartolomeo and Simone di Nanni.

Not until the following year, on 2nd July 1433, was a contract signed with Fra Angelico. As in the case of the huge frame a design for the painting was the basis of the agreement which, as always, required the colors, the silver and the gold, to be of the finest quality. The linen-makers' guild had decided upon a monument of especial splendor and had the tabernacle encased in costly marble. The fixing for the painter's payment is therefore the more remarkable ("190 florins or as much less as he thinks fit"). Was the vow of poverty of the Observant Dominicans used as a means of setting the price by the patrons? Incidentally, the painter's earnings went to the order, and not into his own purse.

The fact that patrons and artist negotiated the design of the tabernacle and the painting on the basis of a drawing, and above all the fact that the frame was ordered before the painting, have led art historians to attribute the leading role in this project to Ghiberti, the cathedral's renowned master-builder. This is the only commission in the 1430s in Florence for a bigger than life-size figure of the Madonna (ill. 25). On the outer sides of the tabernacle recess, the Apostles St. Mark and St. Peter are depicted (ill. 25), and on the inner sides, St. John the Baptist and once again St. Mark. His second appearance on the inside gives his venerable status special emphasis. He is wearing the same garments as when depicted outside the tabernacle. Now, however, he is looking straight towards the viewer and has raised his right hand in a gesture of blessing. As is generally the case with Fra Angelico's depiction of St. John the Baptist, over his animal-skin tunic he is wearing long robes which reach down to his ankles and reveal very little of the hermit's body. The contour of the robe's hem is harmoniously repeated by the landscape depicted in the background. Because the saints must not tower above the seated figure of the Mother of God in the pictorial center, there is still a great deal of empty space above their heads.

The standing figures of the Saints, however, draw a direct comparison with the sculptures in Or San Michele which were made from 1404 on by Ghiberti, and also by Nanni di Banco and Donatello. The latter had made a sculpture there,

for the linen-makers' guild, of Saint Mark who was their patron saint.

Ghiberti's statue of *St. Matthew* (ill. 22) draws the best comparison with Fra Angelico's panel statues from the point of view of form since its architectural niche, despite the Gothic arch, most recalls that of the Linaiuoli Tabernacle. The folds of the garment in Ghiberti's figure show the shod feet as far as the ankles, and rise up the right leg which is thrust forward, over the clearly visible knee, and fall on the left in a cascade beneath the left hand, in which the book is held. The material lies in large folds over the breast but they are so tight that the right arm has only a little freedom of movement. Fra Angelico's broad-shouldered, powerful St. Peter (ill. 24) most resembles Ghiberti's Evangelist but his garment is draped like a wide shawl around him, gathering up on the ground, and allows little of the figure's stance to be seen. *St. John the Baptist*, whose hairshirt ends above the ankles, has his right leg turned slightly outward, but the pose finds no echo in the folds of his other garment. A look back at the *San Pietro Martire Triptych* (ill. 11) at this point, shows how Fra Angelico had developed his own formulations without the concrete influence of the sculptor.

The form of Fra Angelico's painting was constrained by the already existing construction of the tabernacle, a rounded arch for the folding wings with St. Mark and St. Peter, and the smaller panel for the Madonna. It was the painter's own idea to bridge the gap between Ghiberti's structure and his Madonna panel with a wooden frame that deepens the perspective and is decorated with music-making angels (ill. 23) which enhance the splendor of the Virgin. The effect is further enriched in the central panel by a golden curtain, which is drawn aside. The way the light is directed brings the rear wall of the barrel-shaped painted niche into shadow, thus creating space.

Even if Fra Angelico was only moderately inspired by the monumental sculptures of Or San Michele, Ghiberti's architecture for the Tabernacle provided inspiration for the painter elsewhere. It seems to have been behind the design for the *Annunciation* in Fiesole (ill. 59). In the loggia scene there, the throne architecture, albeit without the gable, recalls Ghiberti, as do the leaf frieze, and the shell-like rippled niche of the God the Father. A variant of the latter can even be seen in the Niccolina frescoes (ills. 109–116).

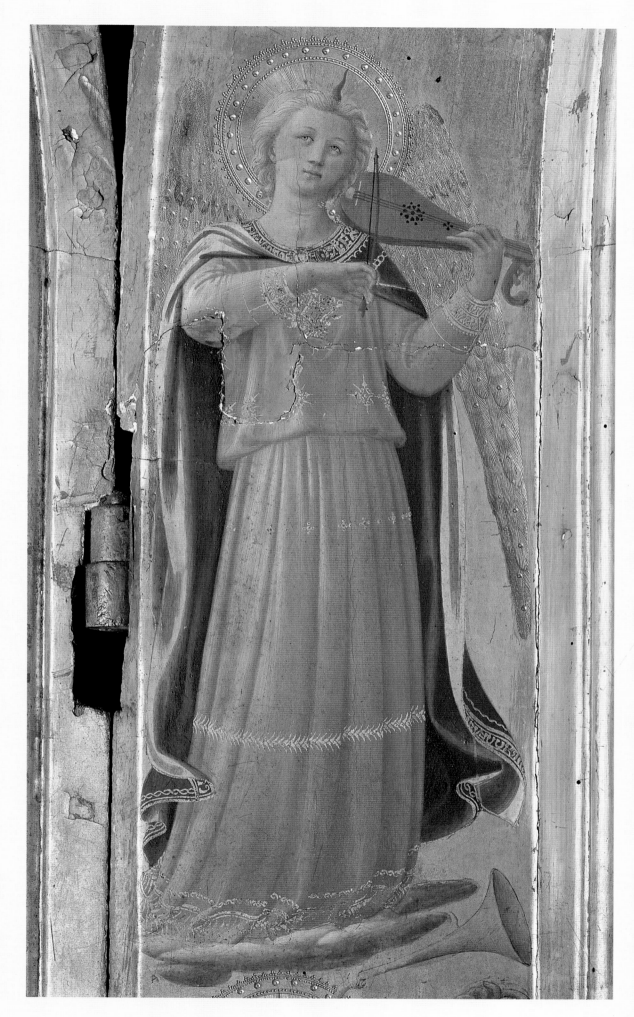

23 *Linaiuoli Tabernacle: The Music Making Angel from the Border* (detail ill. 25), 1433

Despite their poor state, the twelve angels in the border, each playing a different musical instrument, belong to the favorite motifs of Fra Angelico's art. They are the embodiment of elegance and gentleness in their soft colors, and express a true piety.

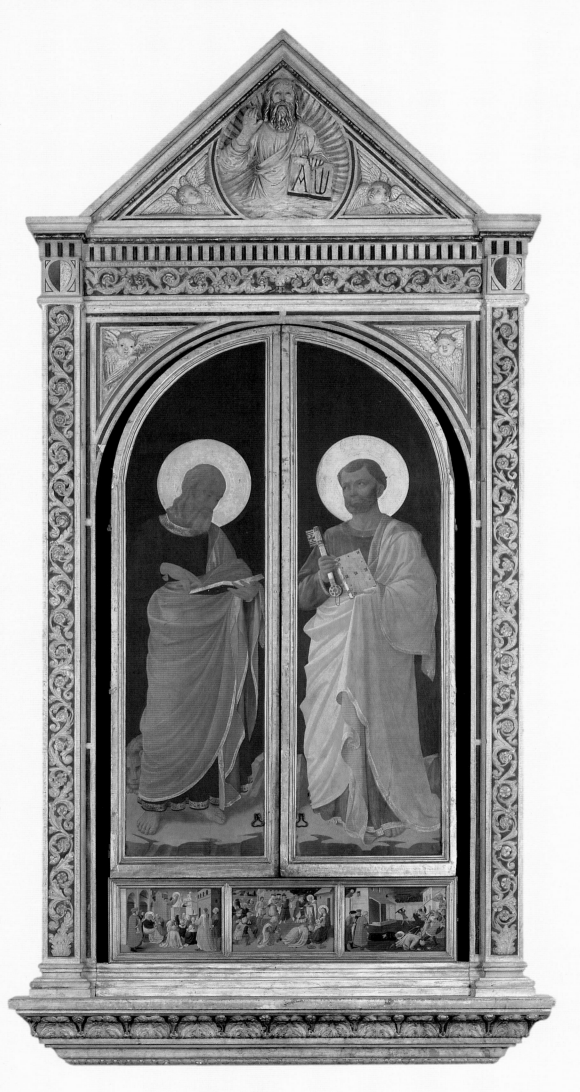

*24 Linaiuoli Tabernacle: The Evangelist Mark and the
Apostle Peter*, 1433, wings closed
Tempera on panel, 292 x 176 cm
Museo di San Marco, Florence

In 1433 Fra Angelico was commissioned to make the
monumental tabernacle for the linen-makers' guild. The
tabernacle architecture was made to Ghiberti's design.
The work was put on show in the hall of the linen-
makers' guild where it stayed until 1777. The Evangelist
and the Apostle stand on clods of earth which are step-
like in appearance. The figures occupy so much space on
the panel that the face and feet of the lion, the attribute
of St. Mark, can scarcely be seen on the left. The dark
background cuts off the open, non-feast day side from the
feast day side.

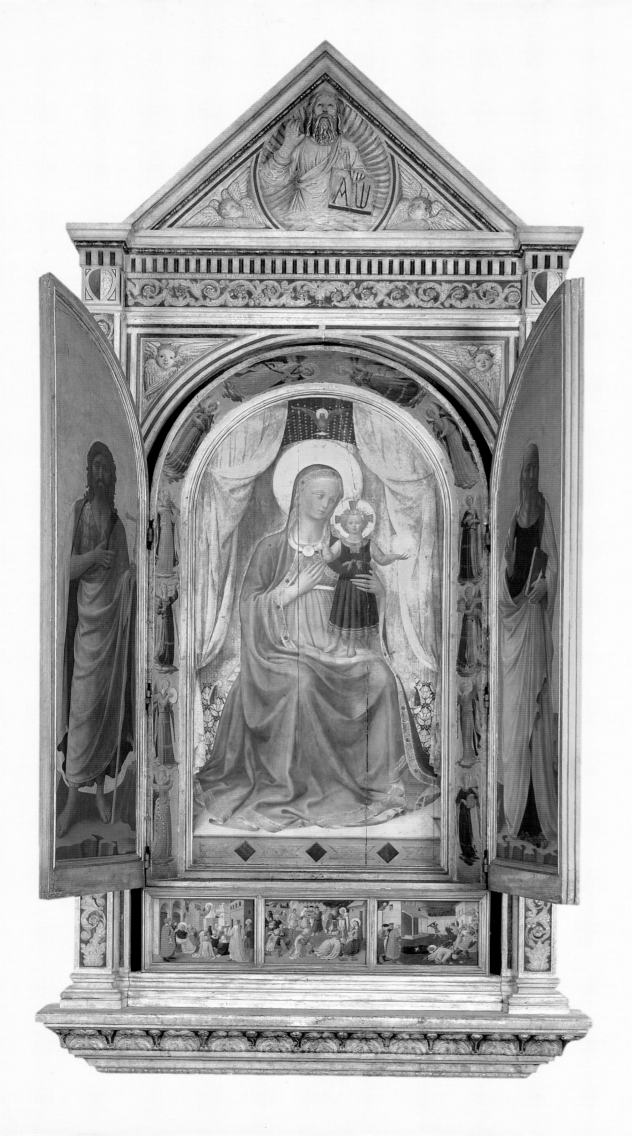

25 *Liniauoli Tabernacle: Virgin and Child making the Blessing*, 1433, wings open
Tempera on panel, 233 x 133 cm
Museo di San Marco, Florence

The central picture with the Virgin and Child is set in a recessed frame which is decorated with a border of twelve music-making angels. The Mother of God sits in a rounded niche with a starry sky above. A gold curtain is drawn back to reveal the view.

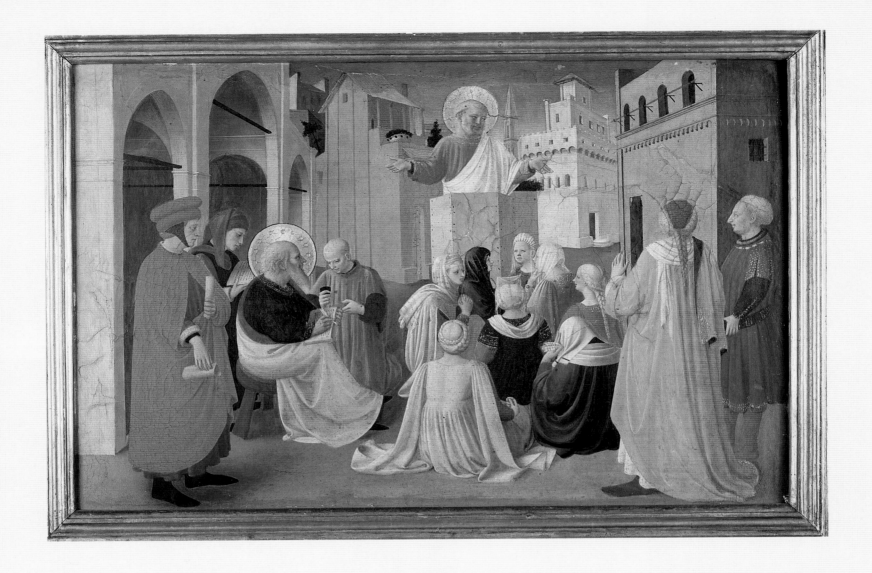

26 (above) *Linaiuoli Tabernacle: Peter Preaching with Mark* (detail ill. 24), 1433, predella
Tempera on panel, 39 x 56 cm
Museo di San Marco, Florence

As in the story from the "Legenda Aurea", Mark is portrayed listening attentively to his master, Peter. Peter, the chief of the apostles, is almost in the center of the picture, stretching far out from the pulpit. The people listening are mostly women; a man standing on the right frames the picture, and a scholar watching Mark writing frames it on the left. Two assistants are attending to the seated scholar. The loggia behind corresponds in size to the figures whereas the background architecture with its bright colors should be seen as purely decorative.

27 (opposite, above) *Linaiuoli Tabernacle: Adoration of the Magi* (detail ill. 24), 1433, predella
Tempera on panel, 39 x 56 cm
Museo di San Marco, Florence

The composition is circular and in the center is a group of three figures, one of whom is pointing at the star. The people crowd round on the left with horses and camels. The oldest King has just paid homage to the Child and is holding both hands of Joseph, the adoptive father, in a touching gesture. The middle one of the three Kings is bending so low over the Child's feet that he has to steady himself with one hand. To emphasize his humility, he is shown in a posture of complete abasement.

28 (opposite, below) *Linaiuoli Tabernacle: The Martyrdom of St. Mark* (detail ill. 24), 1433, predella
Tempera on panel, 39 x 56 cm
Museo di San Marco, Florence

The Martyrdom of Mark, the Evangelist, of which several episodes are joined together, takes place in Alexandria. Mark was dragged through the streets until he was half dead. The following night he was comforted in prison by the appearance of Christ. In the foreground he lies in a black cloak, now dead after being dragged yet again along the ground. His tormentors are about to burn him but a hailstorm occurs, and they flee. The storm is convincingly portrayed against the wall in the background with its decorated pilasters.

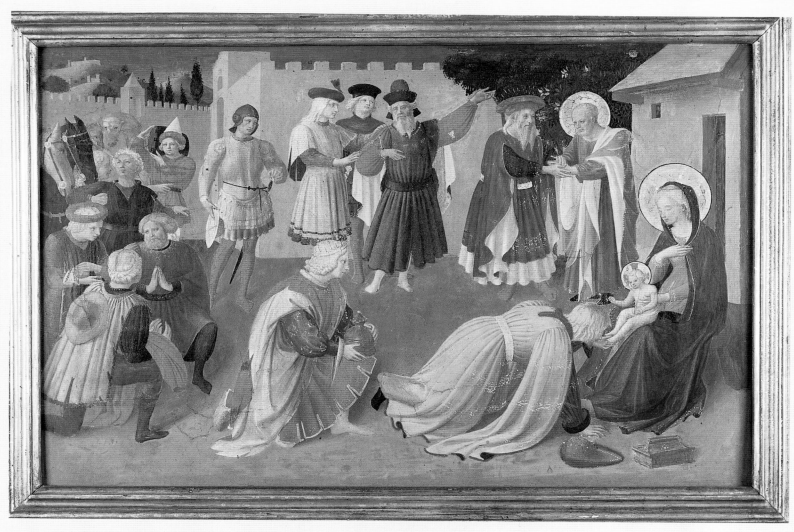

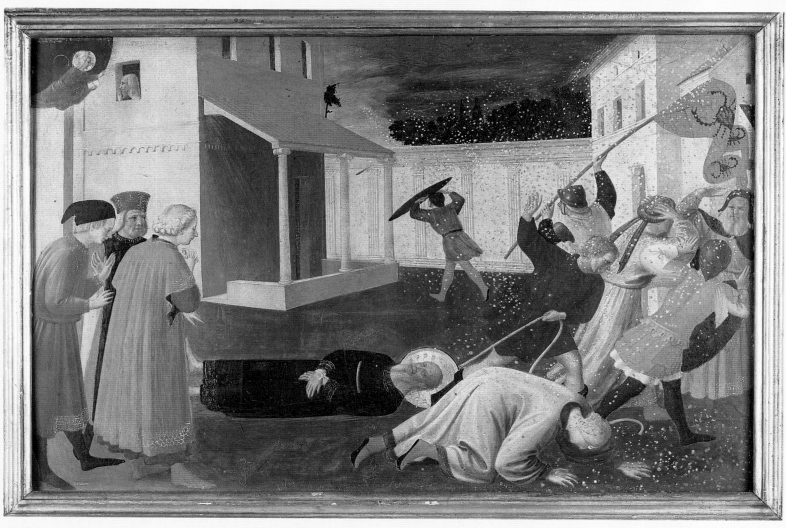

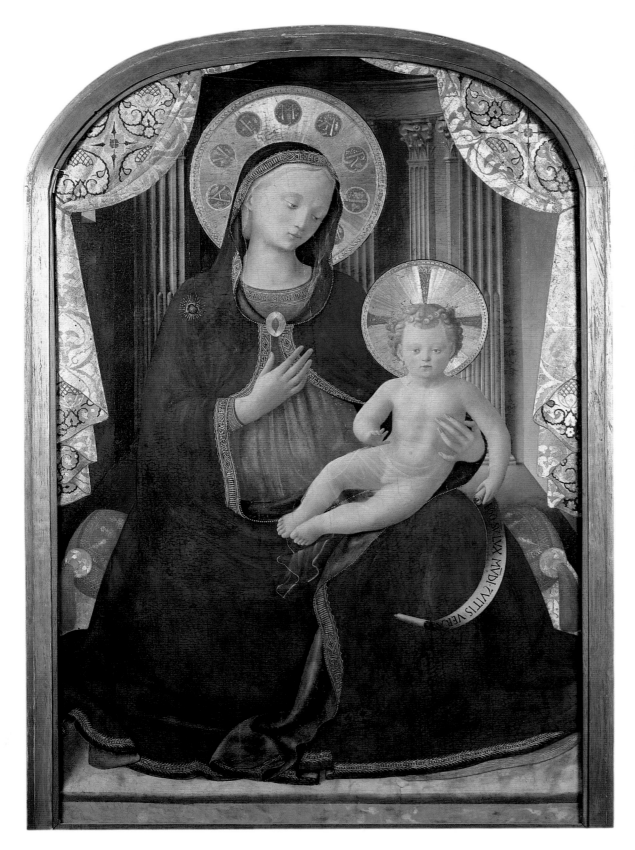

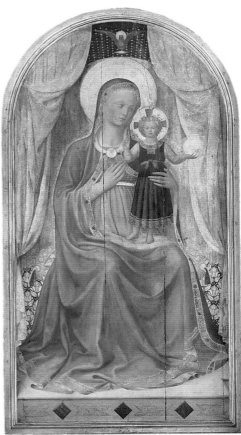

29 (left) *Madonna and Child*, after 1433
Tempera on panel, 100 x 60 cm
Pinacoteca Sabauda, Torino

The panel, which is probably cut off at the top, is a variation on the Madonna of the *Linaiuoli Tabernacle* (ill. 30). A curtain drawn back behind reveals the picture once again. The Virgin is set further back in space. The Child, no longer in a Lordly pose wearing an oriental garment, is naked and seated, holding a ribbon of text in his hand, which is not typical of Fra Angelico. Pillars and columns form the background.

30 (above) *The Virgin Mary and Christ Child making the Blessing* (detail ill. 25), 1433

The Linaiuoli Triptych demonstrates Fra Angelico's development in his early work towards a mature pictorial language of his own. The Virgin Mary sits heavily whilst the Christ Child, wearing His costly garment, gives the artist ample opportunity to paint with great subtlety. As original painted, the different gradations of gold tones will definitely have contributed to the effect of perspective.

is used, and the confident introduction of shadow, be dated earlier.

The altarpiece, most parts of which are now in the Galleria Nazionale dell'Umbria in Perugia, two predella panels being in the Pinacoteca Vaticana (ills. 33 – 38), was executed in 1437, according to traditional sources, for a side chapel dedicated to St. Nicholas in the church of San Domenico in Perugia. St. Nicholas of Bari appears, therefore, on the left side of the panel together with St. Dominic: on the right are St. John the Baptist and St. Catherine of Alexandria. Bishop Giudalotti is believed to have commissioned it since the chapel was under his family's patronage. The frame that belonged to it originally was removed, probably in the 19th century, and the panels are now mounted in a modern setting.

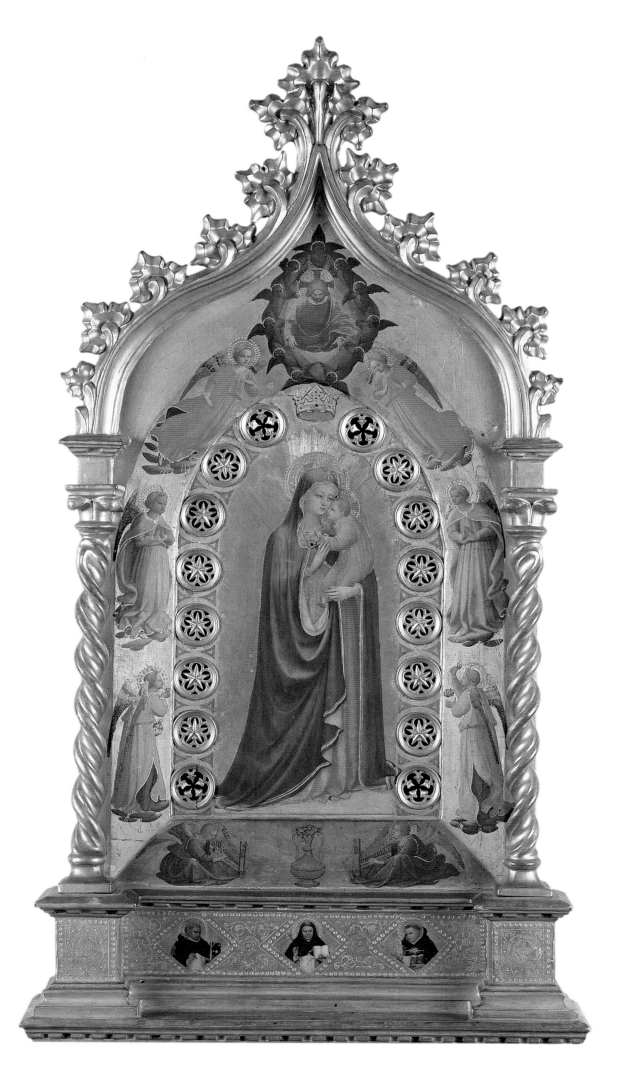

31 *Madonna della Stella,* before 1434
Tempera on panel, 84 x 51 cm (as a whole),
60 x 30 cm (picture)
Museo di San Marco, Florence

This reliquary for Giovanni Masi is Fra Angelico's only
standing Madonna. The delightful angels in the border
can be compared with those in the *Linaiuoli Tabernacle*
(ills. 23, 25). The angels sitting beneath the figure in
green establish a link with the green grass of the ground;
the receptacle is a reminder of the symbolic comparison
of the Virgin's body with a sacred vessel. The four
reliquaries were intended for the Dominican convent of
Santa Maria Novella in Florence.

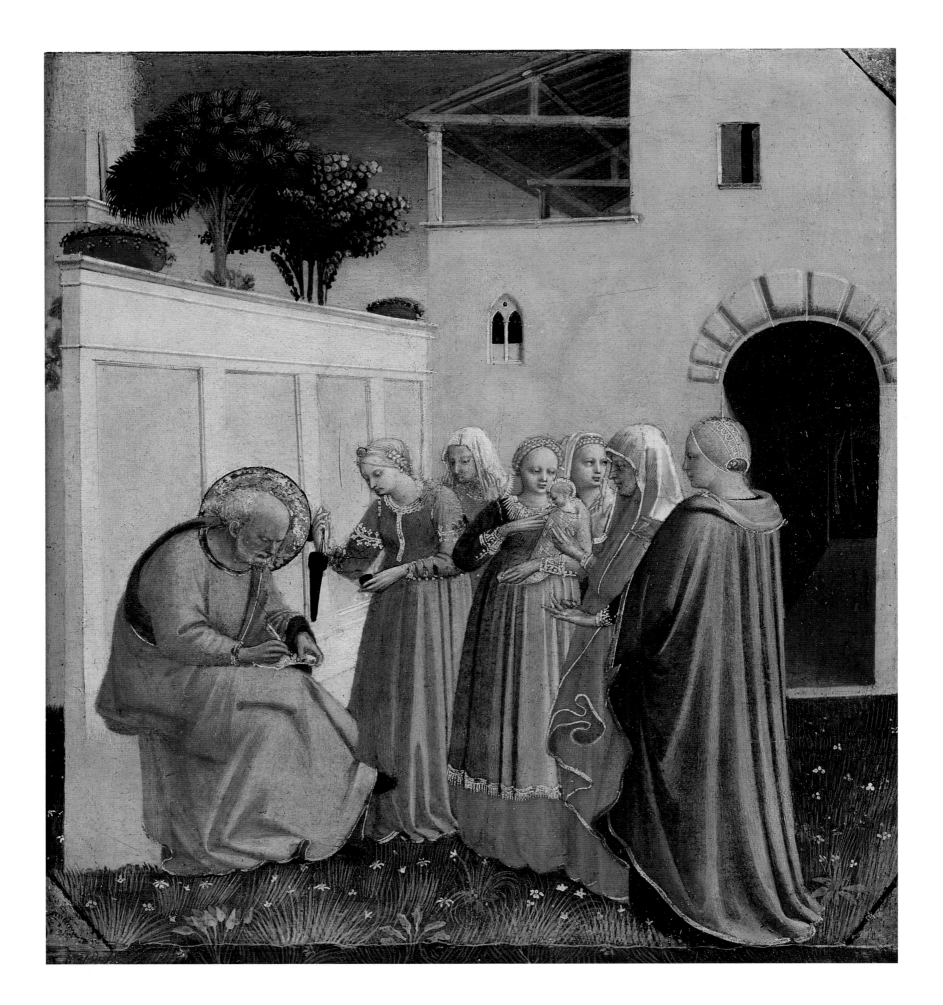

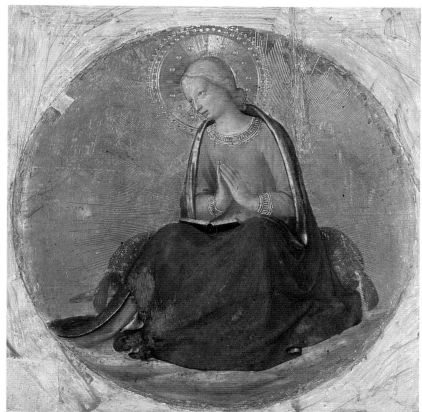

33 (above left) *Perugia Triptych: Angel of the Annunciation from the finial* (detail ill. 35), 1437
Tempera on panel, 29 cm diameter
Galleria Nazionale dell'Umbria, Perugia

The angel is kneeling in profile in a round medallion with a gold ground that looks like a huge auriole. He is turned to the right and sits on a cloud, floating on air.

34 (above right) *Perugia Triptych: The Virgin from the Annunciation from the finial* (detail ill. 35), 1437
Tempera on panel, 29 cm diameter
Galleria Nazionale dell'Umbria, Perugia

The Virgin in three-quarter profile, is sitting, also wafted by heavenly breezes, in front of a ray-like, gold, decorated ground. She is turned toward the angel in the other medallion. To fill out the circle the sitting pose is widened, in contrast with the slender upper body.

32 (opposite) *The Naming of John*, ca. 1434/35
Tempera on panel, 27.3 x 24.9 cm
Museo di San Marco, Florence

Zacharias, who did not want to believe the angel's message that his elderly wife was with child, was struck dumb. After the child's birth, when asked how he was to be named, he went against family tradition and wrote down John, and could speak again. This panel with its charming illumination and depth is part of a predella from a lost altarpiece with which three other fragments are linked (*St. James the Great frees the Magician Hermogenes* – Kimbell Art Museum, Fort Worth, *Death of the Virgin* – Philadelphia Museum of Art, Philadelphia, and *the Meeting of St. Dominic and St. Francis* – The Fine Arts Museum, San Francisco).

The same concept which lay behind the triptych made for the Dominicans in Cortona (ill. 21) (which still, however, contained the irritating divisions between the central and side panels) was not brought convincingly to fruition until the creation of the Perugia altarpiece. As in the earlier Cortona altarpiece, the central painting is set back far in space from the side panels. The monumental throne architecture, by now more classical, has a leaf frieze which has similarly been cut off by the frame. The wings of the platform that the throne stands on abut on a table covered with gold brocade on which St. Nicholas' mitre has been placed at the left hand side.

The two foremost angels are placed in front of the throne, in such a way that they, and their wings with the delicate gold ground, have more freedom of movement. The motif of the basket of roses and the vases in the foreground is familiar from the older Cortona altarpiece but the even distribution of white, pink, and red petals lends the composition more harmony of color. The angel in blue adds even more to this. The interplay of red and green leads the eye to the figure of St. Nicholas, who is wearing a magnificent green cope (ill. 35). He is lost in contemplation of his book, whereas St. Dominic is pointing to the Holy Scripture. The saints on the right are less impressive: the stiffly draped cloak worn by John the Baptist and the twisted ribbon of text are no more convincing than St. Catherine, who is a slightly changed, but still recognizable copy of St. Mary Magdalene in Cortona. Saint John's staff disappears behind his halo in a witty manner.

The Perugia altarpiece marks an important step in the development of Fra Angelico's creativity, as far as his

treatment of surface and the qualities of light are concerned. In the altarpiece itself, the reflections of gold from the brooch on the Virgin's shoulder for example, and St. Nicholas' brocade edging, shine out, full of nuances. The predella offers an inspiring effect in the novel observation of nature, such as the atmospheric elements in the storm on the high seas which can be seen in the background (ill. 37).

The *Annalena Altarpiece* (ill. 39–45) is named after the first place it was known to have been installed, namely the Florentine convent of San Vicenzo d'Annalena. It was certainly not created for the house itself, which was founded only in 1450 or 1453, the patron saint being Vincent Ferrer who was not canonized until 1455. A dating before this has been widely accepted, though it is still debatable whether it precedes the *San Marco Altarpiece* (ill. 47). Because of the choice of saints in the main panel which include Francis, Peter Martyr, and John the Evangelist as well as Lawrence, Cosmas and Damian – the predella tells the story of the last two (ills. 40–45) – it is believed that the work was destined for a chapel dedicated to St. Peter Martyr, which had been endowed by Cosimo de' Medici. Since this future patron of the convent of San Marco had returned to Florence only in 1434, this date counts as *terminus post quem*. William Hood believes it to have been destined for the Medici chapel in the transept of San Lorenzo.

The *Annalena Altarpiece* is of great significance for the *San Marco Altarpiece* (ill. 47). If 1434, or shortly thereafter, is its real date, it is the oldest altarpiece of the Early Renaissance in which the division into Gothic

arches was rejected in favor of the rectangle. The saints on either side of the enthroned Virgin stand on a single plane that continues through the whole picture. The wall with its leaf frieze behind the figures is convincingly transformed into an architectonic whole. Only the colored inlays, which form two arches at either side of the Virgin's throne, recall the polyptych form. The present uniformly dark shading at the top probably originates from a restoration. Pots of flowers most likely stood on the wall, with trees towering above it as in other pictures, including predella scenes (ills. 40–45).

Lastly, by varying the form of the throne niche, a device he had used in the Maria *Cortona Triptych* (ill. 21) and in the *Perugia Triptych* (ill. 35), Fra Angelico sets the Virgin's throne on a different plane behind, thereby emphasizing the saints. Here they are not standing at the front edge but partly on the lower step of the stone platform, and partly on the grass in front, so that the space is opened up. As if it were essential to use a certain amount of gold in the creation and he wanted to use more, Fra Angelico includes a gold brocade cloth, stretched across behind the saints. However, it is clearly not the traditional plain gold ground, devoid of spatial effect, but a curtain fixed to the back wall with hooks. There may well be only a loose connection between the altarpiece in San Marco (ill. 47) and this one, if unity of space alone is the criterion of their form, but the predella panels draw a direct parallel with the life story of Cosmas and Damian (ills. 40–45), since these are a reminder of Cosimo de' Medici whose patron saints they were.

Fra Angelico's most important commission was the work in the convent of San Marco in Florence when it was being renovated and rebuilt, at which time he and his fellow Observant Dominicans from Fiesole moved in. The Museo di San Marco is now housed there and contains most of his works. Certain questions of ownership had to be cleared up before the work on extending the Choir and rebuilding the altar could be started. The *Coronation of the Virgin with Saints* by Lorenzo di Niccolò, dating from 1402, was a substantial altarpiece that belonged to San Marco before the Dominicans took over the building. But Cosimo de' Medici decided in 1438 to give it to Cortona. In 1440 the convent there received it, as an inscription on the picture testifies.

In 1438, the young painter, Domenico Veneziano, applied to Cosimo's son, Piero de' Medici, for the task

35 *Perugia Triptych*, 1437
Tempera on panel, 332 x 80 cm
Galleria Nazionale dell'Umbria, Perugia

The Virgin is surrounded by saints Dominic and Nicholas on the left, and John the Baptist and Catherine of Alexandria on the right. Similar to the *Cortona Triptych* (ill. 21) in structure, the side panels are included in the unifying design. The use of light is remarkable with reflections from window, and with the shadows on the vases in the foreground it is worthy of an old Flemish master.

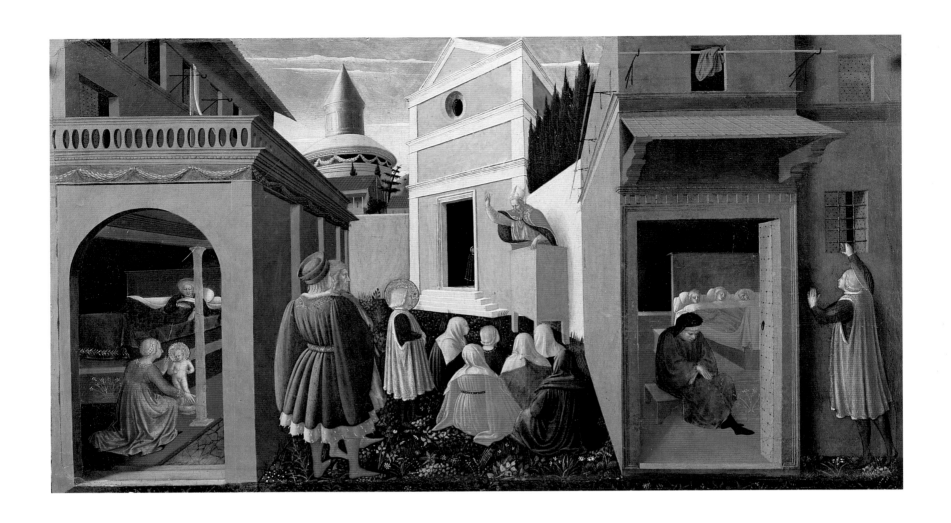

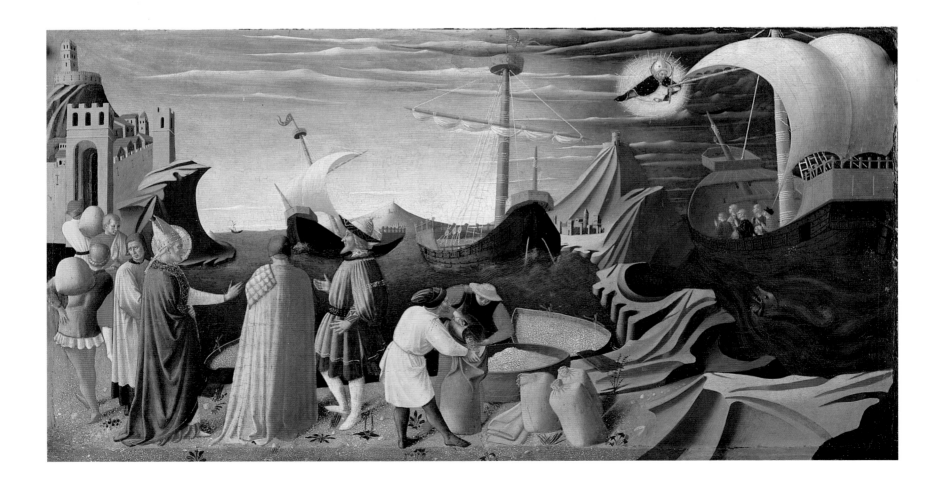

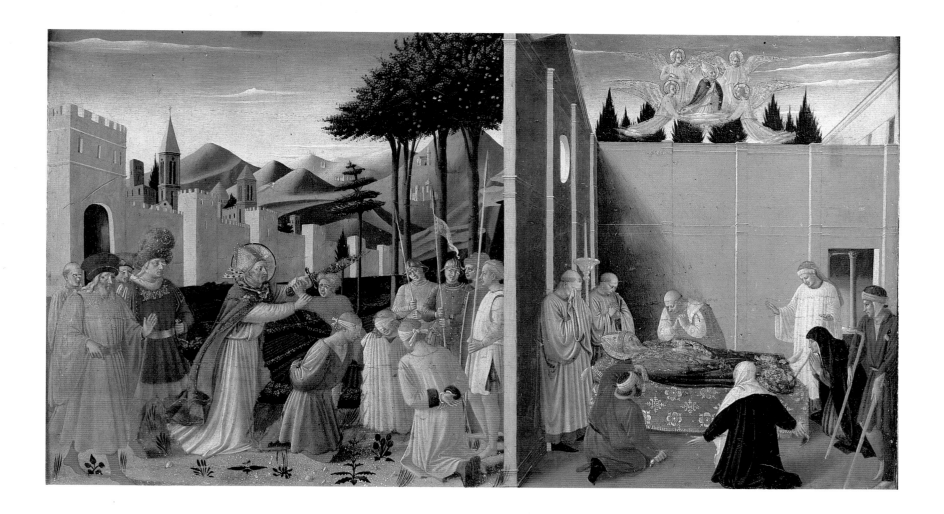

36 (opposite, above) *Perugia Triptych: The Birth of St. Nicholas, his Calling, the Giving of Alms to the Three Poor Girls* (detail ill. 35), 1437, predella
Tempera on panel, 34 x 60 cm
Vaticano, Pinacoteca Apostolica Vaticana, Rome

Three episodes from the saint's life are combined in one picture. Large openings reveal the interior scenes. The house in the middle ground also has an opening into which a boy is disappearing, as if Fra Angelico decided to exaggerate this old device in an attempt to disguise it. There are heavy shadows on the architecture and the light comes only from the left.

37 (opposite, below) *Perugia Triptych: Nicholas Saving a Ship at Sea, the Propagation of the Wheat* (detail ill. 35), 1437, predella
Tempera on panel, 34 x 60 cm
Vaticano, Pinacoteca Apostolica Vaticana, Rome

Two episodes from the sea voyage are combined on this panel. They are divided by a cliff formation in the sea, and more spectacularly, by a change of light. On the left, which actually defines the foreground, the Unloading of the Wheat takes place. The sky is bright and the sea calm. As the storm gathers, the mast of the ship is used as a dividing line to show the sailors on the right, begging St. Nicholas for help.

38 (above) *Perugia Triptych: Nicholas Frees the Innocent, his Death* (detail ill. 35), 1437, predella
Tempera on panel, 34 x 60 cm
Galleria Nazionale dell'Umbria, Perugia

On the left Nicholas, with his cloak billowing out, hurries towards the executioner to prevent him from cutting off the heads of three criminals. He and his followers are coming from a city whose walls stretch right into the ground. Fra Angelico uses a wall-like construction to divide the panel in order to include the Saint's death. Although the place is supposed to be an interior, there is no roof. Above the wall two angels are carrying off his soul, and behind the tops of cypress trees can be seen.

39 (following page) *Annalena Altarpiece*, ca. 1437–1440
Tempera on panel, 180 x 202 cm
Museo di San Marco, Florence

Named after the first place it was installed, in the convent of San Vincenzo d'Annalena, this is the first known rectangular altarpiece of the Renaissance if one accepts a dating before the San Marco work. The architect, Filippo Brunelleschi, had first ordered rectangular altarpieces for his church San Lorenzo in Florence in 1425. Next to the seated Virgin and Child there are the Saints Peter Martyr and Francis on the outside, on the left Cosmas and Damian, and on the right John the Evangelist and Lawrence set on a plane that carries through the picture.

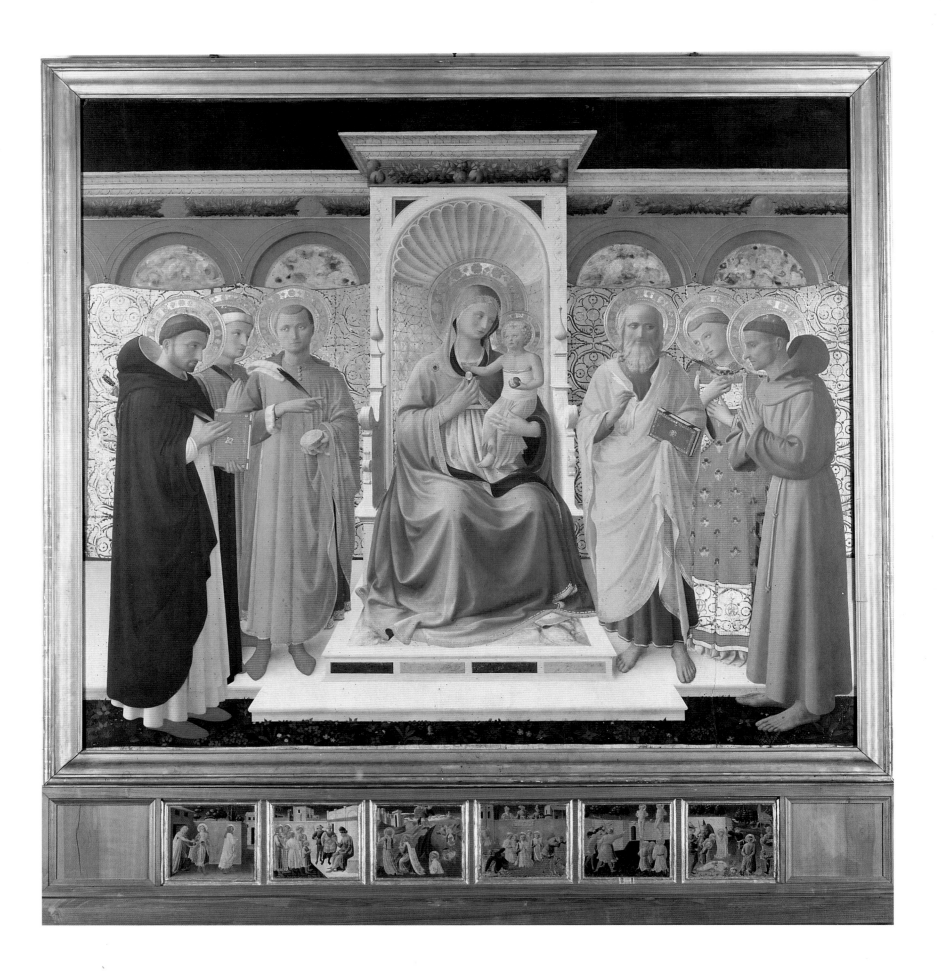

40 *Annalena Altarpiece: The Healing of Palladia*
(detail ill. 39), ca. 1437–1440, predella
Tempera on panel, ca. 20 x 22 cm

As in the San Marco altarpiece, scenes from the lives of
Cosmas and Damian are depicted in the predella. The
two saints were doctors who practised their art in the
service of God and so cured people without payment.
Palladia, whose healing is not depicted, begged Damian
to accept money. Cosmas learns later that it was accepted
and is angry.

41 *Annalena Altarpiece: Cosmas and Damian before Lycias*
(detail ill. 39), ca. 1437–1440, predella
Tempera on panel, ca. 20 x 22 cm

According to Jacobus da Voragine in his "Legenda Aurea",
there follows the trial before Lycias. The saints' brothers
are mentioned only in the Legend however, and Fra
Angelico shows them younger. The smallest seems to be
explaining to Lycias that they, as Christians, are not
prepared to sacrifice to his gods.

42 *Annalena Altarpiece: Cosmas and Damian are saved
from drowning by an angel* (detail ill. 39), ca. 1437–1440,
predella
Tempera on panel. ca. 20 x 22 cm

Lycias has the saints tied up and thrown into the sea so
that they will drown. An angel rescues them and returns
them to the judge. The henchmen who have thrown
Cosmas and Damian into the sea have to stoop to be
portrayed fully. While one Saint is falling with a mighty
splash into the water, the other is still in the air. In the
foreground, where the angel is bringing them on land,
there is only one out of the water while the other is still
half in the sea. This is to make clear that the action is in
progress.

43 *Annalena Altarpiece: Cosmas and Damian at the Stake*
(detail ill. 39), ca. 1437–1440, predella
Tempera on panel, ca. 20 x 22 cm

In the next episode of their martyrdom, Cosmas and
Damian again appear with their brothers. All five are
kneeling and praying at the stake which burns not them
but their tormentors who are fleeing in pain out of the
picture. Lycias watches from a wall which forms the
background.

44 *Annalena Altarpiece: Cosmas and Damian are Crucified
and Stoned to Death* (detail ill. 39), ca. 1437–1440,
predella
Tempera on panel, ca. 20 x 22 cm

Two events from the life of Cosmas and Damian are
combined since they follow one another. First, the two are
crucified. The people are ready to stone them, but
miraculously the stones hit only the tormentors. In the
end the three brothers are released from prison and in
their presence, horsemen shoot at the saintly doctors with
arrows which in turn are deflected. The people throwing
stones and the archers are standing together. The stones
fly like round balls through the air. To show that it will
come back, one arrow is already pointing the wrong way
as the bow is pulled.

45 *Annalena Altarpiece: The Beheading of Cosmas and
Damian* (detail ill. 39), ca. 1437–1440, predella
Tempera on panel, ca. 20 x 22 cm

In the end after Lycias has almost declared himself beaten
by the martyrs, they are beheaded together with their
brothers. To left and right the soldiers stand like the
pillars of the composition; one of the martyrs is lying
beheaded on the ground, the other figure is seen from the
rear. The brothers are kneeling together next to each
other. All aspects, from profile to full-face, are shown.

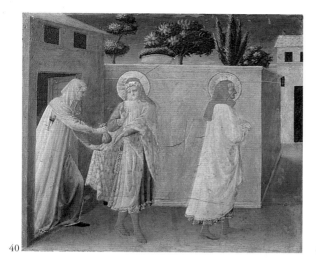
40

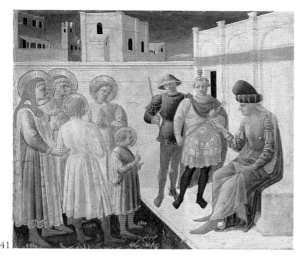
41

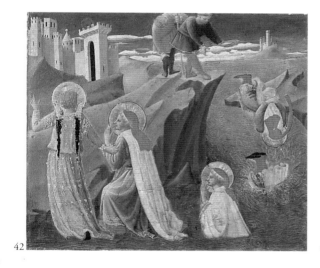
42

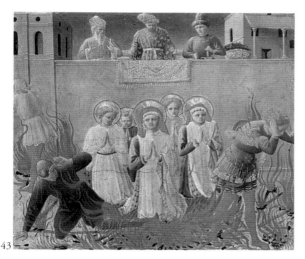
43

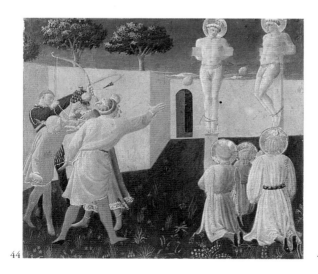
44

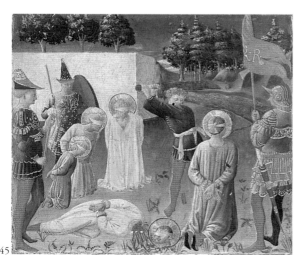
45

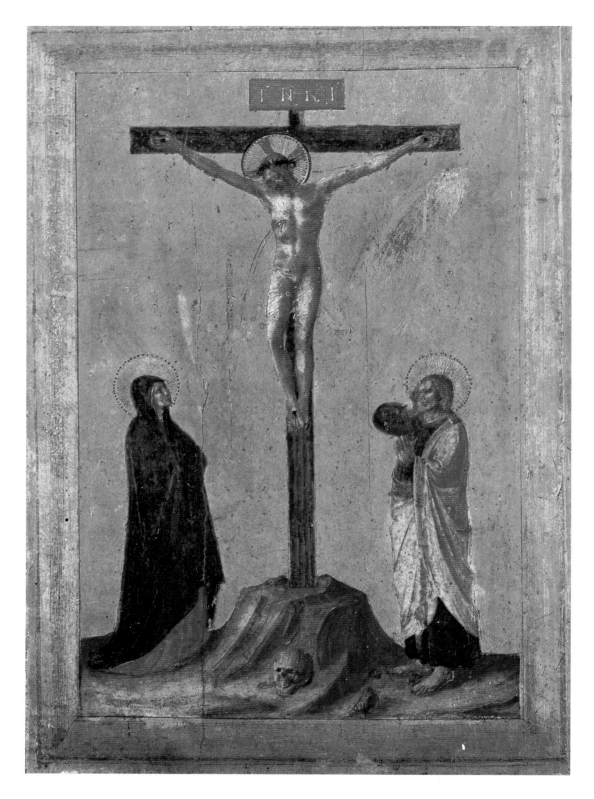

of making "an altarpiece of great splendor", mentioning thereby "the superb masters, Fra Filippo and Fra Giovanni who did not lack for work". At this time Fra Angelico had presumably started to develop his own ideas for an altarpiece. Whatever the case may be, it was ready to be put in place by Epiphany (6 January) 1443 for the solemn consecration of the church in the presence of Eugenius IV.

The *San Marco Altarpiece* (ill. 47) is Fra Angelico's most famous altar painting, but sadly it is only a shadow of its former glory now because of clumsy restoration, which has abraded the whole of the surface and destroyed all the subtleties of the painting. A curtain drawn back reveals the host of saints before the Virgin enthroned in the Garden of Paradise. Garlands of roses are fixed behind. The Virgin's steep throne with its shell niche, leaf frieze, brocade cloth and golden pilasters is set far back into the picture. A curtain attached to the trees divides the figures from the landscape with its dense trees in the middle ground, and sea and mountains in the background.

There are several indications of the patron Cosimo de' Medici in this altarpiece, his most important commission to date. As in the *Annalena Altarpiece* (ills. 39–45), the Medici saints figure with St. John the Evangelist in the central part together with the patron saint of the church, St. Mark and the Dominican saints, Dominic, Peter Martyr and Thomas Aquinas, as well as in the predella. There are even more signs of Cosimo in the painting – on the border of the oriental carpet, a Persian *Bakhtiar*, the only one in Fra Angelico's œuvre, the Medici *palle* are depicted. In the pattern itself are what are probably meant to be the Zodiac signs of Pisces and Cancer, which are reminders of the Council which began in 1439 to bring about the union of the Eastern and Western Churches, and in which Cosimo had played an important role.

The carpet's diminishing squares recede to the central group of the Virgin and Child who is characterized by the globe in his hands as the master of all earthly things. The pattern of the carpet also defines the surface on which the saints are standing. In an attempt to relieve the wedge-shaped formation of the saints, Fra Angelico includes some kneeling figures. Apart from the wonderful figure of St. Lawrence, who is looking straight at the onlooker, Cosmas and Damian have the effect recommended by Alberti in his treatise "De Pictura", in which he says at least one person should be included in the *historia* who, as it were, invites the onlooker into the picture. Hitherto, the only similar feature was to be found in the *Miracle in the Snow* by the Sienese artist Sassetta (from 1432 to 1434), now in the Pitti Palace in Florence. Fra Angelico surpasses the effect here with the rear view figure of Damian: for while the figures of St. Lawrence and St. Cosmas invite the onlooker to prayer, St. Damian, in lost profile, is setting an example of worship.

The verses around the edge of the Virgin's mantle, the opening words of the daily Holy Office of the Virgin, show how strongly the altarpiece was woven into the liturgy of the Dominican friars. St. Mark's Gospel is

46 *San Marco Altarpiece: The Floor with the Crucifixion* (detail ill. 47), ca. 1439–1442

Even if the present state does not show the quality of the painting, the Crucifixion painted into the main panel as a picture within a picture gives an idea of its ambitious composition. In addition to the seated Madonna and the Lamentation in the predella it emphasizes the place where the sacrament was kept, which in Dominican churches was on the altar.

open at chapter 6 in which the sending forth of the apostles is described. This is a reminder of an important rule for Observants, namely preaching to, and saving the souls of, the laity.

As in the *Annalena Altarpiece* (ills. 39–45), the predella contains scenes from the Life of the healing Saints (*medici*), Cosmas and Damian (ill. 48–53), but told here more cogently. It is unusual for a busy artist's studio not to have reused a cycle of pictures once established, especially as these included the saints' younger brothers. Experts have come to different conclusions about the reason for this. The coloration in the Annalena predella has a more archaic look and is poorer in quality, so that we may conclude that studio assistants possibly had a hand in its production. A dating of the *Annalena Altarpiece* later than the San Marco one, and the use of the predella designs from San Marco, as John Pope-Hennessy believes, still does not explain the differences in composition of the Life of the Saints. A more practical assessment might be that Fra Angelico let his assistants copy for a later work the designs he had already made.

47 *San Marco Altarpiece*, ca. 1439–1442
Tempera on panel, 220 x 227 cm
Museo di San Marco, Florence

While the other works for San Marco were designed to meet the needs of the Dominican friars, Cosimo de' Medici's wishes had to be consulted for the altarpiece. The choice of saints was based on his patron saints, Cosmas and Damian, his brother's namesake, Lorenzo, and Saint Mark, the patron saint of the church. The surface has been destroyed by aggressive restoration and the original frame is lost.

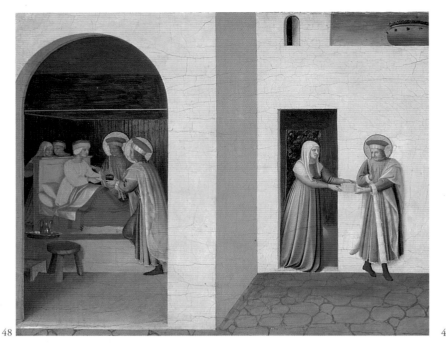

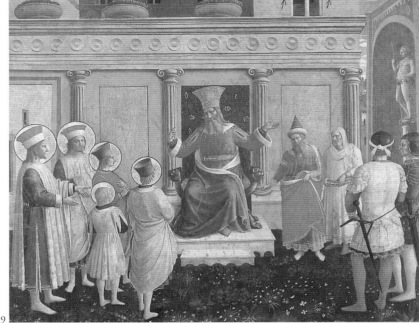

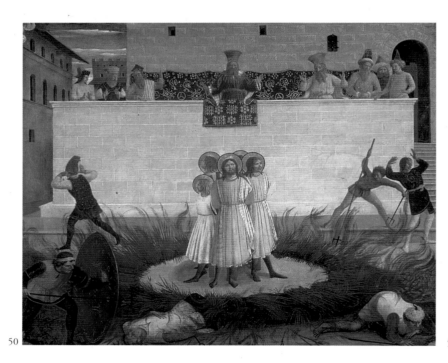

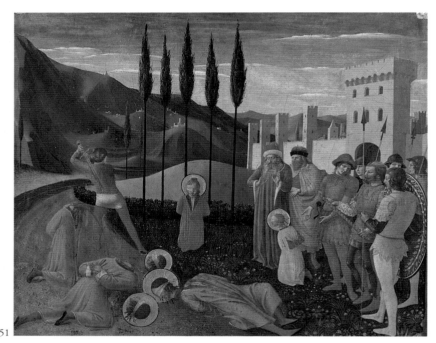

48 *San Marco Altarpiece: The Healing of Palladia,* 1439–1442, predella
Tempera on panel, 38 x 45 cm
National Gallery of Art, Washington

As in the *Annalena Altarpiece* (ill. 39), the predella shows the life of Saints Cosmas and Damian but in a more convincing version and ambitious execution. The healing and the presenting of the money are separated so that the dark room where the healing takes place is separated from the scene of the presenting of money by an outer chamber. Damian alone, turning hastily, accepts the gift.

49 *San Marco Altarpiece: Cosmas and Damian before Lycias,* 1439–1442, predella
Tempera on panel, 38 x 45 cm
Bayerische Staatsgemäldesammlungen, Alte Pinakothek, München

Lycias is sitting in front of a wall which recalls classical Antiquity in its structure. On the right in a niche there is a statue of a pagan god. Cosmas and Damian and their younger brothers are standing on the left and on the right next to the niche there are Lycias' advisers. He shows with a look that he wants the Christians to pay homage to the god.

50 *San Marco Altarpiece: Cosmas and Damian are to be burnt alive,* 1439–1442, predella
Tempera on panel, 36 x 46 cm
National Gallery of Ireland, Dublin

The fruitless attempt to burn the doctors and their brothers is portrayed in a wonderful composition of horizontal and circular motifs. The condemned and Lycias form the axle that becomes the center of a wheel of fire which turns itself onto the fleeing henchmen.

51 *San Marco Altarpiece: The Beheading of Cosmas and Damian,* 1439–1442, predella
Tempera on panel, 36 x 46 cm
Musée du Louvre, Paris

Cosmas and Damian and their brothers are arranged almost in a circle to extend the space in the middle distance which is enclosed by five cypresses. The group of soldiers crowds into the picture in a diagonal line from the left, with a city wall set diagonally behind them. Tiny walled cities bring the hills in the background to life.

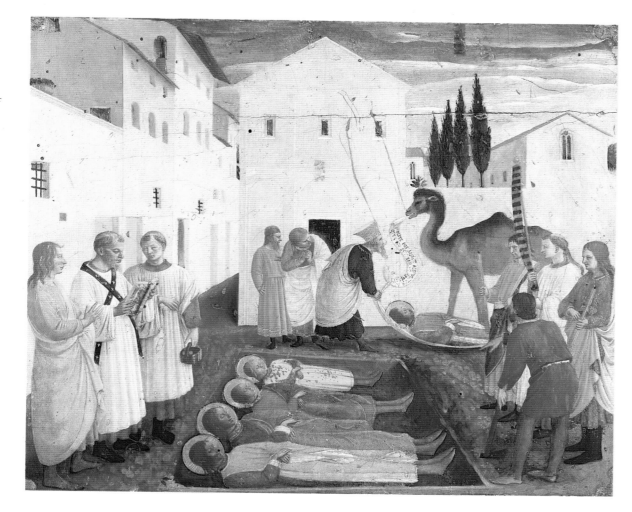

52 *San Marco Altarpiece: Burial of Cosmas and Damian,* 1439–1442, predella
Tempera on panel, 37 x 45 cm
Museo di San Marco, Florence

When Cosmas learned that Damian had secretly accepted Palladia's gift (ill. 48) he no longer wanted to be buried with his brother. A camel speaking in a human voice says that it will still be possible. Damian is laid down right in front of the animal in the middle distance. The brothers are already in the grave that has been dug for them; a priest is blessing them. The unadorned architecture of the city square surrounds the group in an almost incidental way that recalls Masaccio and Masolino's work in the Brancacci Chapel.

53 *San Marco Altarpiece: The Healing of the Deacon Justinian,* 1439–1442, predella
Tempera on panel, 37 x 45 cm
Museo di San Marco, Florence

Justinian's leg was wasted with cancer; while he is asleep at night Cosmas and Damian come to heal him using the leg of a dead moor. Fra Angelico sets this unusual episode in a bedchamber. The bed curtains and the bed covers are thrown back for the onlooker. Even the lining of the saints' cloaks can be seen. The light falls as if from where the onlooker is standing in the gentle grey-toned scene. On the right more rooms can be espied through an open door. Apart from reflecting the mood, it is the portrayal of anecdotal details, such as the slippers and the glass vessels on the bed, which makes this panel such a triumph.

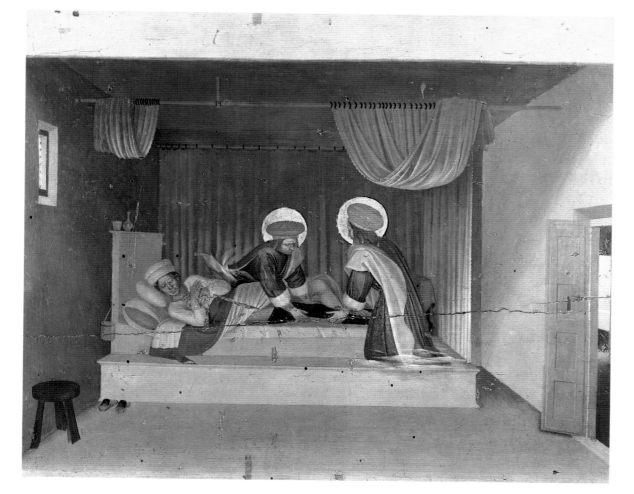

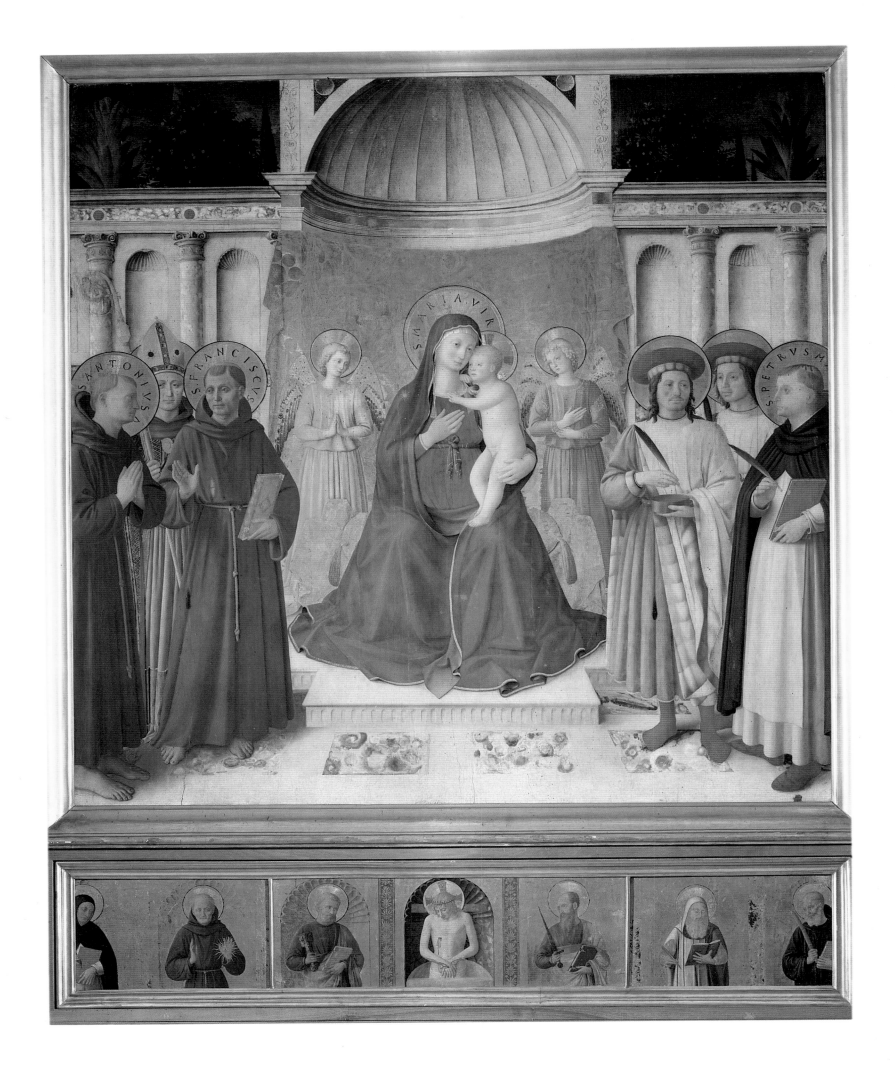

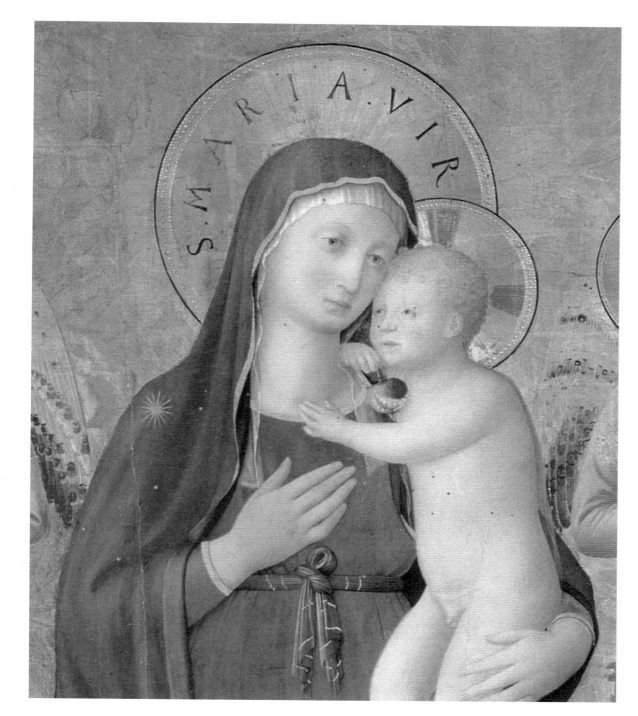

55 (right) *Bosco ai Frati Altarpiece: Madonna* (detail ill. 54), ca. 1450

The posture adopted by the Virgin Mary follows the pattern of the *Linaiuoli Tabernacle* (ill. 25). That said, the picture's effect is altered by the Christ Child's changed position. Without wearing any clothes, He leans against His mother's arm, and His trailing leg and standing leg are clearly differentiated. The Christ Child is looking up at the Virgin, who is tenderly nuzzling her cheek against the Child's forehead. She, however, is looking pensively into the distance, as she anticipates the boy's future Passion. For this altarpiece, the artist has drawn on his experiences of painting the frescoes in the Niccolina (ills. 109–116).

54 (opposite) *Bosco ai Frati Altarpiece,* ca. 1450
Tempera on panel, 174 x 174 cm
Museo di San Marco, Florence

The altarpiece was made for the Franciscan convent of San Bonaventura in Bosco ai Frati which was near Cosimo de' Medici's villa in Cafaggiolo, and was under his patronage. The presence of Cosmas and Damian supports the belief that it was he who commissioned the painting. The main panel and the predella were reduced by 12 cm on each side. The older composition of the *Annalena Altarpiece* is effectively improved upon here (ill. 39). The wall behind is divided by half columns and the brocade curtain decorates the much wider niche behind the Madonna. In addition to the narrative predella scenes, the rather unusual waist-length figures of the Saints Dominic, Bernard, Peter, Paul, Jerome and Benedict in their shell niches were probably included at the request of the Franciscans. In the middle, the *Man of Sorrows* refers to the Eucharist. The altar is dated to about 1450 because St. Bernard was not canonized until then.

ITALY AND THE NORTH: THE LAMENTATION OVER THE DEAD CHRIST AND ITS INFLUENCE ON ROGIER VAN DER WEYDEN

The structural concepts that Fra Angelico developed in his predella scenes were of great significance for other artists. The *Lamentation over the Dead Christ* (ill. 56), the central panel of the San Marco predella, is proof indeed of the connection between Italy and the North, frequently emphasized by art historians. Joseph of Arimathea is holding out the body of the Redeemer directly towards the onlooker, in an almost symmetric composition in front of the open tomb in which the sarcophagus lies waiting. The upper part of the body down to the loincloth has great presence but the physicality is much diminished by the foreshortened legs. The weakness of the picture lies in the history of the motif, which is derived from the *Man of Sorrows*, found also in the frescoes at San Marco (ill. 89). A narrative element, more in keeping with the Cosmas and Damian stories elsewhere in the predella (ills. 48–53), has been introduced into the static composition. The Virgin and St. John are kissing the hands of Christ, but the stance of the figures and the direction of their gaze are more fitted to the portrayal of a Christ who is the Son of God, to be worshipped, and not the Son of Man, broken by suffering.

Trade relations between Italy and the southern Netherlands were lively. In 1450 the Flemish painter Rogier van der Weyden (1399/1400–1464) painted a portrait for Lionello d'Este of his illegitimate son Francesco who had been sent to the court of Philip the Good for his education (New York, The Metropolitan Museum of Art). Rogier, at the height of his fame, did not sell paintings only from his homeland to Italians, but also travelled to Rome in the Holy Year of 1450, as is known from Bartholomeo Fazio's "De viris illustribus" (written in 1453–1457). His route must have taken him via Bologna and Florence.

He made a variation of Fra Angelico's *Lamentation over the Dead Christ* in a monumental painting (ill. 57) that came into the Grand Ducal collection in Florence in 1666 from the private collection of Carlo de' Medici. But there is not much left of the Italian's artistry apart from the borrowing of the iconography. The liturgical function, which is supposed to recall the Eucharist, is abandoned, and the symmetry lost by the addition of the figures of Nicodemus and Mary Magdalene. The Flemish painter, not one to conceal his talent, boldly exploits the image of the open tomb that had hitherto been unknown in the North. A path leads down on the left towards the city of Jerusalem, which lies on the horizon and is composed of houses of a northern European character, painted in great detail. The empty crosses on Calvary stand in the middle distance – a reminder, perhaps, of the crucifix picture within a picture in the San Marco altarpiece. Glowing colors, soft fur and magnificent brocade clothe the figures in the foreground, which gains

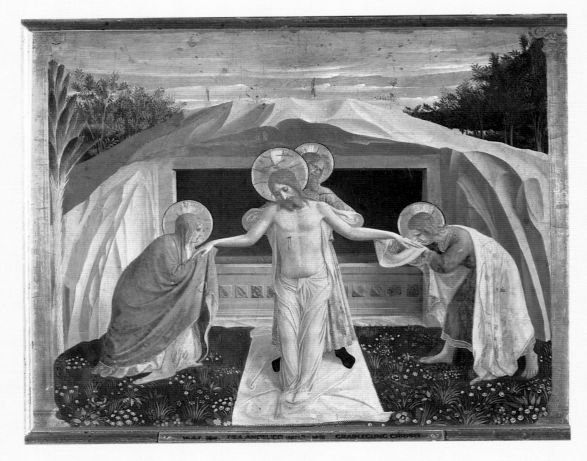

more depth with the stone cover of the sarcophagus lying askew, and the kneeling figure of Mary Magdalene.

The faces, lined with pain, down which course crystalline tears, and a gaunt Christ marked by his suffering, lend the picture a completely different character. The actual event is also more starkly evoked. The shadows on the grassy flower-strewn field, as well as those on the folds of the drapery, are put in to heighten the subject matter of the painting. The metallic glint from Mary Magdalene's flask of ointment, however, might well have given Fra Angelico an idea for something similar (cf. ill. 35). Probably with regard more for his own peace of mind than for the new developments in Italian art, Rogier shows off his talents here by painting in oils, a medium little known then in Italy, which led to his becoming prized by Italian collectors.

56 (above) *San Marco Altarpiece: The Lamentation over the Dead Christ*, 1439–1442, predella
Tempera on panel, 38 x 46 cm
Bayerische Staatsgemäldesammlungen, Alte Pinakothek, München

The central panel of the predella is a thematic play on the Eucharist. The Virgin and John are worshipping the dead Christ, as in a Deposition and the iconography is unusual. The sepulchre however, can be seen in the background, so this is a presentation of the body of Christ and a lamentation before the burial.

57 (opposite) Rogier van der Weyden
The Lamentation, ca. 1450
Oil on oak, 110 x 96 cm
Galleria degli Uffizi, Florence

This picture by the Flemish painter clearly takes the central panel of the San Marco altarpiece predella as its model. It has all the richness and sumptuousness that painting with oils, instead of tempera, produces. The lavish use of fabric, vegetation, landscape and light give the picture a completely different character.

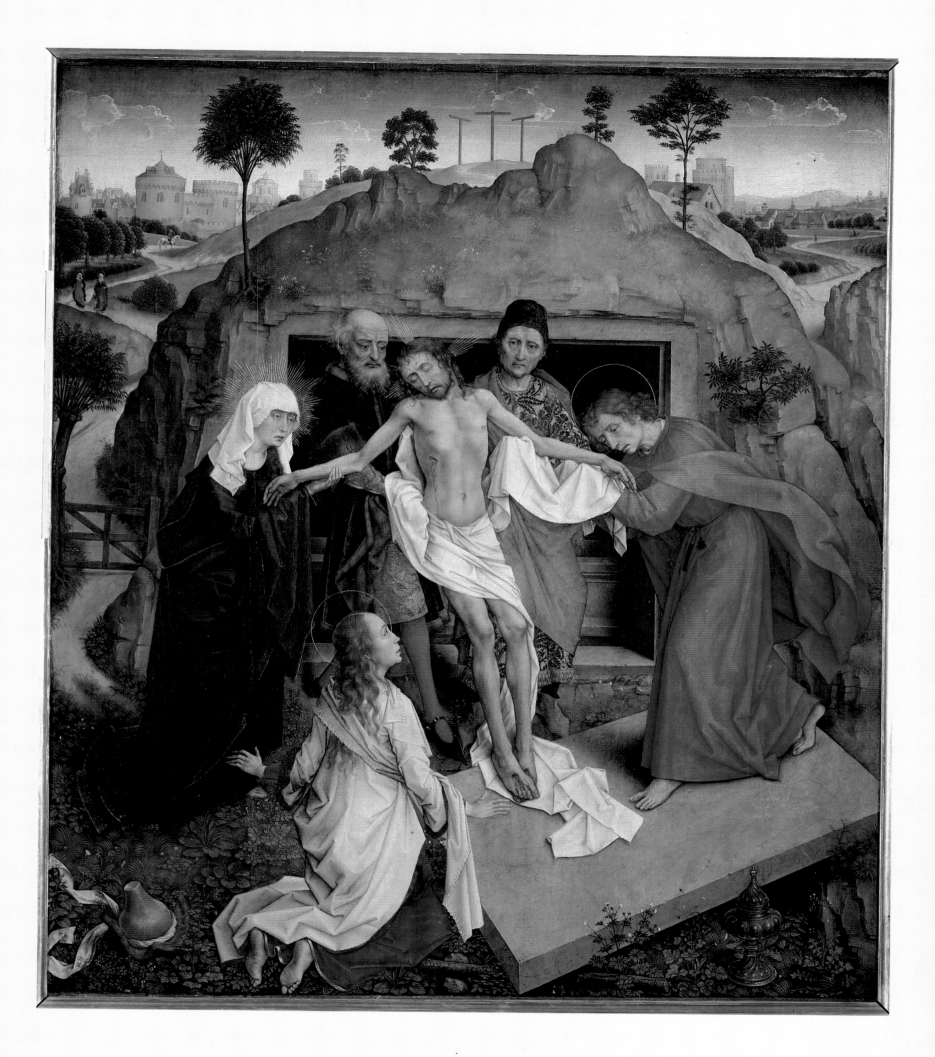

THE ALTARPIECES WITH RELIGIOUS "STORIES"

Legend has it that in 1252 the Servite monk, Bartholomew, began a fresco of the Annunciation which an angel miraculously completed. This fresco laid the foundations of the church's wealth. From the ceiling-beams hung innumerable votive gifts from grateful worshippers. In the light of the picture's miraculous associations, it should come as no surprise that Florentine artists liked to paint the same composition.

This work in the church of San Marco shows both the view into Mary's chamber and the architecture of the roof. The actual Annunciation appears to be taking place in a type of loggia. The conversation between Gabriel "Ave gratia plena dominus tecum" (Hail, thou that art highly favored, the Lord is with thee) and Mary "Ecce ancilla Domini" (Behold the handmaiden of the Lord) is represented in gold letters; this was probably a later addition. The composition of the figures, and the arrangement of the seat parallel to the picture, are references to the fresco of the *Annunciation* in SS. Annunziata.

Even in the narrative themes of Fra Angelico's œuvre there is a gradual move towards the rectangular form, and therefore to the release of the art from the strictures of the traditional form. But it is particularly in his Annunciations, of which there are many, that it can be seen most clearly.

The Annunciation is a significant traditional theme in Florentine mural painting. The Cathedral itself, Santa Maria dei Fiori, is dedicated, after all, to the "Virgin of the Flowers", and the city coat of arms bears the lily of the Annunciation. It was the miraculous fresco in Santissima Annunziata (ill. 58) by an anonymous artist of the Trecento that established the compositional model for this important subject that lasted well into the 1430's. Both the Dominican convent of Santa Maria Novella and the church of San Marco have variations of it in the same place, the inner wall of the façade.

In the Santissima Annunziata fresco, the Virgin is sitting in a cell-like room on the right and the angel is kneeling, with his arms folded over his breast, on the left. He has stepped over the threshold towards her and the tips of his wings stretch out through the open door. A ray of light sent from God the Father shines from the top left through a round window above the door and the Holy Ghost, in the form of a dove, flies down. The Virgin is gazing up at it. Fra Angelico's own interpretation of the Annunciation was to take into account the Dominican belief in the perfect conjunction of nature and divine grace. If this led him away from the model in Santissima Annunziata as the interpretation of the subject, the rectangular form of the fresco must have attracted his artistic interest.

As far as possible precursors in the area of panel painting are concerned, Lorenzo Monaco's *Annunciation* in the Bartolini chapel in the church of Santa Trinità in Florence paved the way for Fra Angelico's solution. In the 1420s, just before his death, the older artist (1370–1425) used the three-part panel as a single unit. The Virgin is sitting in a loggia supported by columns, in front of her bare room, with a view of the forest behind it. The division of the composition into the triptych form must have concerned him. The structure of the building and the dividing columns in the picture itself are used instead to establish this new arrangement. However, the features Lorenzo Monaco used to create space, such as the back of the seat behind Mary placed in front of the actual wall, have only a limited effect.

Fra Angelico goes a step further in the Annunciation panel for San Domenico in Fiesole, now in the Prado (ill. 59), by finishing the architecture in a straight line on the same plane as the edge of the picture. The opening to the Virgin's chamber has no door but there are painted cornices beneath the lintel as in Lorenzo Monaco's painting. The younger artist skillfully extends the interior space by the arrangement of the furniture, and creates light effects with reflections from the light shining in the window on the long wall. The arrangement of the composition is still derived from the original triptych form. The two principal figures face one another from beneath a double arch: the angel is in the center so that there is room on the left for the Expulsion from the Garden. The theological basis of the Annunciation, the removal of Eve's transgression through the receiving of the Lord through the Virgin, the second Eve, thus finds expression in the painting.

The medallions with saints found in the spaces beneath the finials in Lorenzo Monaco's painting, are placed by Fra Angelico in the space between the arches, though here they are mere architectural features, except for the central one with a bust of God. There is no other figure of God the Father, but the element of the Divine is present in the light shining down on the Virgin and the angel who is the herald of the Coming. The effects of light, and the aspects of nature depicted in the amazing abundance of flora, now replace the gold ground. The ingenuity and the artistry of the painter supplant its sumptuousness.

The *Annunciation* for San Domenico in Cortona (ill. 66), whose frame still exists, shows how difficult was the evolution towards a rectangular form of altarpiece. There are Corinthian pilasters such as might be found in a work of Brunelleschi or Michelozzo, but here they bear the weight of the structure and the figures are accentuated by the vaulted area above with its starry sky. The figure of God the Father is missing and in his place a prophet is depicted in the central rosette. The Holy Ghost is hovering in an aureole of light above the Virgin.

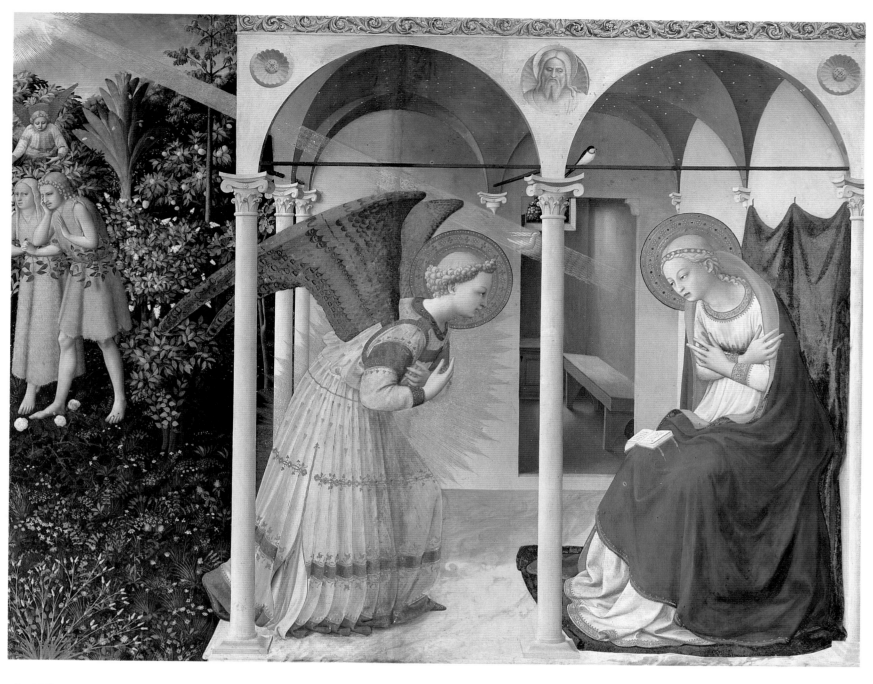

59 (above) *The Annunciation*, ca. 1430–1432
Tempera on panel, 194 x 194 cm (complete),
154 x 194 cm (main panel)
Museo Nacional del Prado, Madrid

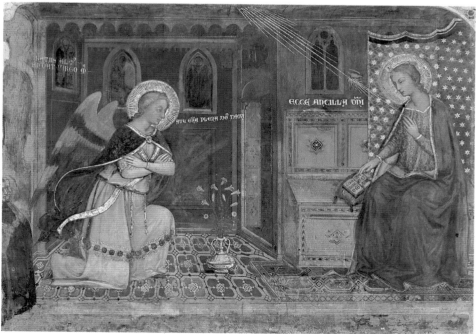

The Virgin is sitting in a loggia open on two sides. She
inclines humbly towards the angel, her arms crossed over
her breast. The elegant columns divide the picture
roughly into three parts and the overlapping of the figures
adds movement to the picture. Further back, on the left,
is the Expulsion from Paradise, implying that the Virgin
as the second Eve is a promise of redemption. This
altarpiece whose predella has the same subjects as the
Cortona (ill. 66) and Monte Carlo (ill. 67) altarpieces
belonged to San Domenico in Fiesole and is claimed to be
the first rectangular Early Renaissance altarpiece in
Florence.

All the sensations of supernatural light are captured in the figure of the angel. The wings are variously painted and pounced, and the reflection of fine rays of light heightens the decorative effect (ill. 68).

The figures fill out the whole area of the painting now and the garden, known as a *hortus conclusus*, a significant Marian symbol, is a lawn covered with flowers and rose bushes. A palm tree and fruit-bearing trees are omens of Christ's Passion. There is a red curtain around the Virgin's bed in the chamber and it is richly illuminated by the figure of the angel which, though he is standing far away from it, is directly in front of it on the surface.

The predella with scenes from the life of the Virgin (ills. 61–65) is carefully composed. *The Visitation* (ill. 62) has an early attempt at a landscape and the *Presentation in the Temple* (ill. 64) has a central view of a triple nave in the temple.

This version of the Annunciation, once established, was used again in the frescoes in San Marco (ills. 91, 98) and in an altarpiece which was in the convent of San Francesco near San Giovanni Valdarno since at least the 17th century (ill. 67). In the latter the open loggia is brought so far forward that its framework dominates the architecture in the foreground, recalling the Florentine model in the fresco of Santissima Annunziata.

Like the Annunciation, another subject often used by Fra Angelico, from the altarpiece for San Domenico in Fiesole right up to the *Armadio degli Argenti* (ill. 133), is the Coronation of the Virgin. Unlike the Annunciation, this picture is painted in varying versions but this one, which could be an earlier work, is of such perfection that experts have often dated it later. It belonged originally to the same church as the *Annunciation* in the Prado (ill. 59) and is now in the

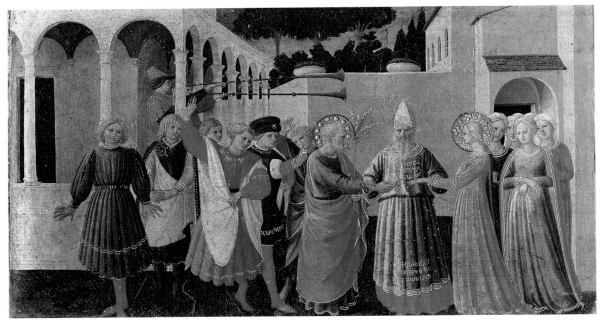

61 *Annunciation: The Wedding of the Virgin* (detail ill. 66), ca. 1432–1434, predella
Tempera on panel, ca. 23 x 35 cm
Museo Diocesano, Cortona

God ordained that the Virgin's bridegroom be chosen from the unmarried men of Israel. Each man would bring a bare branch to the altar, and the one who brought the branch that bloomed, and on which a dove settled, would be chosen. Men and women come together to meet each other at the ceremony, at which a priest joins Joseph's right hand with the Virgin's left. The young women are quietly moved while the men behind Joseph show their anger that their rod was not the one to bloom. An arcade stretches into the distance with two men blowing trumpets.

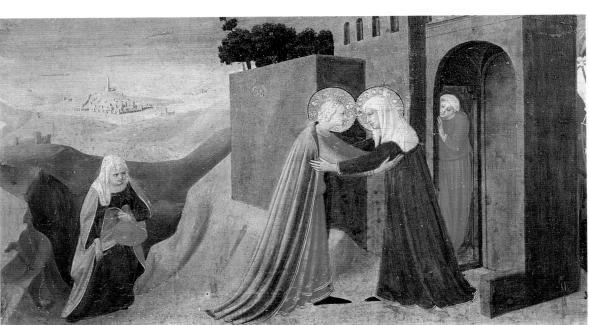

62 *Annunciation: The Visitation* (detail ill. 66), ca. 1432–1434, predella
Tempera on panel, ca. 23 x 35 cm
Museo Diocesano, Cortona

The Virgin and Elisabeth are meeting each other; behind is a landscape which is an early example of a realistic landscape depiction. It is the view from San Domenico in Cortona onto Lake Trasimeno and Castiglione del Lago. The arduousness of the steep climb is clearly reflected in the face of the servant following the Virgin. The maid leaning on the door lends an intimacy to the scene.

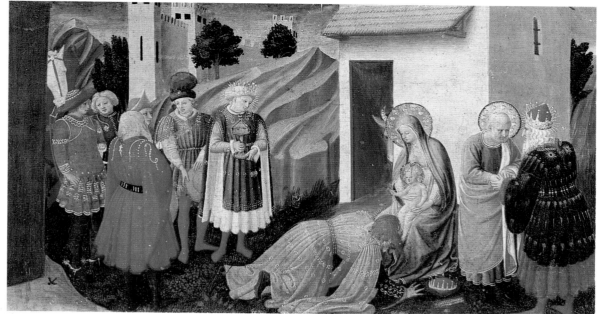

63 *Annunciation: Adoration of the Magi* (detail ill. 66), ca. 1432–1434, predella
Tempera on panel, ca. 23 x 35 cm
Museo Diocesano, Cortona

The strip of earth in the foreground of *The Visitation* extends to the area of the picture where the Virgin is sitting in front of a small stone stable with an ox looking out. The eldest King, dressed in a magnificent black robe trimmed with fur, is greeting Joseph; the middle King is paying homage to the Child. Receding behind a diagonal stable wall, next to the branches of a tree, the background is painted with a brown wash up to the horizon.

64 *Annunciation: Presentation in the Temple* (detail ill. 66), ca. 1432–1434, predella
Tempera on panel, ca. 23 x 35 cm
Museo Diocesano, Cortona

This is a direct view into a temple with three naves shown in central perspective, with a vanishing point at about the level of Jesus' and Simeon's heads. The architecture is actually much too small for the figures but the scene with Joseph, Mary, Hannah and Simeon, who is holding the Child lovingly to his cheek, seems empty.

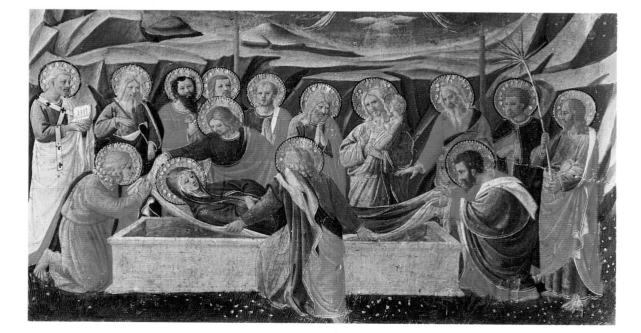

65 *Annunciation: The Death of the Virgin* (detail ill. 66), ca. 1432–1434, predella
Tempera on panel, ca. 23 x 35 cm
Museo Diocesano, Cortona

The row of Apostles is standing along the back of the Virgin's fairly long sarcophagus into which she is being laid carefully on a shroud. In the foreground a figure in rear view is helping one of the apostles with this. Standing behind him, the figure of Christ is already holding his mother's soul in his arms. Angels hover above him around the light which brightens the otherwise blue sky.

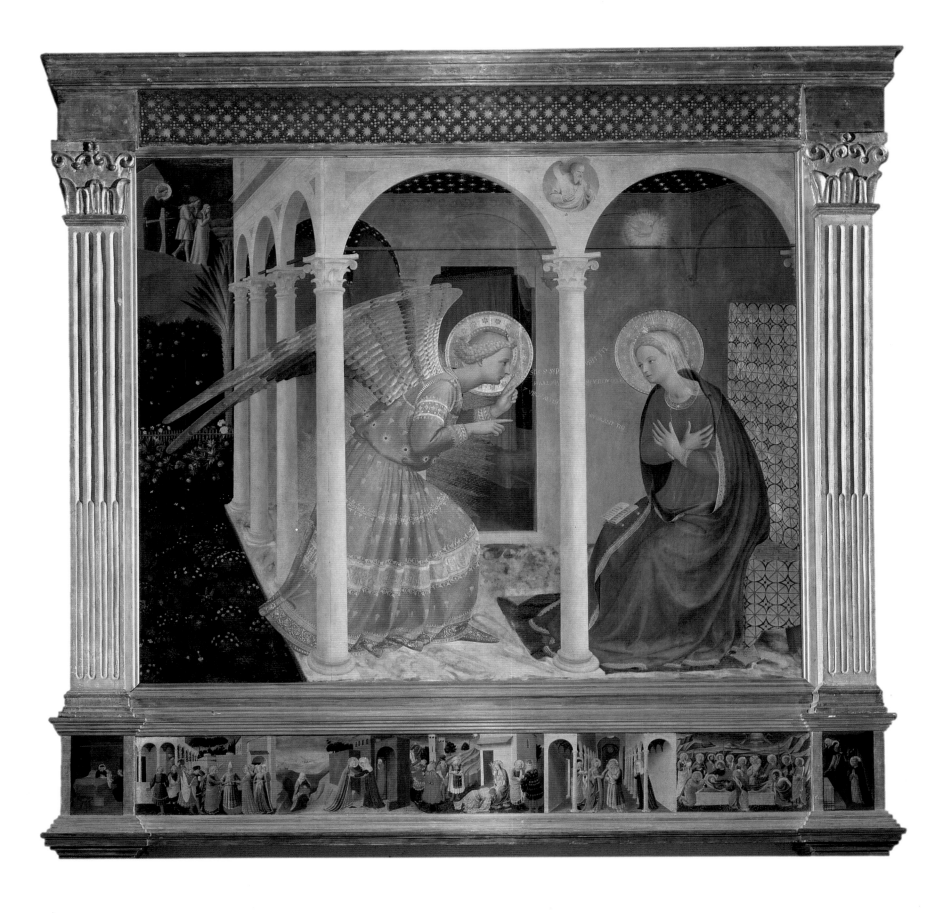

66 *Annunciation*, ca. 1432–1434
Tempera on panel, 175 x 180 cm
Museo Diocesano, Cortona

Corinthian pillars frame the rectangular main picture, which is set back between them The area of the arches bridges the distance with a star-filled sky, a feature which appears again in a different form on the ceiling of the corridor. As in the *Annunciation* in the Prado, the predella scenes are painted on panel, the dividing borders having been left out in favor or a continuous landscape. The narrow outer areas show the Birth of the Virgin and the Presentation of the Order's Robes to St. Dominic. This altarpiece was intended for the convent church of San Domenico in Cortona.

67 (below) *The Monte Carlo Altarpiece*, ca. 1440
Tempera on panel, 195 x 158 cm
Museo di San Giovanni Valdarno

The two wider arcades of the architecture are aligned with the frontal plane so that the altarpiece is almost a diptych. Correspondingly the lunette with the prophet in the space between the finials is shaped like a picture which has been inserted and not like an architectural motif. The square room has a smooth starry ceiling, a frieze and marble panelling on the walls. The predella shows scenes from the life of the Virgin, like the other two Annunciation altarpieces.

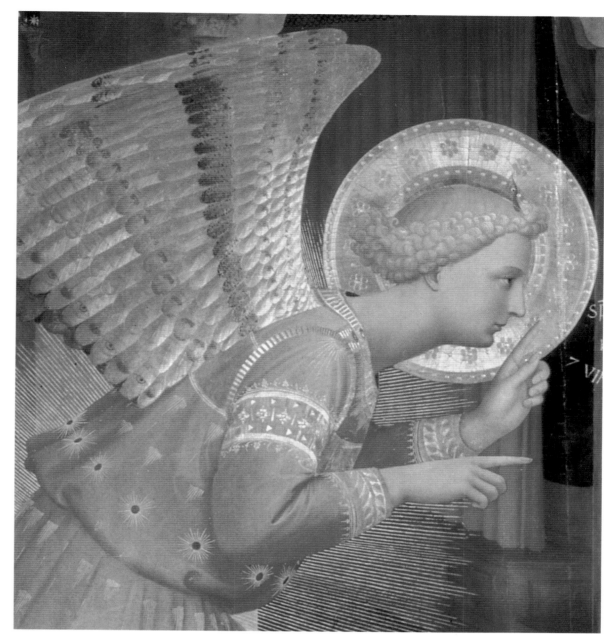

68 (above right) *Annunciation: The Archangel* (detail ill. 66), ca. 1432–1434

The archangel is holding up his left hand as he speaks. In soft golden letters, the artist has recorded the dialogue which, according to St. Luke, passes between the two figures. The Virgin's answer appears above her head. Gabriel's iridescent golden wings, as well his gold braid and the beams of light surrounding him, bathe the whole picture in a warm glow which illuminates the curtain in front of the Virgin Mary's bed in her bedchamber. Fra Angelico paints colors on to gold in such a way that he creates the effect of enamel shimmering through. In the archangel's wing, he displays supreme skill in applying this technique.

Musée du Louvre with the predella (ill. 70). Christ is sitting on a throne beneath a Gothic canopy and his Mother is kneeling humbly on the steps below. The music-making angels rise only to the base of the imposing canopy, which in its basic form corresponds to that of the Madonna panel in Frankfurt (ill. 19). The steps jut out at oblique angles at the level of the throne and the saints on them are seen from below, while the others on the tiled floor kneel at about the eye level of the onlooker. Vasari highly praised the great variety of the poses, and the moods shown on the faces of the saints who fill the foreground and the steps to the throne. He lost no chance here of drawing a parallel between the tender sentiments expressed in the picture, and the life of the pious friar. Commentators today, however, do not find its qualities so obvious. No other work of Fra Angelico's is so variously assessed and indecisively dated. It is dated variously from 1429, as William Hood believes to be the case, to about 1450 as

claimed by John Pope-Hennessy, who also believes that it was finished by another artist after Fra Angelico's death. By comparison the scene on the small reliquary for Santa Maria Novella (ill. 69) looks like a practice exercise. The saints are crowded together, their position on the ground not indicated. They are all shown in rear view except Dominic. The steps of the throne, which are carelessly executed, are rounded forward.

The circular composition of the *Coronation of the Virgin* now in the Uffizi (ill. 71) serves to give structure to the gold ground, which has no spatial features. The circle is picked up in the round stream of light onto the two Coronation figures, and in the semi-circular edge of the panel. The figures are foreshortened relatively quickly, so that the angels behind the throne of clouds bearing Mother and Son look tiny. There are even more saints than in the Coronation for San Domenico in Fiesole; their attention is directed partly towards the center of the picture and partly towards the onlooker to

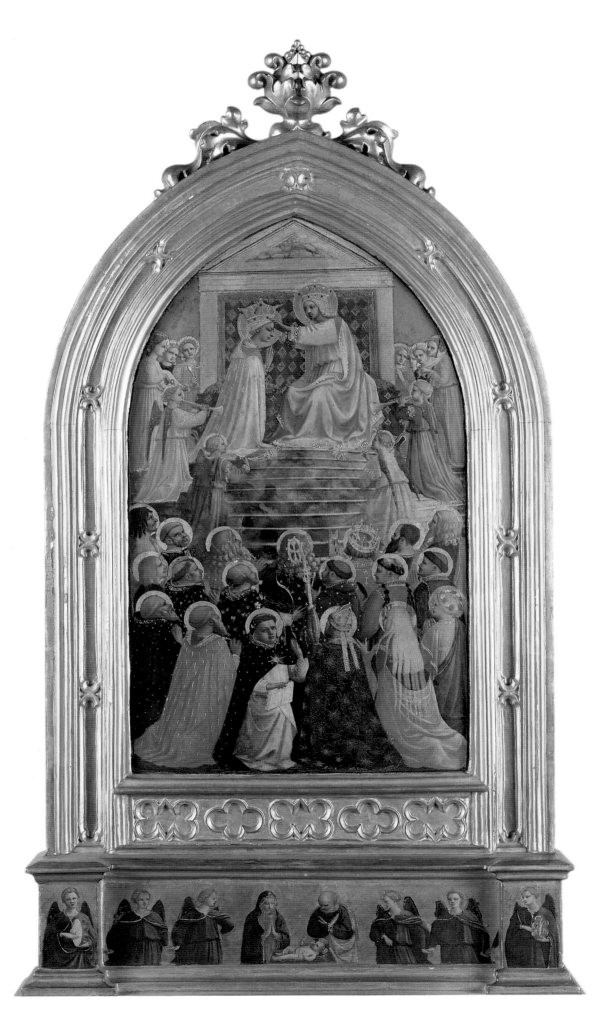

69 (left) *The Coronation of the Virgin*, before 1434
Tempera on panel, 69 x 37 cm
Museo di San Marco, Florence

There are saints in attendance at the *Coronation of the Virgin* who are turned toward the throne, kneeling, which is why all of them except Dominic, who is facing the onlooker, indicating the event, are shown in rear view. The steps of the throne are of mottled marble and rounded in shape. The angels on them are painted so thinly that the steps now partly show through. The Gothic arch above the throne finishes at the upper edge of the picture. The four reliquaries made for Giovanni Masi were not meant to open; they probably contained small relics in their original frames, which are now lost.

70 (opposite) *The Coronation of the Virgin*
Tempera on panel, 213 x 211 cm
Musée du Louvre, Paris

The altarpiece designed for San Domenico in Fiesole shows the *Coronation of the Virgin* surrounded by music-making angels and saints in gorgeous raiment decorated with gold, kneeling below on a tiled floor. Colored marble steps lead to the Gothic throne on which more saints are standing, seen from below. The Virgin is kneeling humbly to receive the crown from Christ. The central predella picture shows the Entombment with the Virgin and John, framed by three episodes on either side from the lives of the Dominican saints.

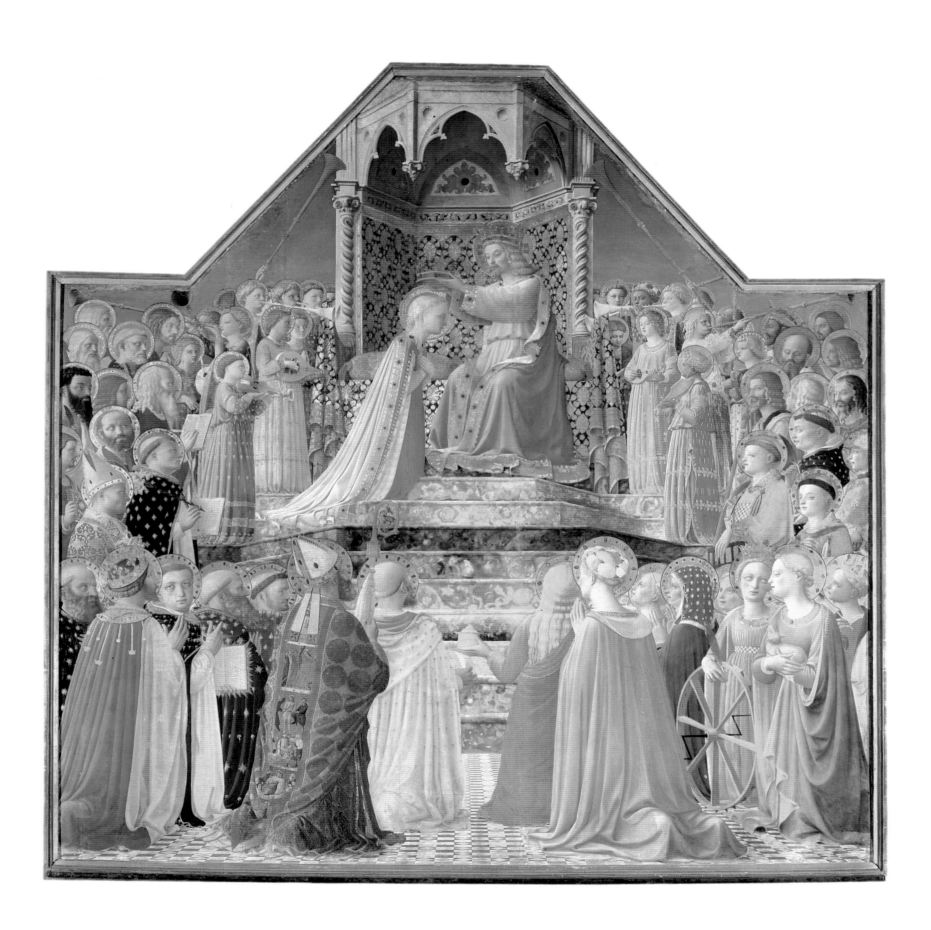

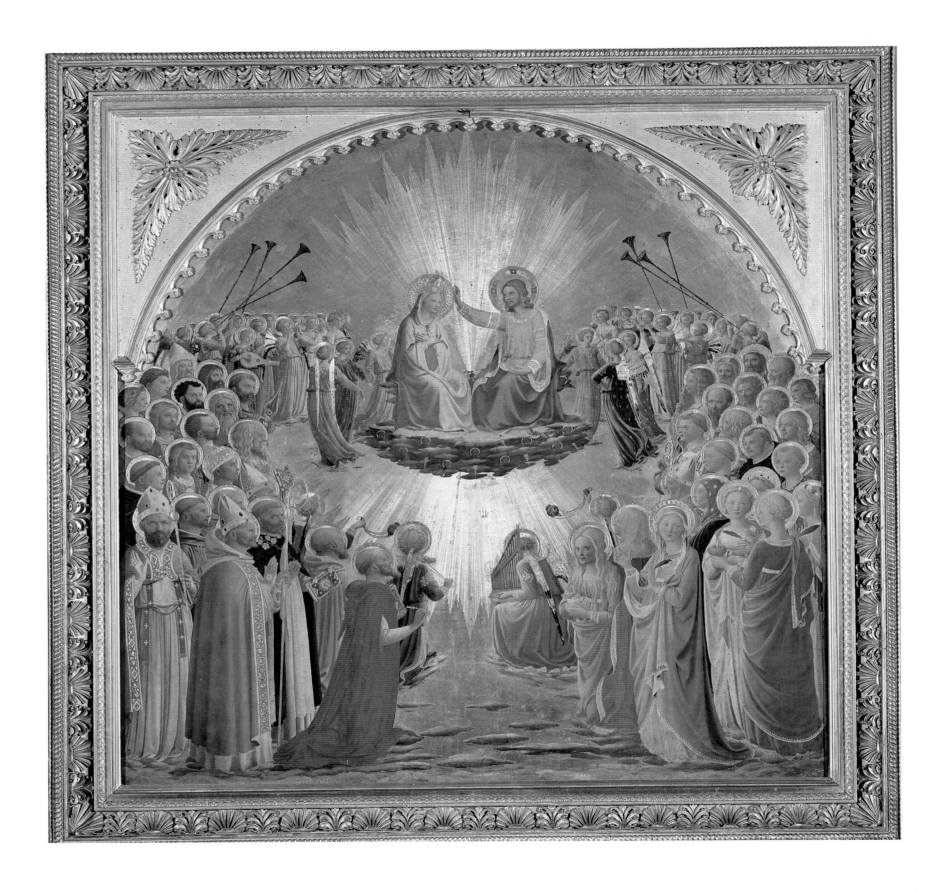

71 *The Coronation of the Virgin*, ca. 1434/35
Tempera on panel, 112 x 114 cm
Galleria degli Uffizi, Florence

The gold ground is used convincingly for spatial effect on
the panel. An aureole of light radiates from the Mother
and Son who are sitting on a bank of clouds; their feet
rest on another one seen from beneath. Saints and angels
are grouped around them in two semi-circles which
diminish in size as they recede and so increase the effect of
depth. The saints stand on little clouds too. In the
foreground, St. Mary Magdalene faces the onlooker. The
picture was once in the hospice of the church of Santa
Maria Nuova in Florence, which was dedicated to St.
Aegidius.

whom the little clouds in the foreground seem to offer a path of refuge towards the throne surrounded by clouds and seen from below. Unlike the two versions mentioned before, it is not the actual Coronation depicted here, but the setting of a stone in the Virgin's crown – a rare iconographic variation. The picture should rightly be called the Glorification of the Virgin.

Fra Angelico's panel-paintings of the *Coronation of the Virgin* are so difficult to date because, while the old-fashioned gold ground of the altarpiece in the Louvre suggests an early date on the one hand, the grouping of Mother and Son in majestic unity seems to be the artist's definitive solution, as demonstrated by the fresco in San Marco (ill. 92) and the panel of *Armadio degli Argenti* (ill. 133). The gold ground does not appear in the fresco but it reappears on the silver cabinet, as if Fra Angelico had consciously decided not to adorn the upper spheres of heaven with earthly riches, but preferred instead a gold ground which merely hinted at celestial glory.

Fra Angelico's *Deposition* for the sacristy in Santa Trinità in Florence, an important work in the history of altarpieces, was originally given in commission by Palla Strozzi to Lorenzo Monaco, who did not complete it (ill. 74). Fra Angelico probably used the original panel when he took over the commission in the 1430's. He had closely studied the work both of Lorenzo Marco, who had decorated the Bartolini chapel with frescoes, and made the Annunciation altarpiece for it, as well as

Gentile da Fabriano's *Adoration of the Magi* for the same chapel. The pilasters for the Santa Trinità panel are painted at the front and sides with saints standing on plinths which have been adjusted so that their perspective conforms with the onlooker's view of them.

Lorenzo Monaco's paintings in the gables can be seen as precursors of the similar ones in the spandrels of Fra Angelico's San Pietro Martire altarpiece (ill. 11). Here, too, a series of narrative pictures has been fitted into an area not designed for them, and, what is more, the artist manages to portray three successive episodes at once. He skillfully uses the top of the rounded arch of the main panel as the rocky base so that Christ's tomb seems to come into the picture on the left, is central in the middle and then disappears on the right.

Fra Angelico uses the division of the panel into arches to arrange the figures in the frieze and allows the arm of the cross to overlap the framework. Christ's body, still showing marks of the scourging, slides gently into the arms of his followers. The diagonal composition of this scene especially impressed the Flemish painter Rogier van der Weyden. On the left are the mourning women, holding the shroud in readiness. Mary Magdalene is kissing the Saviour's feet and a figure seen from behind closes the action. On the left, one of the men holds up the crown of thorns and the nails as if they were already relics. In the foreground, there is a kneeling figure who is distinguished from the saints by his halo of fine small rays: he is thought to represent

72 *The Wedding of the Virgin*, ca. 1434/35
Tempera on panel, 19 x 50 cm
Museo di San Marco, Florence

This panel together with the *Entombment of the Virgin* (ill. 73) made up the predella of the *Coronation of the Virgin* in the Galleria degli Uffizi (ill. 71). In the center of the frieze-like composition the priest is joining Mary's left hand and Joseph's right, while a dove sits on his branch which is in bud. The temple with its marble tablets, and the garden wall with its square motif, and the flowerpot seen from below make a convincing backdrop.

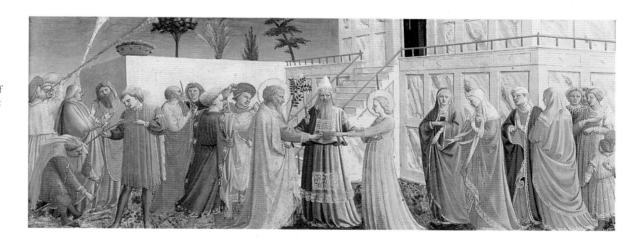

73 *The Entombment of the Virgin*, ca. 1434/35
Tempera on panel, 19 x 50 cm
Museo di San Marco, Florence

In the *Entombment of the Virgin* Fra Angelico uses an elongated format to arrange the figures almost symmetrically around Christ in the center. He is receiving the soul of the Virgin. While the line of the heads recedes at the edges, the mountains are higher nearer the sides. The torches at the corners of the Virgin's bier give spatial depth.

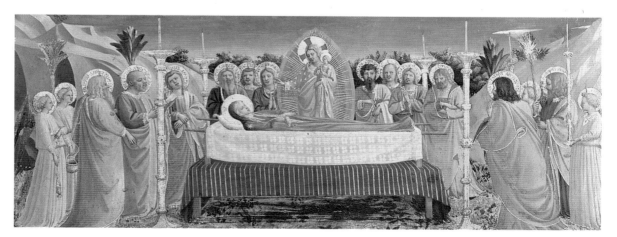

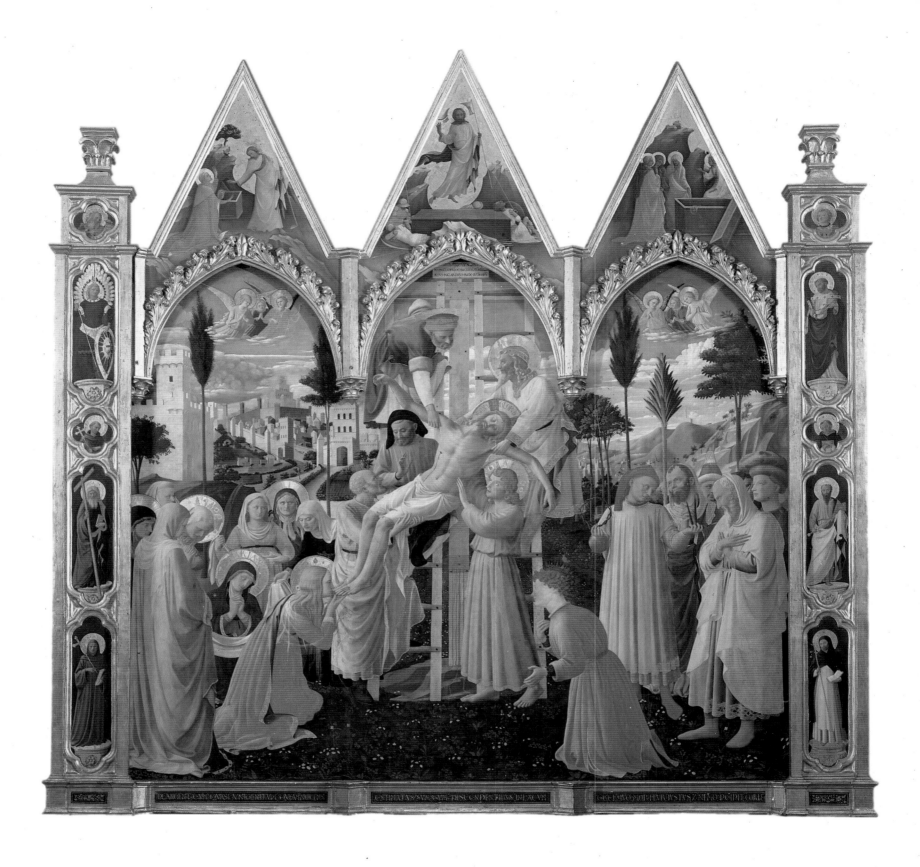

74 *The Deposition*
Tempera on panel, 185 x 176 cm
Museo di San Marco, Florence

This panel has the traditional triptych form with Gothic finials but the columns have been left out in order to have a unified surface for the painting. Palla Strozzi commissioned the panel from Lorenzo Monaco for his family chapel in Santa Trinità. The pictures in the finials are by him. Mary Magdalene is kissing the dead Christ's feet. Her counterpart is an unknown saint. The men are standing behind him, one holding the crown of thorns and nails as though they were already relics. The work is dated between the early and late 1430s

Alessio degli Strozzi. The figure serves, like Cosmas in the *San Marco Altarpiece* (ill. 47), as the intercedent between Christ and the onlooker who is being invited to prayer.

The spatial concept of the landscape behind the women skillfully bridges the gap between the middle distance and more distant areas with the tower of the gated city wall leading into the far distance. Similarly, on the right behind the men there are hills covered with houses, and mountains reflecting the blue sky which form the horizon.

As in the *San Marco Altarpiece*, the inclusion of a text

in the picture defines the theological content, giving to the whole a meditative quality.

The *Last Judgement* (ill. 76) is unique in Fra Angelico's œuvre. Its shape is due to its intended function as the back of a seat designed for use by the priest and attendants during High Mass. A receding perspective of open graves divides the damned from the saved. Christ's tomb lies across the front of the graves. Paradise on Christ's right, and Hell on his left, continue to the horizon. While the walls of Paradise appear small in the background, the mountain of Hell is brought up close

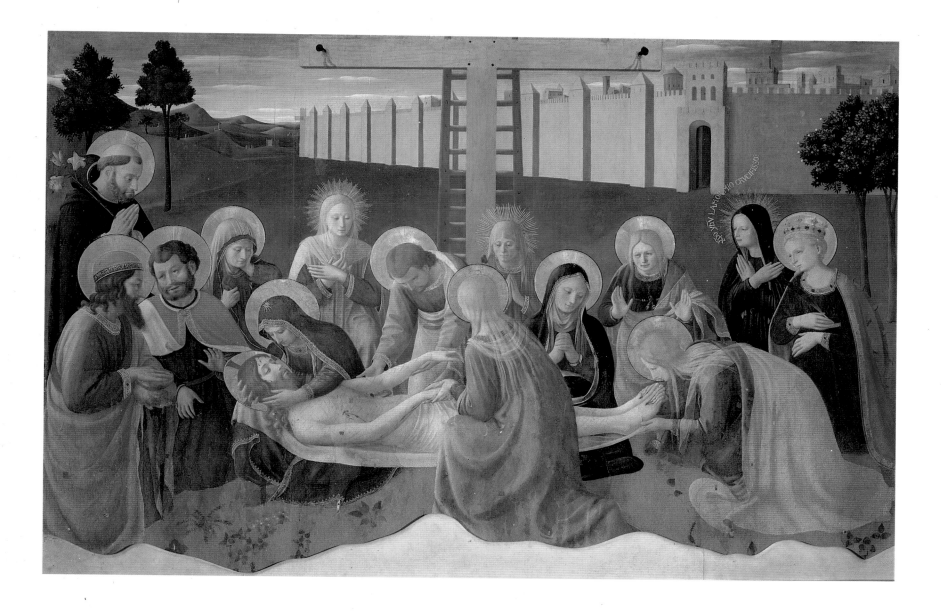

to the onlooker. The movement towards each of these is clearly defined: those who are saved join hands in a harmonious circle (ill. 77), while the damned jostle and push each other aside (ill 78). If at first glance the saints around Christ as Judge seem unconnected with the rest, closer observation will reveal that some of the Blessed on earth are looking up to them in prayer.

The complex composition is at first somewhat disturbing because the different dimensions of Heaven and Earth prevent a unified perspective. The events in Hell have to be shown in minute detail so that the effect on the onlooker of the frightening prospect of eternal damnation is not lost. Light has a special role in the overall effect. The bright sky on the horizon is an earthly sign indicating, as it were, the heavenly sphere up beyond the clouds. The bright center of this other realm is Christ as Judge with the starry firmament behind him.

The *Lamentation over the Dead Christ* (ill. 75) is one of Fra Angelico's few works that can be dated with certainty. It was commissioned in 1436 by Fra Sebastiano Benintendi. The Blessed Villana who stands next to St. Catherine was beatified in 1441, a date which appears on the Virgin's mantle.

The starkly horizontal figure of the dead Christ establishes the arrangement of the surrounding figures, who are kneeling and caught in various gestures of mournful adoration. Besides the Blessed Villana there are two other holy women, set apart by their fine-rayed nimbus from the other saints. Like Dominic on the left, the only standing figure, who is said to have the patron's features, they are set back slightly from the other mourners. The ladder, unlike in the *Deposition* (ill. 74), rests behind the cross, which forms the center of the picture. In this way the alignment of the arm of the cross with the upper edge of the picture remains undisturbed. The vertical of the cross finds echoes in the watch towers of the city wall of Jerusalem, which projects itself like a stark backdrop from the right of the picture, and defines the bare landscape in the upper third of the panel.

The vessel of ointment in the hands of the man on the left points to the imminent interment. More important, though, is the way that those around him are adoring Christ, as he lies as stiffly in Mary's lap as if he were on a marble slab. The saints, in various moods and poses, embody the different forms of contemplation of Christ's sufferings, and are the focal point of the work.

75 *Lamentation over the Dead Christ*, 1436–1441
Tempera on panel, 105 x 164 cm
Museo di San Marco, Florence

Sebastiano Benintendi ordered the panel in 1436 for the Confraternity of Santa Maria della Croce al Tempio in Florence. A possible predella is lost. The damage on the lower half is so bad that it has been painted over. The composition is remarkable for the clear arrangment of kneeling figures around Christ and the cross which marks the center, as well as for the proud city wall with its dark shadows. St. Dominic on the left is said to have the patron's features; on the right is the Blessed Villana, Sebastiano Benintendi's grandmother. As in many of Fra Angelico's works, the gold braids of the garments bear inscriptions. The date 1441, presumably the date of completion of the work, is hidden in the gold decoration of Mary's cloak.

76 *The Last Judgement*, 1432–1435
Tempera on panel, 105 x 210 cm
Museo di San Marco, Florence

The peculiar shape of the painting is a result of the use it
was to be put to. It is the back of a seat for a priest to use
at the Mass. It was probably commissioned by the
Florentine church of Santa Maria degli Angeli when
Ambrogio Traversari was made Abbot General of the
Camaldulensi. The separation of the Blessed and the
Damned is achieved with a receding rectangle with open
graves. The saints are on clouds surrounded by golden
rays. They and the host of angels surrounding Christ as
judge form the shape of the central lobe of the picture.

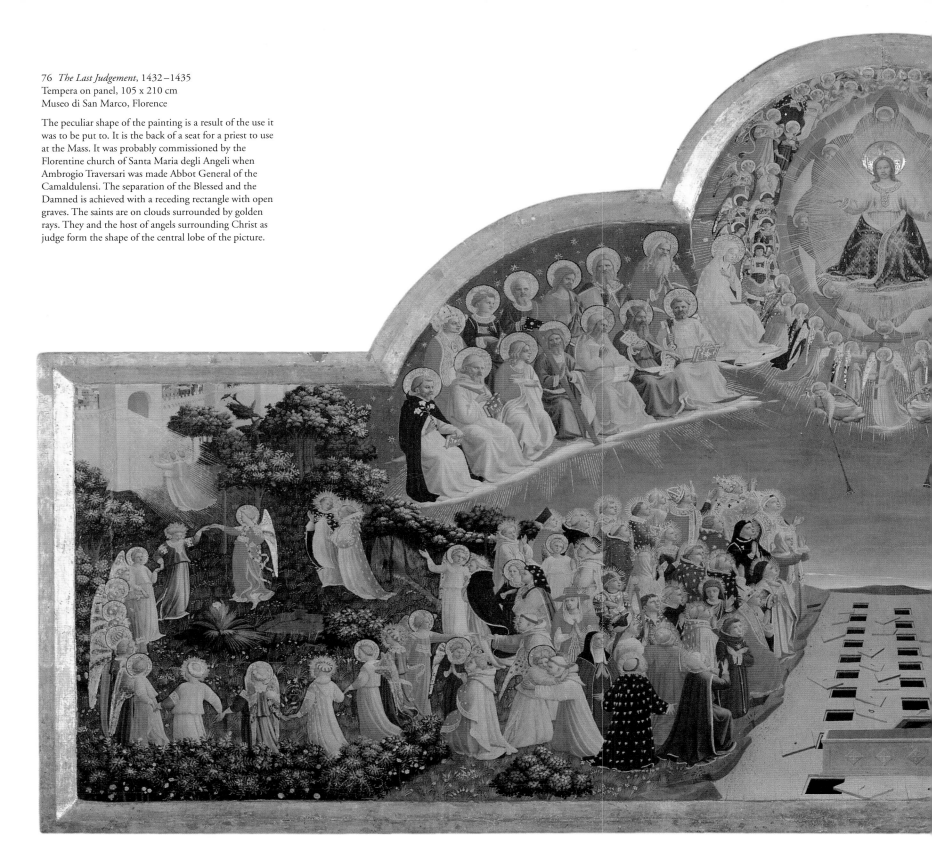

77 (following double page, left) *The Last Judgement* (detail ill. 76), 1432–1435

The Blessed form a circle and seem to dance lightly into Paradise led by the angels. A couple, perspectively foreshortened, come to the Gates of Paradise through which shines a supernatural light. This work of Fra Angelico's is one of the artistic high points of the early 1430s.

78 (following double page, right) *The Last Judgement* (detail ill. 76), 1432–1435

The hectic unrest of the Damned on the right half is a counterpoint to the joyful calm of the Blessed. Demons are driving them to Hell in which there are compartments where people are undergoing different torments. Satan is eating people while he seemingly carries Hell on his shoulders. Although Fra Angelico was always credited with the design of this, its execution was attributed to studio assistants since the portrayal of evil was nowhere else to be found in Fra Angelico's work.

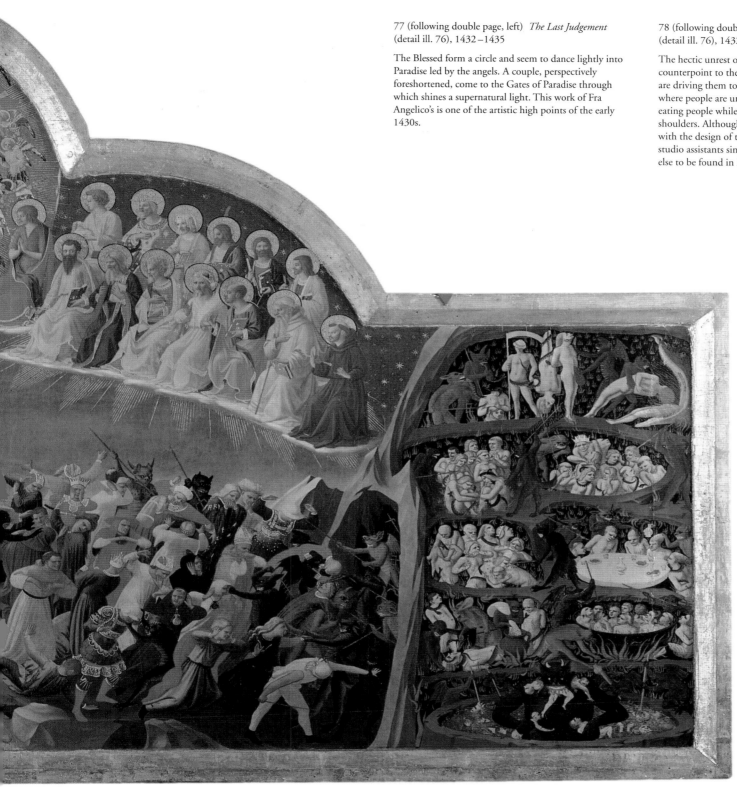

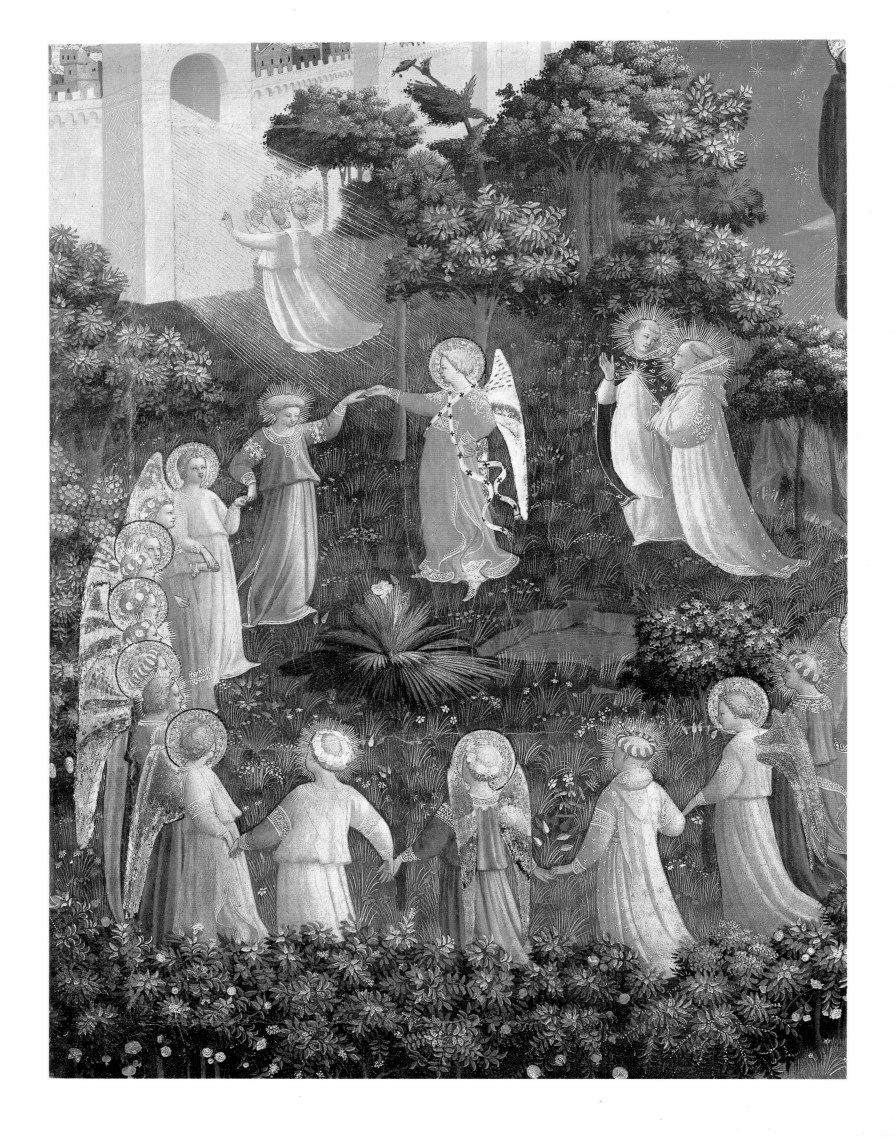

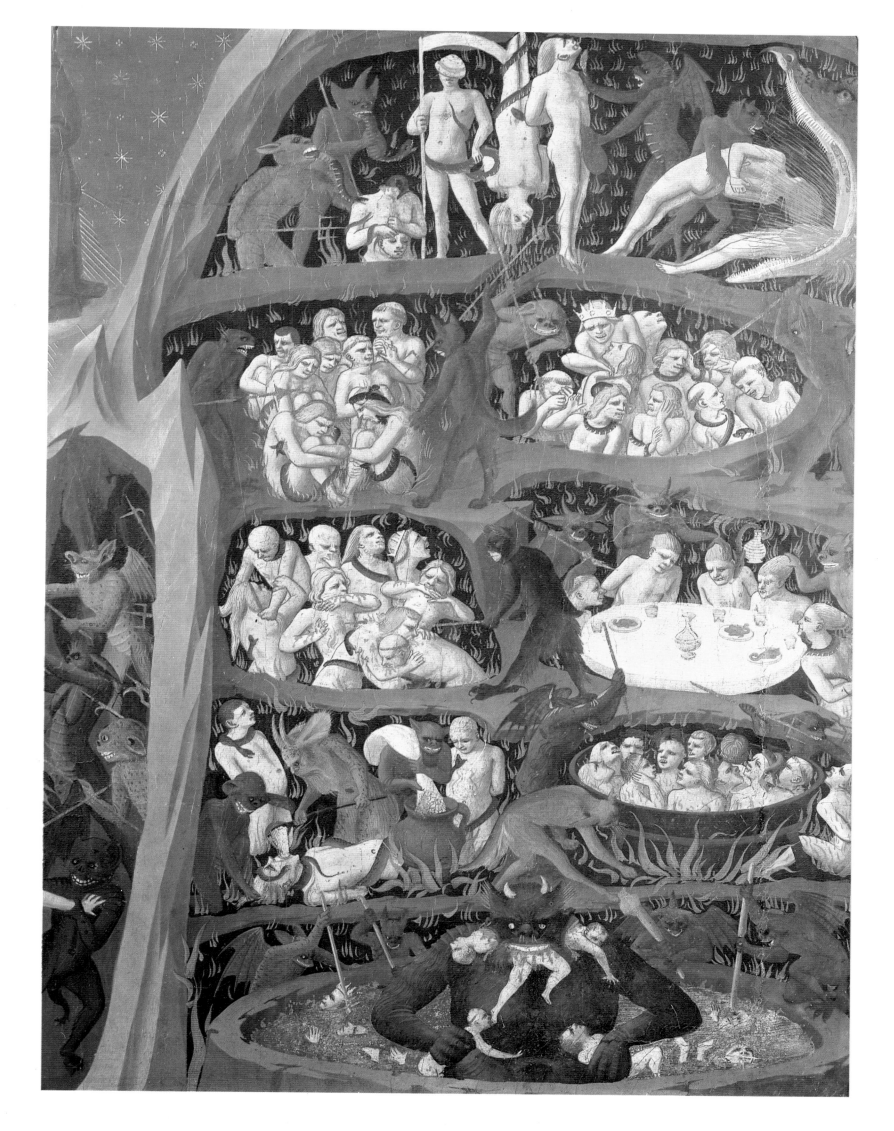

THE FRESCOES IN SAN MARCO:
STRICT OBSERVANCE AND THE
SENSATION OF LIGHT

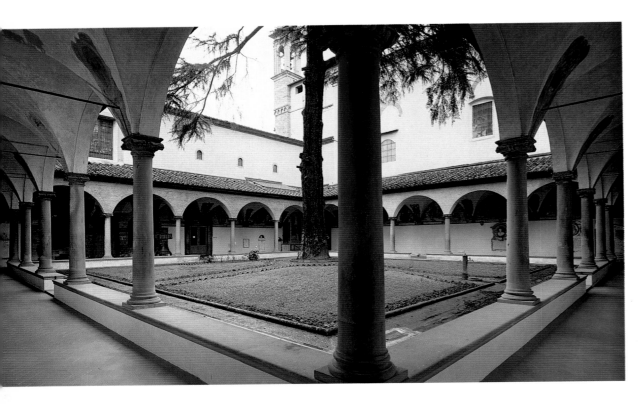

79 View of the Convent of San Marco, Florence Cloister

As in Fra Angelico's day the visitor can escape from the bustle of the town into the quiet of the cloister. But its appearance has changed a great deal since it was built. The simple arcade once adorned only with the great fresco of *Christ on the Cross adored by St. Dominic* (ill. 82) has given way to an accumulation of gaudy memorials, producing a far less tranquil impression.

80 (opposite) *Christ on the Cross adored by St.Dominic* (detail ill. 82), ca. 1442

St. Dominic's face is a mask of deep mourning and pity. The body of Christ, and Dominic's face and hands are portrayed with well observed anatomical detail. Dominic's face, seen slightly from below, has the beginnings of a grey beard and there are veins on the backs of his hands. It is as if the artist wanted to make a realistic image of the saint, and not a glorified ideal.

In 1436 Cosimo de' Medici gave the Dominicans the church and the convent of San Marco in Florence, which had previously been in the possession of the Sylvestrine Brothers. Michelozzo was charged with the radical restructuring of the buildings, and Fra Angelico with their decoration. Without doubt the frescoes of San Marco are the most important works that Fra Angelico has left to posterity. Confined as they are to important events in the life of Christ, and deliberately uncomplicated by ornament, they enhanced the artist's fame even among contemporaries.

These frescoes, fascinating as they are, pose a problem for modern art historians by confronting them with a piety, implicit in the pictures, that has become quite foreign to us today. The attempt to find a programme for the cell frescoes is fraught with uncertainty even if one consults the most learned Dominican theology. Unlike in undertakings of this sort in later centuries, one must conclude that here there was no single dominating strand of thought which determined the programme. It is clear though that the frescoes were aimed at diverse groups, be they novices, lay brothers, or clerics.

The new building work on the convent of San Marco is something of an exceptional case, since the architect and the artist were at work simultaneously. This made it possible to create a concept for the decoration that met the demands of the building. Moreover, the artist himself was a member of the community that lived there, so with this familiarity he was better able to fulfil the patron's wishes. Unfortunately any documents concerning the working process are lost, so it is not known how the decoration proceeded or how long it took. The *Cronaca di San Marco* merely mentions Fra Angelico as the supposed creator of the paintings. It is unusual that the convent was given a library, since the Observants set little store by learning; it was also Cosimo de' Medici's gift, and the first public library ever.

The cloister (ill. 79), which must have been open to the lay brothers as well, was decorated with a huge fresco of Christ on the Cross and five lunettes above the door (ills. 81, 82): the effect matches the pale colored architecture and the gray ornamentations in the cloister. The chapter room, the daily meeting place for the friars and the order, has a monumental Crucifixion (ill. 85) with many attendant figures on the wall facing the door.

The first twenty cells in the dormitory on the upper floor were built in 1437. The north dormitory on the other hand was not started until 1440. The library wing followed in 1441 after Cosimo de' Medici had taken over the library of the scholar Niccolò Niccoli, who died in 1437. It was finished in 1444. Finally in 1442 the south wing was erected over the hospice, but there was damage caused in 1453 by an earthquake, which probably meant that further changes had to be made. The tops of many of the frescoes have been destroyed because the original flat ceilings were later replaced by vaulted ones with arches that came down so far that they intruded into some of the pictures. More than half of a fresco in the north wing has been destroyed by a window that was put in later, and another has disappeared altogether along with the cell it was in.

On the upper floor there are cells meant only for the

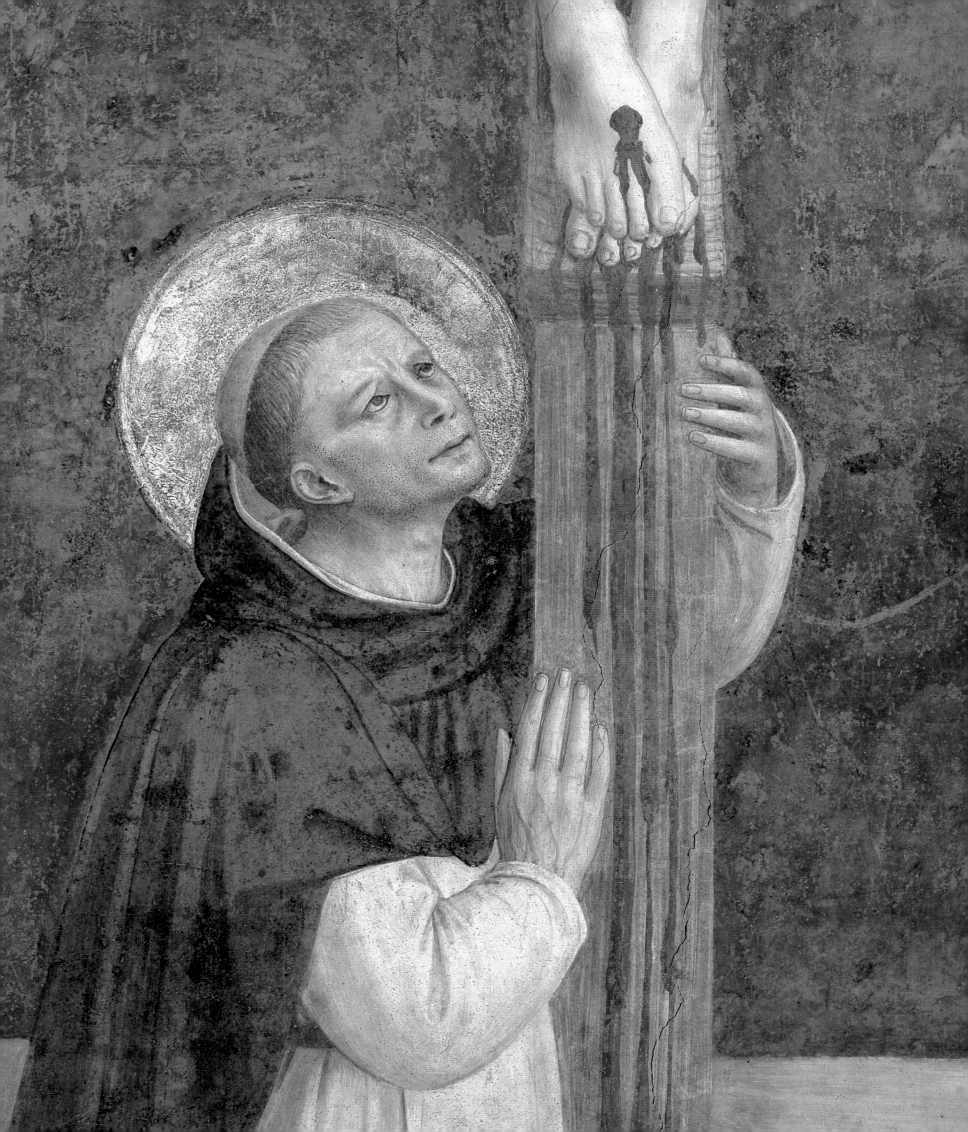

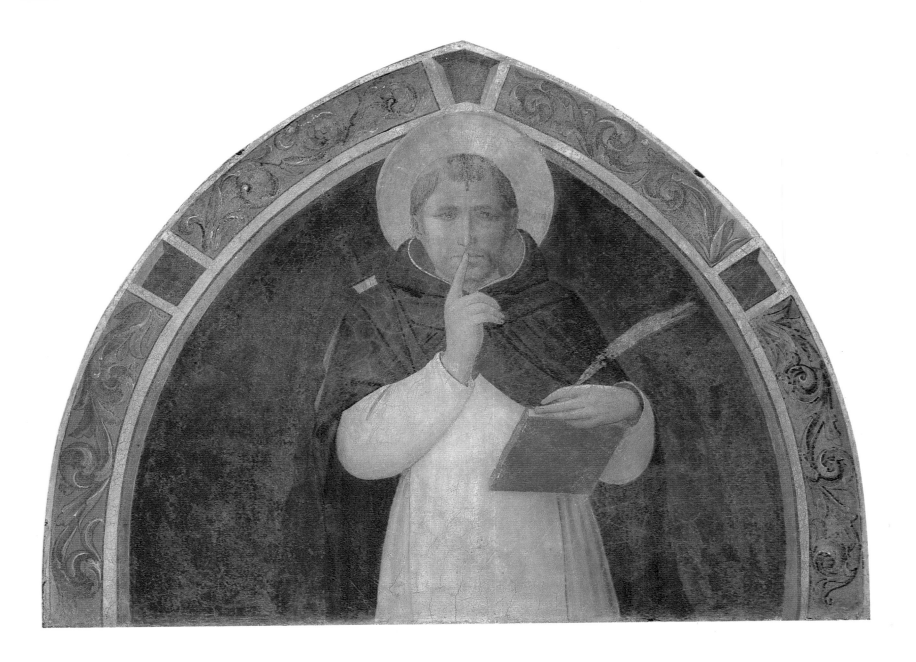

friars and their special guests, such as the founder Cosimo de' Medici. Each of these has a fresco, and there are three in the corridor, all of which were intended for spiritual contemplation. The subjects chosen are specifically intended for men with a learned understanding of the history of the Life of Christ. The representation of light in the frescoes often takes account of the natural light coming through the window on the same wall. Fra Angelico relied on light from the windows, usually to the right of the fresco, that would shine on the adjacent wall and be reflected back onto the fresco. It is unusual in European painting to have a light source from the right, such as we have here.

The fresco in the chapter room was meant not only for the members of the community who met there daily but also for meetings that took place there concerning the whole order. It has therefore a representational element as well as a devotional one.

Fra Angelico's painting, which decorates the huge semicircular wall opposite the door, seems to serve neither of these two interests in full (ill. 85). At first glance it is a large Crucifixion with many extra figures

and narrative devices, but a closer look reveals that it belongs only in part to this genre. The figures in the group around the Virgin, along with the two thieves, are the only ones that belong to a typically populated Calvary scene. The rest of the figures do not belong to the historical context but to the realm of the saints. On the left next to the thief who repented stand the Saints John the Baptist, Mark, Lawrence, Cosmas and Damian. Kneeling on the right are Dominic with Jerome, Francis of Assisi, Bernard de Clairvaux, Giovanni Gualberto, and Peter Martyr. Behind them are Saints Ambrose, Augustine, Benedict, Romuald, and Thomas Aquinas.

As in the cloister fresco, the bottom of the picture is a simple straight line: only a skull beneath the cross betokens the name of the place: Golgotha, "place of a skull". The effect of the once blue sky is diminished because of pigment loss. But the life-size figures are impressive with their imposing presence. They are not conceived as a group in a narrative context but as individuals. All of them but St. Mark, who is pointing to a book, and St. John, who, looking out of the picture,

81 (above) *Peter Martyr enjoins Silence*, ca. 1441
Fresco, 108 x 145 cm
Museo di San Marco, Florence

The lunette over the door which connects the cloister to the church has a painted Gothic architectural frame with recesses seen perspectively. Peter Martyr with his halo stands out slightly from the recess. The painting here is secondary to the architecture, serving the function of reminding the friars of the rule of silence before entering the church.

82 (opposite) *Christ on the Cross adored by St. Dominic*,
ca. 1442
Fresco, 340 x 206 cm
Museo di San Marco, Cloister, Florence

Intended for the Observant Dominicans who held to the strict Rule of the founder. On the one hand, the imposing Crucifix provides a constant example in Dominic who is here only a virtual participant in the event. On the other hand, the fundamental concepts of the Passion taken out of a temporal context through Dominic's presence are there to be experienced symbolically. In 1628 the fresco was surrounded with a stone frame and incorporated into a memorial of the Fabbroni family.

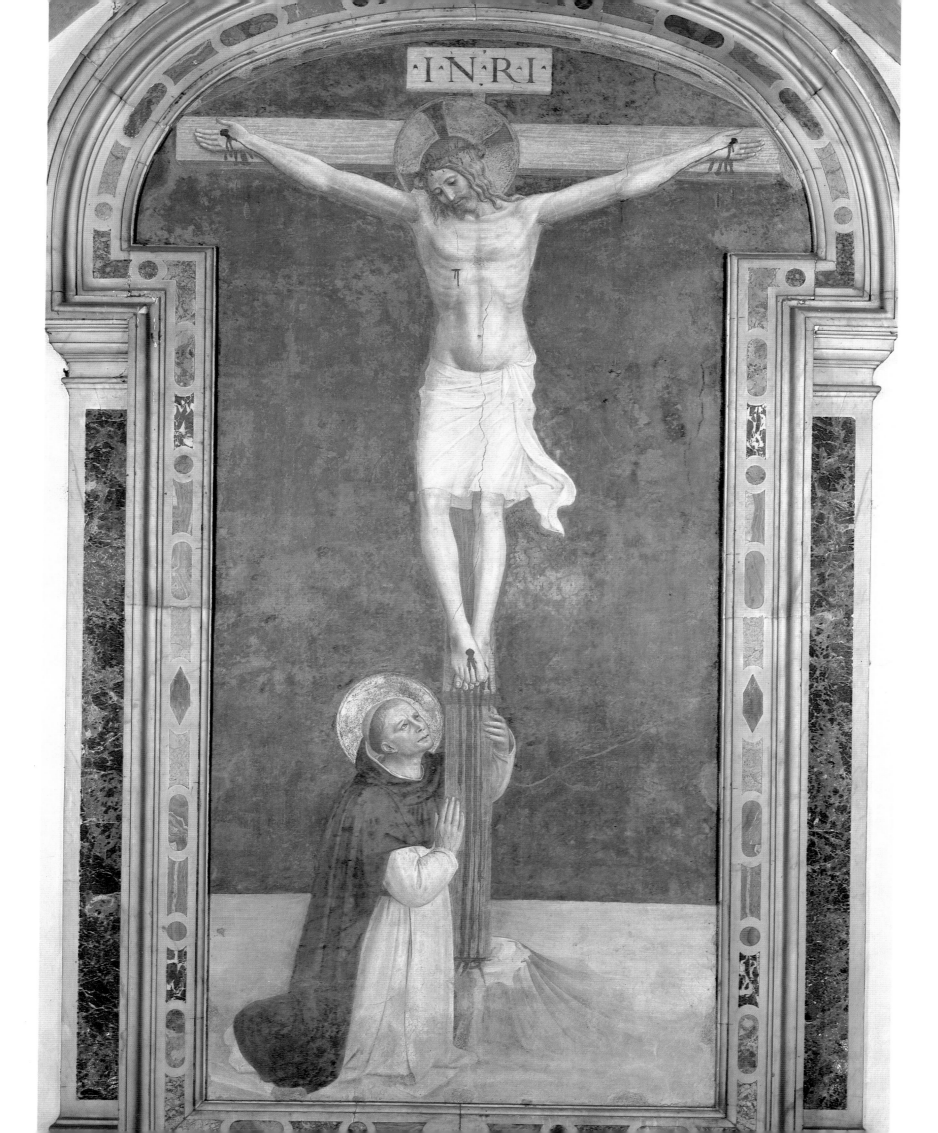

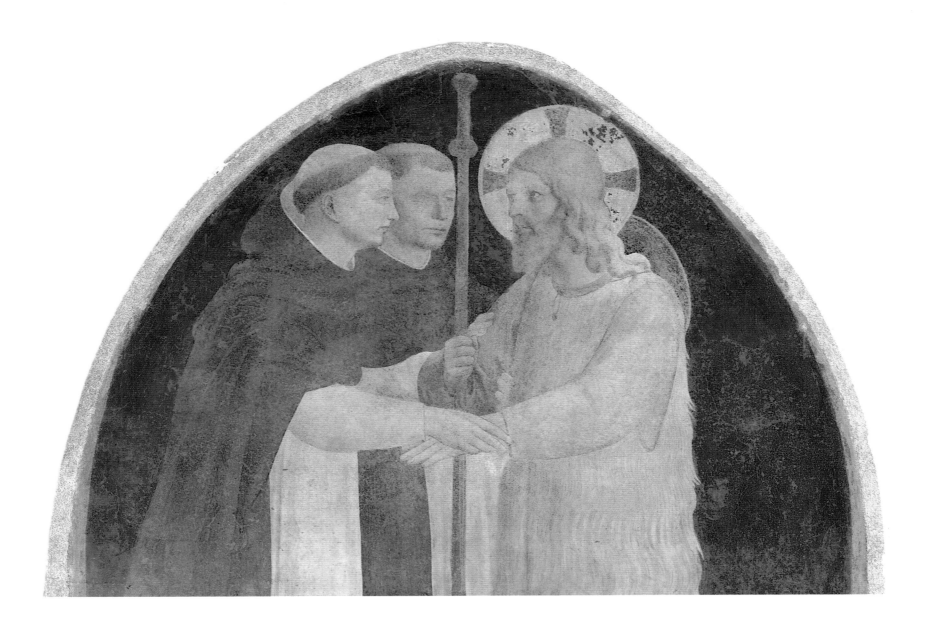

83 *Christ as Pilgrim is received by two Dominicans,*
ca. 1441
Fresco, 108 x 145 cm
Museo di San Marco, Florence

This fresco decorates the entrance to the pilgrims' hospice
which since 1919 has been a museum for most of Fra
Angelico's altarpieces. One of the convent's functions was
to shelter pilgrims. Christ appeared to the two apostles at
Emmaus as a pilgrim, and as such he is received here by
the Dominicans. Thus it was made clear to the friars what
their part was in the church service, from which every
pilgrim was allowed to profit.

is pointing to the group around the Virgin, are portrayed
in different attitudes of mourning and pity. If their
attention does not rest somewhere in the distance, it is
fixed upon the sorrowing Virgin rather than the Saviour.
Her body is held in such a way that its shape forms
a cross. She fulfils both the role of the Mother of
God as intercedent, and the first compassionate soul.
Compassio, the theological ideal of pity, is the central
motif of this fresco in the chapter room and is there to
evoke feelings of devotion in those who lived in the
convent.

The prophets and scholars in the decorative band (ill.
84) over the arch of the fresco proclaim the theological
import of the Crucifixion, while the busts in the
medallions below reflect the community's strong roots
in the Dominican order.

As the most simple subject, a pictorial formula of
Christ on the Cross with St. Dominic kneeling in
various attitudes of devotion on his right is repeated in
all its simplicity in cells 15–21 on the south corridor.
Because these cells were put to very simple use, they were
the novitiate's quarters, the frescoes were painted not by
Fra Angelico himself, but by studio assistants. Little
color was used because the message in these frescoes is

not the story of the Crucifixion found in the gospels but
Dominic's different attitudes of prayer. These derive
from the Dominican Rule on prayer indicated in the
"modi orandi corporales" (The Nine Ways of Prayer),
which describe the physical postures and gestures of the
founder of the order when at prayer. The Crucifix does
not presume a knowledge of biblical history but allows
the art of meditation to be learned from imitating the
founder. The same is true of *Christ at the Column of
Flagellation* in cell 27 (ill. 87).

As in the fresco of the *Man of Sorrows,* the *Mockery of
Christ* in cell 7 opposite is so deprived of narrative
content that it looks to the layman like a stark icon.
Christ is wearing the crown of thorns (ill. 90): the red
seat of torment stands on a pedestal and on the green
wall behind it are displayed the symbols of mockery:
hands slapping, a spitting head sarcastically raising his
hat. It is half sculpture, half altarpiece, this pedestal
stands upon a rose colored step which stretches back to
a wall not unlike the one dividing the cells in the
convent. It looks as though the frame surrounding
the fresco were casting a shadow. The Virgin and
St. Dominic are sitting on the step, both with similar
gestures. The Mother of God's gesture shows sorrow

84 *The Crucifixion* (detail ill. 85), 1441/42

The Crucifixion is framed with an architectonic
decorative border with painted lunettes from which
patriarchs and prophets look out, holding ribbons of text
which refer to Christ's Passion. The Erythraean Sibyl is
the last, with a text about Death and Resurrection.

85 *The Crucifixion*, 1441/42
Fresco, 550 x 950 cm
Museo di San Marco, Chapter Room, Florence

The fresco occupies the whole of the back wall of the
room. While the other decorations in San Marco were left
to the artistic will of their creator, the Crucifixion was
prescribed for the chapter room. Although narrative
details from the Gospel are left out for the most part, the
two thieves and the group of mourners around the Virgin
on the left of the cross are included.

86 Plan of the frescoes on the upper floor
Museo di San Marco, Florence

1 Noli me tangere (cf. ill. 97)
2 Entombment (cf. ill. 95)
3 Annunciation (cf. ill. 91)
4 Crucifixion with Mary, John the Evangelist,
 Dominic and Jerome
5 Nativity (cf. ill. 121)
6 Transfiguration of Christ (cf. ill. 94)
7 The Mockery of Christ (cf. ill. 90)
8 The Resurrection (cf. ill. 96)
9 Coronation of the Virgin (cf. ill. 92)
10 The Presentation of Christ at the Temple
11 Mary with Child and two Saints
15–21 Crucifixion with Dominic
22 Crucifixion with Mary
23 Crucifixion with Mary, Dominic and Angels
24 Baptism of Christ (cf. ill. 93)
25 Crucifixion with Mary, Mary Magdalene and
 Dominic
26 Man of Sorrows (cf. ill. 89)
27 Christ at the Column of Flagellation (cf. ill. 87)
28 Christ carrying the Cross (cf. ill. 88)
29 Crucifixion with Mary and Dominic
30 Crucifixion with Mary and Dominic
31 Christ in Limbo (cf. ill. 107)
32 The Sermon on the Mount
32a Temptation of Christ (cf. ill. 100)
33 Arrest of Christ (cf. ill. 103)
33a Entry into Jerusalem
34 Agony in the Garden (cf. ill. 102)
35 The Institution of the Eucharist (cf. ill. 101)
36 Christ being Nailed to the Cross (cf. ill. 104)
37 Cruxifixion with Thieves, Mary, St. John,
 St. Dominic and St. Thomas Aquinas (cf. ill. 105)
38 Crucifixion with Mary, John, Cosmas and Petrus
 Martyr
39 Adoration of the Magi (cf. ill. 108)
40 Crucifixion
41 Crucifixion
42 St. Dominic with the Crucifix – the Piercing of
 Christ's Side (cf. ill. 106)
43/44 Crucifixion

while that of the founder is a sign of contemplation of the content of the scripture he has just read. Neither is taking heed of the mocking.

The friar who made his devotions in this cell was given the chance to reflect on the mocking of Christ, to express his pity at the sorrow of the Mother of God and, by imitating Dominic, to gain a deeper understanding of the life of Christ through the study of the scriptures. The fresco does not attempt to link those portrayed, although the light coming from the right which takes into account the natural source of light from the adjacent window falls on all of them together.

The veneration of the Virgin is a strong element in the faith of the Observant Dominicans. In the legend, St. Dominic receives the habit of the order from the Virgin's hands. Fra Angelico depicts the event in some of his Annunciation altarpiece predellas. It is no wonder then that two frescoes with the Virgin as the main figure appear (ills. 98, 99) in the quarters where only the friars were allowed.

In the cell frescoes too, the Mother of God plays a great role. The *Annunciation* (ill. 91) follows the familiar design but is stripped of all narrative detail. Unlike in the other frescoes (ills. 59, 66, 67), the light does not come from a window to the right of a picture or rather from the wall next to it, but from the left. The Virgin is kneeling on a prayer stool and her shadow can be clearly seen on the right. The angel himself does not radiate light as in the altarpieces: in fact it seems as though something on his left were emitting a glistening stream of light.

If the divine presence is manifest in the last fresco in the supernatural light, other qualities are found in the *Coronation of the Virgin* (ill. 92). The Virgin's Assumption takes place in a realm far removed from the world, as the aureole of light between the Virgin and Christ indicates. Richly varying tones of white, yellow, and grey make the figures seem almost transparent. The figures are sitting on a bank of clouds as if this alone were sign enough of the unimaginable. However, the Mother and Son are illuminated from the right. The saints kneeling below are in normal colors as if to show they belong to a different realm. This puts the scene of the Coronation at an even greater distance.

In the *Transfiguration of Christ* (ill. 94) the light of the mandorla becomes almost a palpable object. The gospels

87 (opposite) *Flagellation*, ca. 1441
Fresco, 165 x 142 cm
Museo di San Marco, cell 27, Florence

Even though a studio assistant is credited with the painting of the fresco, Fra Angelico is certainly responsible for the design. The onlooker is appealed to at many different levels. The actual subject, the Flagellation, is unsupported by narrative detail. The Virgin, as the intercedent in the prayer, is sitting turned away from her son in deep mourning. Neither she nor Dominic were actual witnesses. The saint is following Christ's example by self-flagellation.

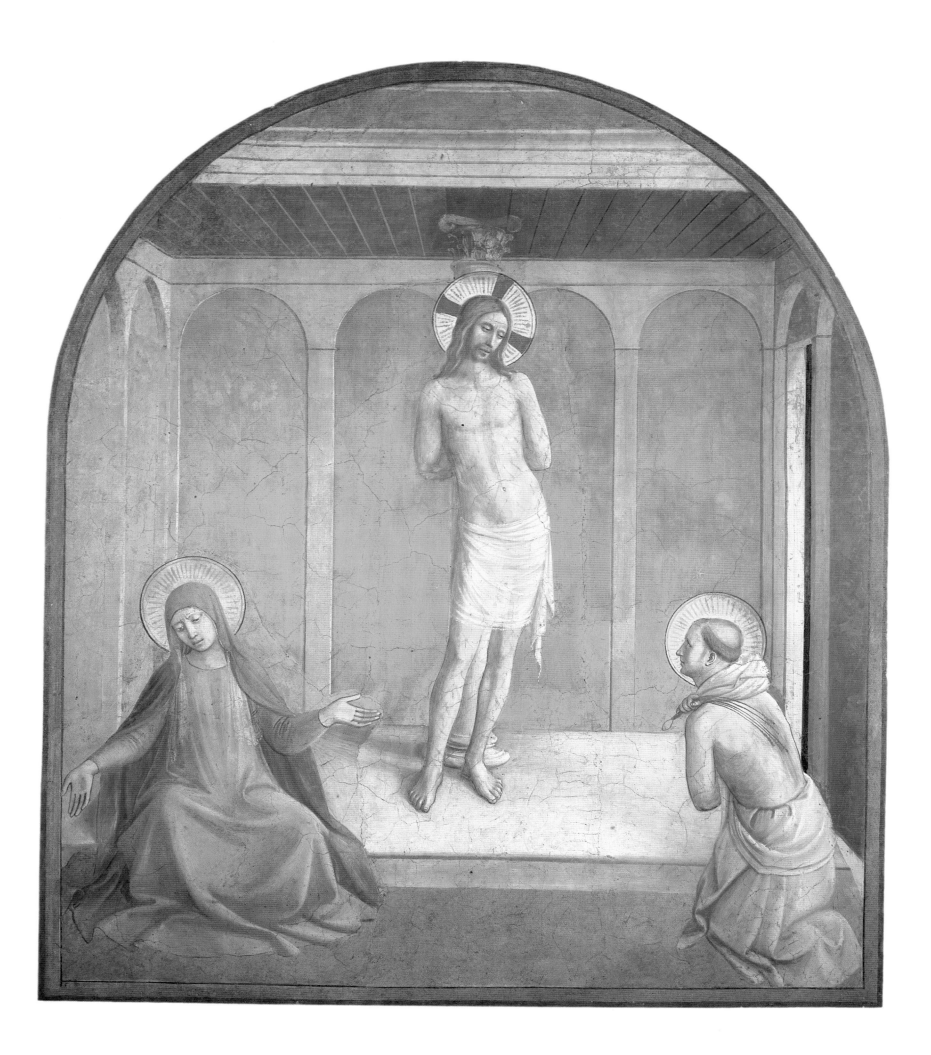

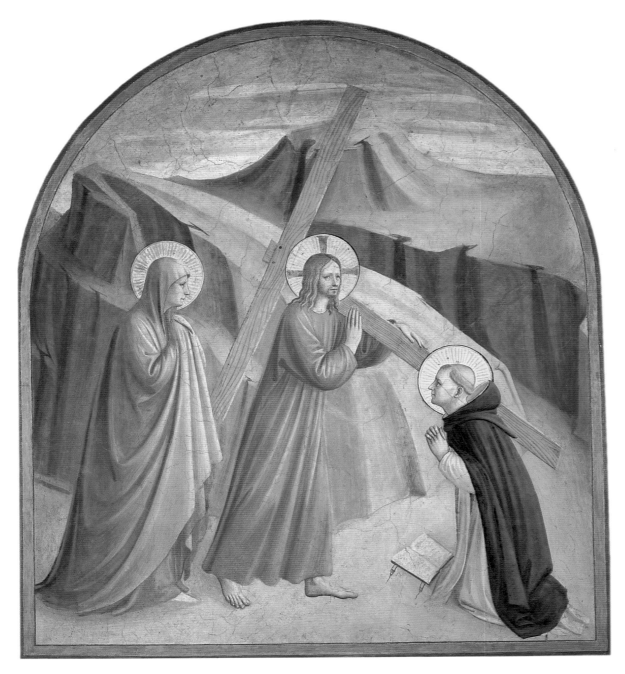

88 (left) *Christ carrying the Cross*, ca. 1441
Fresco, 148 x 131 cm
Museo di San Marco, cell 28, Florence

Even though an assistant is credited with the execution of
this fresco, Fra Angelico's design is convincingly adapted
to the intention of the cell frescoes. Christ is carrying the
cross through a bare landscape unaccompanied by his
tormentors or judges. The Virgin alone follows his weary
path. St. Dominic is looking at her and addressing to her
the prayer at which his prayer book is lying open. His
position in the picture indicates that the meeting is not
meant to be realistic. Were it so, Christ would be about to
stumble over him.

89 (above) *Man of Sorrows*, ca. 1441
Fresco, 165 x 142 cm
Museo di San Marco, cell 26, Florence

Standing in the sepulchre, Christ displays his wounds. All
around him are the symbols of the events of the Passion;
the forty pieces of silver, the betrayal with a kiss, Peter's
denial, the crown of thorns, the mockery and flagellation,
the nailing to the cross, the sponge soaked in vinegar and
the piercing of his side. It is not meant as a depiction of a
real event but as a devotional picture including the Mater
Dolorosa, and Thomas Aquinas as spectator, in the
medieval tradition.

90 (opposite) *The Mockery of Christ*, ca. 1441
Fresco, 187 x 151 cm
Museo di San Marco, cell 7, Florence

The great expressive power in this fresco reflects the most
ambitious design of the frescoes in San Marco. Christ,
wearing the crown of thorns and holding a stick of
bamboo and a ball, recalling the Ecce Homo motif, is
sitting on a white pedestal in front of a panel which
stands out from the wall almost three dimensionally. The
tormentors are portrayed against this in abbreviated
symbolic form according to medieval tradition. The
Virgin and Dominic sit on the step below. While they
seem not to notice what is happening, they are clearly
meditating upon the event.

say that Christ went up Mount Tabor with Peter, John,
and James, and He was transfigured before them. "His
face shone like the sun and His garments became white
as light". (Matthew 17:2). Moses and Elijah spoke with
him: only their heads are to be seen. As the disciples
express their emotions each in a different way, the Virgin
and Dominic face each other in profile. The founder is
illuminated not from inside the picture but naturally,
from the cell window on the right, which lights his cheek
and leaves the rest of his face in shadow.

Apart from the pictures that are remarkable for their
mystical effects of light, the frescoes in the east wing
that relate to the Crucifixion (ills. 87–90) are most
memorable. The sacrifice of the Son of Man on the
Cross and his Resurrection were clearly the most
important emblems of Christianity to Fra Angelico.

The *Entombment* in cell 2 (ill. 95), which was

presumably executed by an assistant, recalls the
Lamentation over the Dead Christ of 1436–1441 (ill.
75). The scene however, is not Golgotha but the one at
the tomb, which resembles the scene in the predella of
the high altar (ill. 56), although the sarcophagus here is
right in the center. The Lamentation is not recounted
in the gospels; the scene enacts the almost the same one
as the Entombment; the *Resurrection* follows (ill. 96)
The view seems to be from the entrance to the sepulchre.
Compared with the previous one, though, the inside is
more spacious and the sarcophagus is positioned parallel
to the entrance of the sepulchre, but it is recognizably
the same place. The women with their flasks of ointment
are looking either at the empty sepulchre, or at the
angels, who through their gestures are explaining that
Christ has risen. He appears above them in a mandorla
of light clothed as he was in the fresco of the

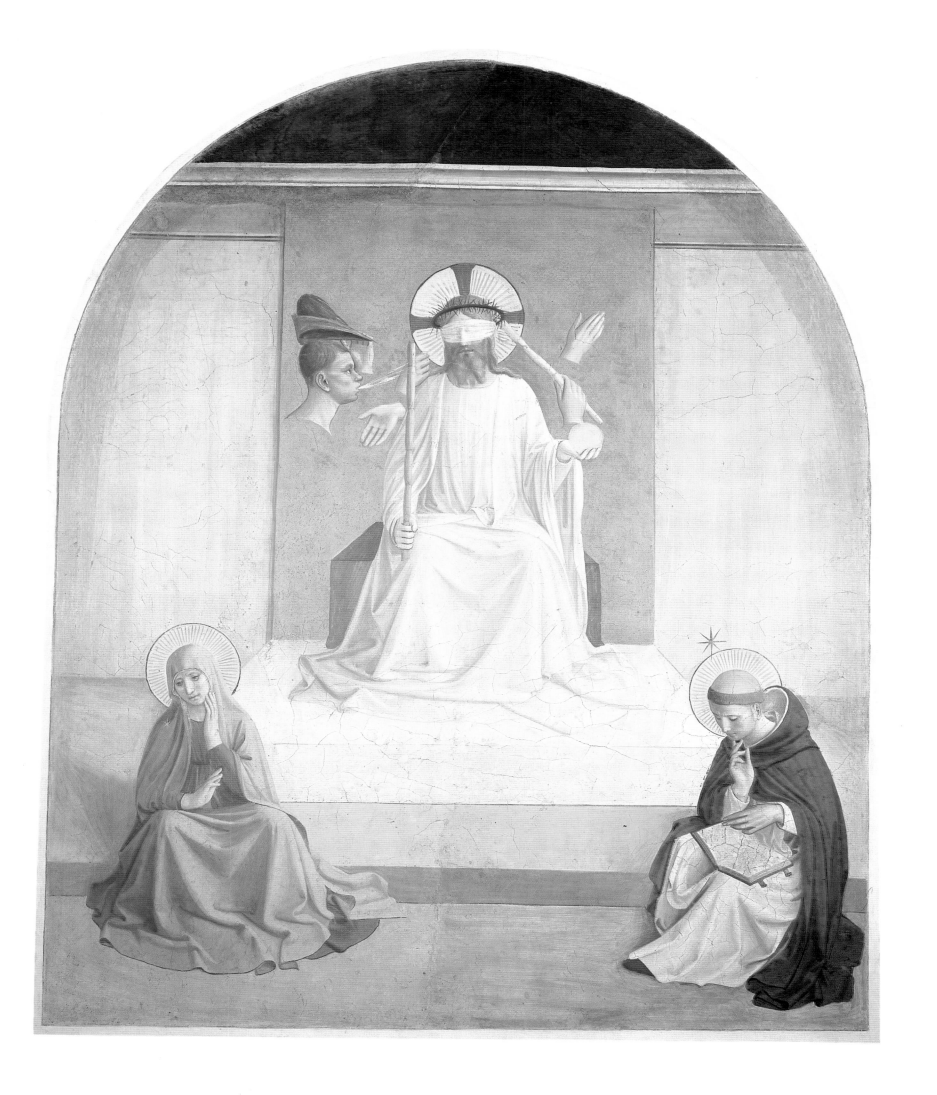

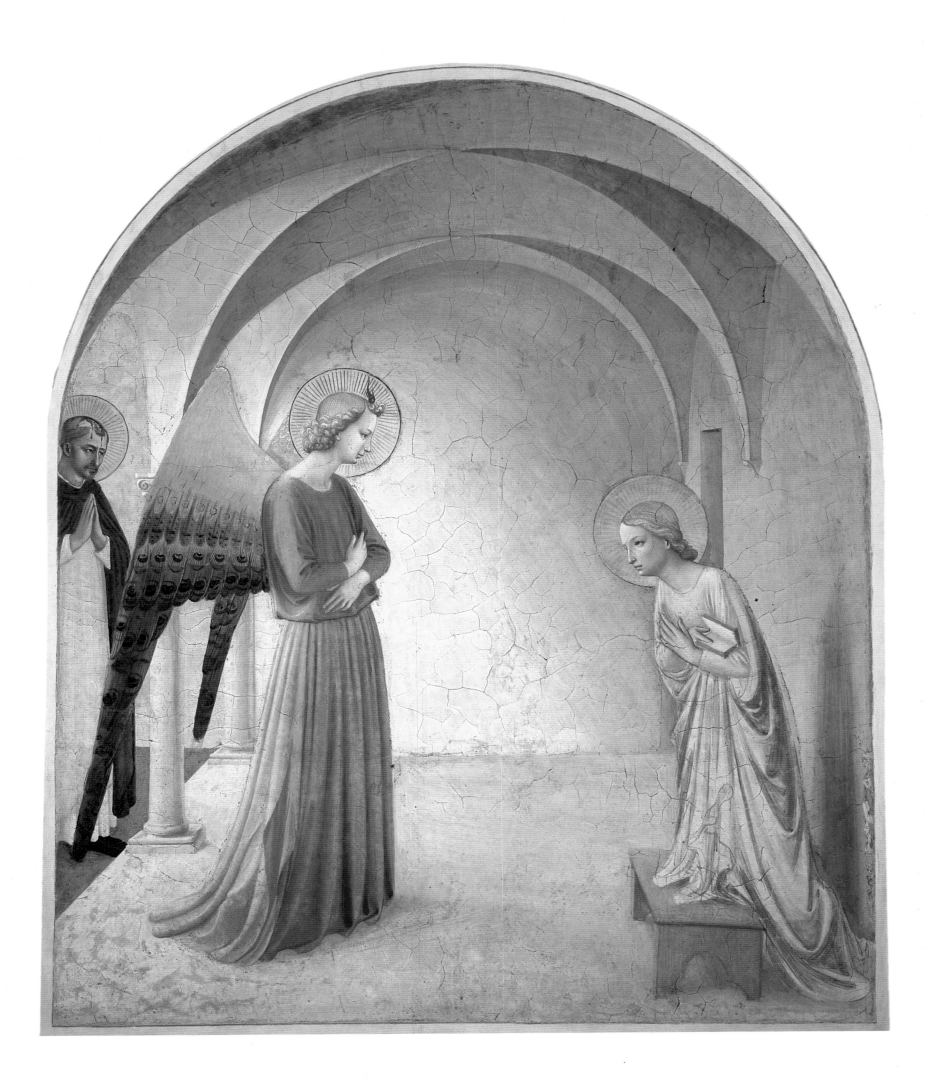

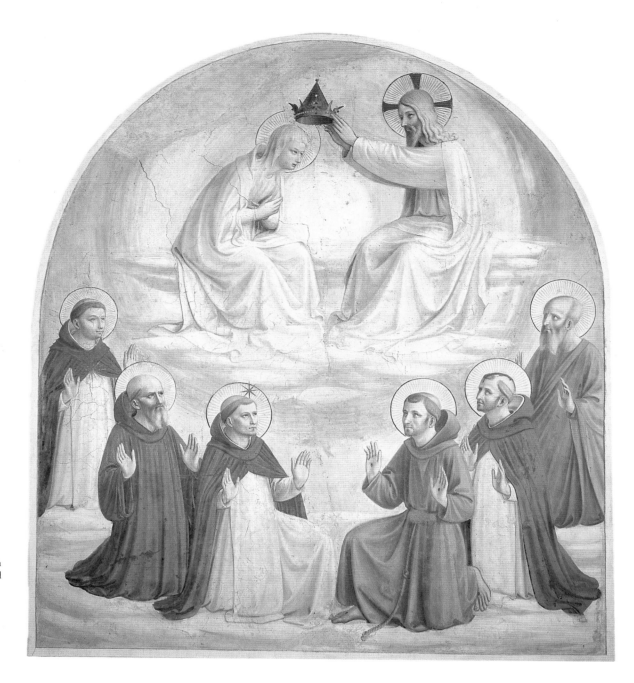

92 (right) *Coronation of the Virgin*, ca. 1441
Fresco, 171 x 151 cm
Museo di San Marco, cell 9, Florence

The Virgin and Christ are sitting on a bank of clouds in a circle of pale green light. The subtlest shades of white and yellow dominate the coloration of the group. The only strong colors are in Christ's halo and the Virgin's crown. On a lower celestial plane Dominic and Francis kneel in the center facing each other, with Thomas Aquinas and Benedict on the left, and Peter Martyr and Mark the Evangelist on the right.

91 (opposite) *Annunciation*, ca. 1441
Fresco, 176 x 148 cm
Museo di San Marco, cell 3, Florence

The well-known setting of Fra Angelico's *Annunciation* appears again in this fresco but the cross vaulted arcade can be interpreted here as the cloister. The subject has an abstract interpretation. The figures are quite motionless and the Virgin is a mere wisp inclined towards the angel. Peter Martyr, a discreet observer, standing at a distance and cut off by the frame, is watching her in prayer. Only his left foot is shown in order to avoid overlapping the tips of the angel's wings.

Transfiguration of Christ (ill. 94). His appearance holding the pennant from the cross and a palm branch as signs of the Passion and the Martyrdom is seen only by the onlooker; the light surrounding him has supernatural qualities but it does not reach the sepulchre.

The last episode is the appearance of the Risen Christ as the gardener to Mary Magdalene, who has remained mourning at the tomb. When Christ makes himself known to her she wants to fall at his feet full of joy, but is warned with the words "Noli me tangere" (touch me not). This scene when painted is always traditionally described with these words.

The *Noli me tangere* belongs to the most beautiful and carefully crafted of the frescoes (ill. 97); it portrays a biblical event without the presence of a Dominican. The scene is still a rocky hillside, the sepulchre is similar to the one in the predella scene (ill. 56). Mary Magdalene is kneeling on the ground, a great deal of light has been painted into the orange of her garment on the right, while near the opening of the tomb it is in deep shadow. Her arms are half open and spread out towards Christ's feet while she gazes up at his face as if in disbelief.

One must bear in mind that the cell frescoes were not designed to be seen all at once, but it is strange that the Mary Magdalene of the earlier Gospel scenes is not recognizable in this figure. Christ is caught in a movement which is something between the desire to touch her and moving away, so that a balletic cross step is the result. The appearance of the Risen Christ as gardener in the scene is suitably matched by the lush and varied greenery. The light on the haloes and on the palings of the fence at the height of Christ's head creates a special atmosphere.

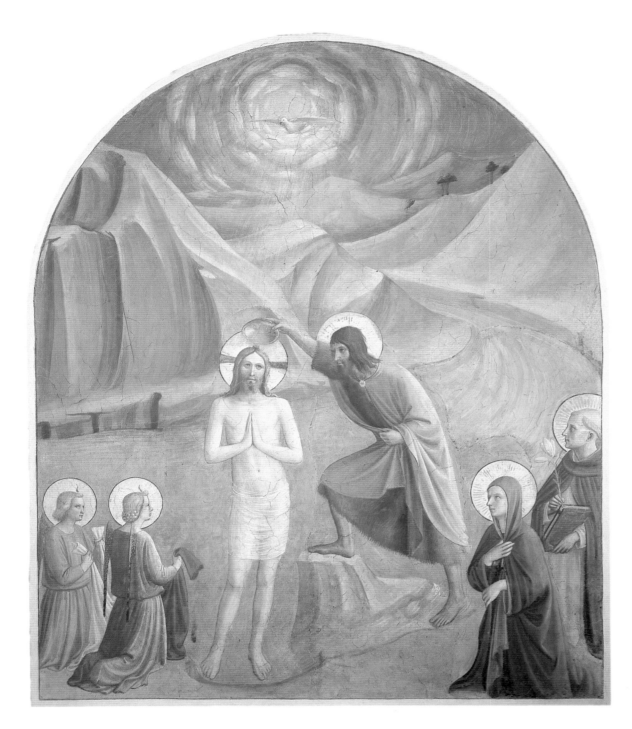

93 (left) *Baptism of Christ*, ca. 1441
Fresco, 179 x 148 cm
Museo di San Marco, cell 24, Florence

The bare hilly landscape stretches far into the distance, using the same basic device as in the *Beheading of Cosmas and Damian* in the San Marco altarpiece (ill. 51). The River Jordan here describes the same bend as the path in the predella scene. The dove of the Holy Ghost is surrounded by a supernatural light giving the scene a mystical air. John the Baptist's feet are cleverly worked; he stands with one foot on the rock, while the other is lapped by the water. The Virgin and Dominic, standing on a strip of ground in the foreground, witness the baptism of Christ, and on the left, angels are holding the clothing in readiness. Although the design is generally attributed to Fra Angelico, the fresco was executed by an assistant.

Altogether there are three frescoes decorating the corridor: the *Annunciation* (ill. 98), *Christ on the Cross adored by St. Dominic* (ill. 82) and the *Madonna delle ombre* (ill. 99). This last fresco, a *Sacra Conversazione*, illuminated from above now, though not in any apparently logical way, was painted by Fra Angelico between cells 25 and 26, and is known as the *Madonna delle ombre*, the *Madonna of the Shadows* (ill. 99). The fresco stands out from all the others because of its decoration. Made as if to imitate a stone altarpiece, there are four tablets painted to look like marble beneath the line of figures in the fresco.

There was a similar Madonna in the friars' quarters in Fiesole, though in this only Saints Thomas Aquinas and

Dominic appear with the Virgin. (Today it is in the Hermitage in St. Petersburg). These saints appear again in the San Marco fresco. The Virgin sits in a shell-like niche, lower than on the high altar, set into a wall running along the whole of the back of the picture rather like the *Annalena altarpiece* (ill 39). Just as in the *Noli me tangere* (ill. 97) the light effects create a mood, in particular the reflection in the gold shell and the heavy shadows on the capitals of the columns. Fra Angelico attempts effects in the drapery that are not usually achieved in a true fresco painting; after the first layer of color was laid down in the wet plaster, the whole surface was given a wash of tempera, to achieve a depth comparable to a panel painting.

94 (opposite) *Transfiguration of Christ*, ca. 1441
Fresco, 181 x 152 cm
Museo di San Marco, cell 6, Florence

Christ dominates the composition in an iconographic imitation of the cross. The heads of Moses and Elijah appear at either side. The favorite apostles cower at the foot of the mound, overwhelmed by the apparition. The Virgin and Dominic are kneeling in prayer on clouds on either side of the central figure of Christ.

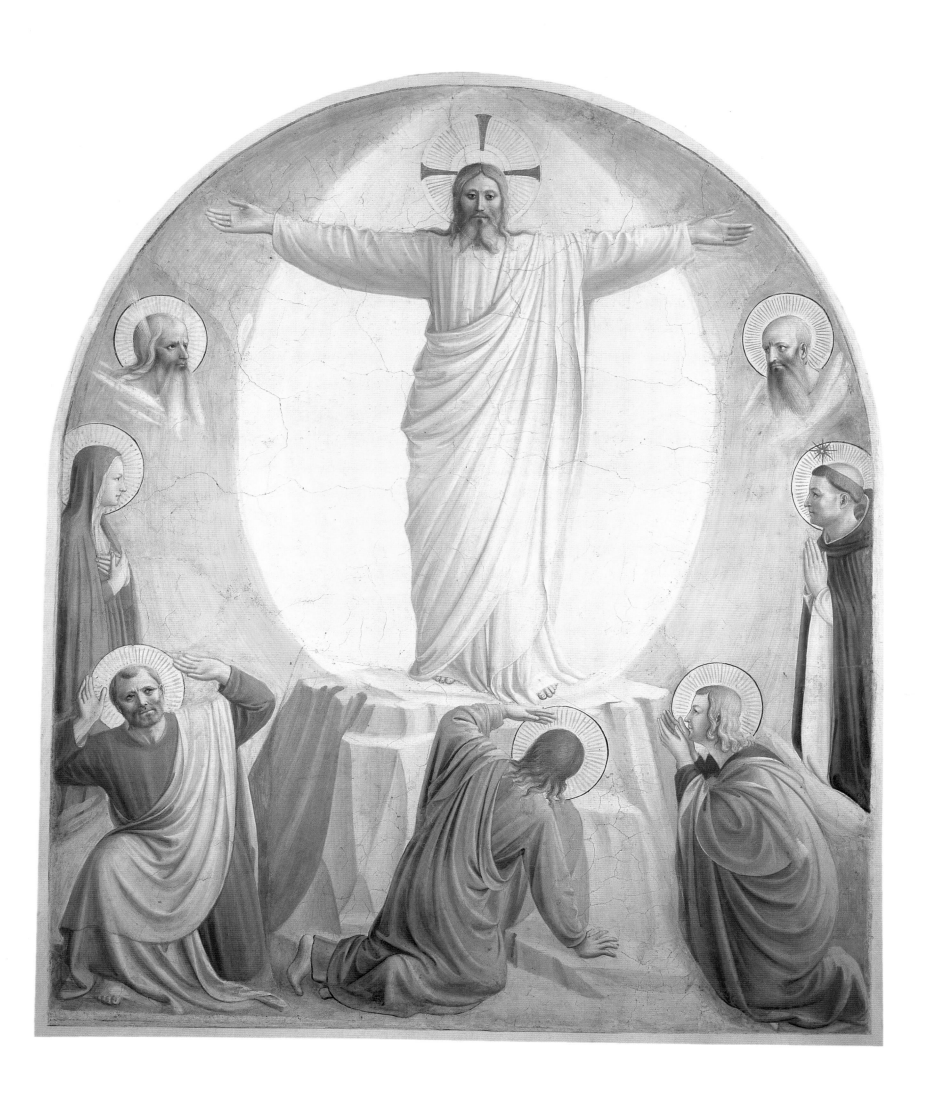

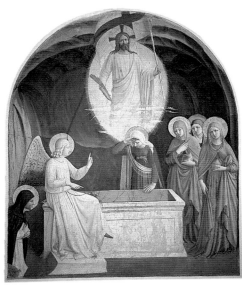

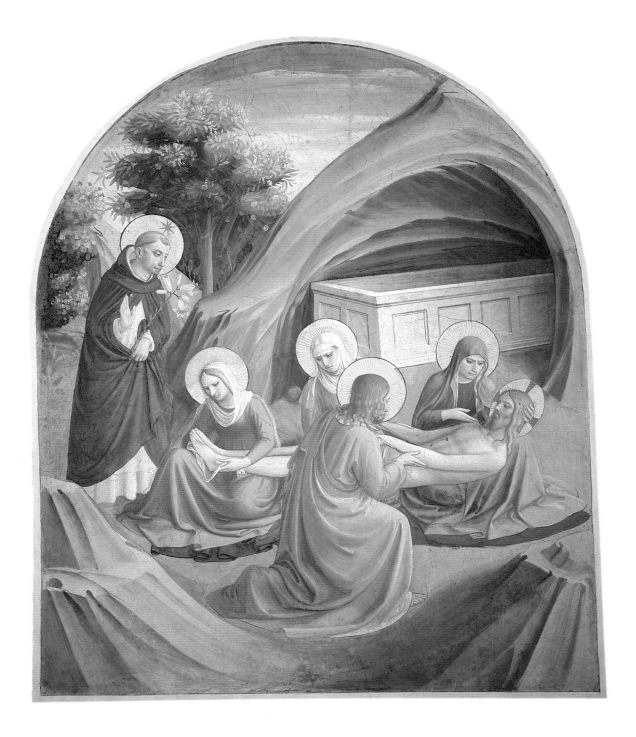

Of all the saints, Dominic alone is looking at the onlooker. In this place he cannot be other than a representative of the Dominican order. He is pointing to his open book and the words, clearly legible, come from the so-called Testament of Dominic: CARITATEM H(AB)ETE. HUMILITATEM SERVATE. PAUPERTATEM VOLUNTARIAM POSSIDETE. MALEDICTION(EM) DEI ET MEA(M) I(M)PRECOR POSSESSIONES I(N)DUCENTI(BUS) I(N) HO(C) ORDINE (Be charitable. Serve humility. Possess voluntary poverty. My own and God's curse be upon him who brings possessions into this Order).

The Observants are bidden, then, in the midst of this splendid monastic decoration, not to forget the Rule of the Order.

The *Annunciation* (ill. 98), which greets the visitor today as he climbs the central staircase to the first floor, shows evidence of Fra Angelico's attempt to reflect Michelozzo's architectural style. Pilasters in the style and color of the stone of the cells form the setting of the painting, which is a view from a loggia. Here too the passer-by is bidden to pay homage and salutation to the Mother of God: VIRGINIS INTACTE CUM VENERIS ANTE FIGURAM PRETEREUNDO CAVE NE SILEATUR AVE (When you come to the image of the immaculate Virgin, be sure that an Ave is not lost in silence as you pass by). The salutation of the angel was added later in another script. Unlike those of the angel in cell 3 (ill. 91) Gabriel's wings here are surprising in their plasticity and color. There is no

95 (left) *Entombment*, ca. 1441
Fresco, 184 x 152 cm
Museo di San Marco, cell 2, Florence

The composition of the group is repeated, though on a smaller scale, from the *Lamentation* for the Confraternity of Santa Maria della Croce al Tempio (ill. 75). The action takes place here in front of the open sepulchre. The painting opens with a rounded crop of hillside which follows the line to the entrance of Christ's tomb. A clump of trees in front of a sky full of delicate clouds completes the picture. This is an episode not found in the gospel. Dominic is present. Some experts have designated the creator of this fresco "the Master of Cell 2".

96 (above) *The Resurrection*, ca. 1441
Fresco, 181 x 151 cm
Museo di San Marco, cell 8, Florence

The women who come on Easter Sunday to wash the body find the tomb empty. An angel is sitting almost casually on the edge of the sarcophagus with his right leg standing on a plinth. He tells the women that the one they are looking for is not there and points to the Risen Christ whom they do not see. St. Dominic, a secret onlooker, kneeling, is cut off at the edge of the picture.

97 (opposite) *Noli me tangere*, ca. 1450
Fresco, 166 x 125 cm
Museo di San Marco, cell 1, Florence

Mary Magdalene is kneeling in front of the open sepulchre at Christ's feet. He carries a hoe on his shoulder. The tension is shown in the balletic cross step and the outstretched hand of the Savior. Innumerable plants decorate the background. The vertical palings of the fence catch the light and separate the garden from the dense forest. This captivating painting is regarded by most art historians as having been executed by the artist because of its especially careful execution and love of detail. This, however, has led William Hood to venture to the conclusion that it is from a later phase and attributable to Benozzo Gozzoli.

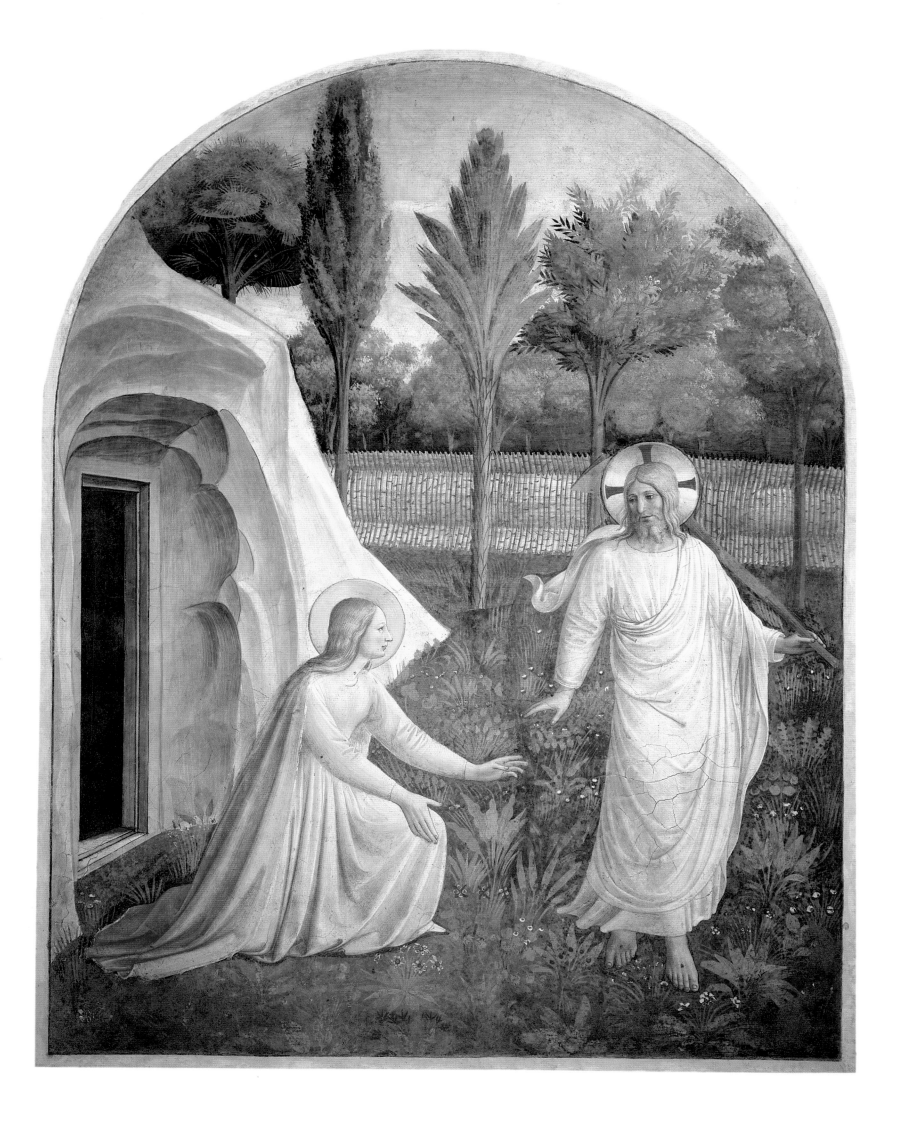

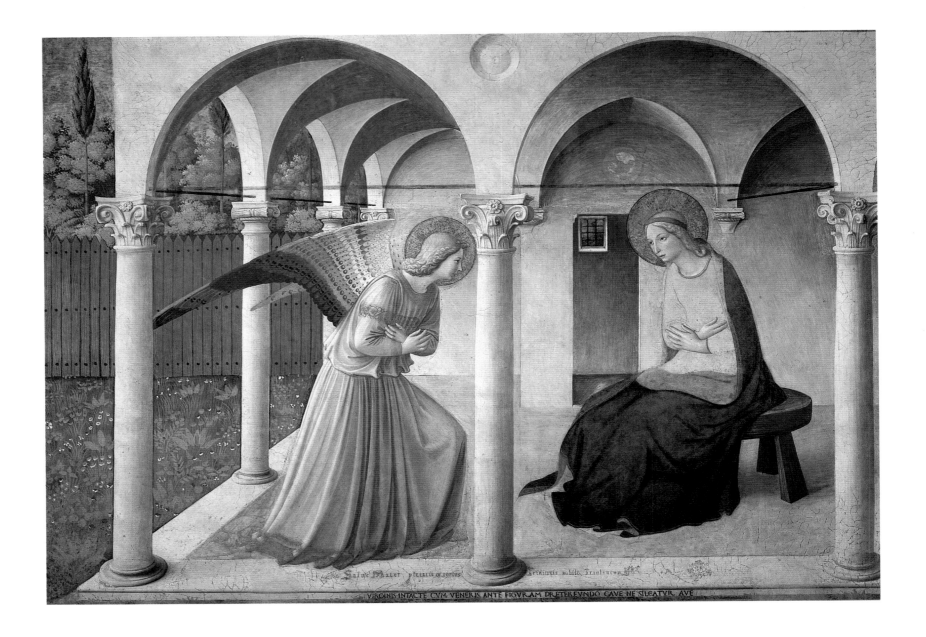

98 *Annunciation*, ca. 1450
Fresco 230 x 297 cm
Museo di San Marco, corridor, Florence

As one climbs the staircase to the first floor the eye is
caught by this fresco which has come to be mean the very
essence of Fra Angelico's art. It is framed as though it were
a view into another world but that is the effect of the
color of the stone the architect used, the *pietra serena*,
which transforms the artist's vision of the Annunciation
(ill. 59).

difference in quality but a later style can be detected in
the manner of painting. The frescoes in the corridor (ills.
98, 99) and the one in cell 1 (ill. 97) were probably
painted in 1450 after Fra Angelico's return from Rome.

The frescoes in the north corridor are less well known
because they are of a different style from the others,
which show only important personalities in the life of
Christ. These, however, offer a wealth of narrative detail,
which may be because they are the product of one hand,
namely that of Benozzo Gozzoli. On the other hand
they do away with the fond idea of the painting friar who
puts pious devotion before the demonstration of his
artistry. The attempts of researchers to identify studio
assistants of Fra Angelico other than Benozzo Gozzoli
and Zanobi Strozzi have been unsuccessful. So it seems

right to believe, with all caution as ever, what the
Cronaca di San Marco claims, namely that their brother,
Fra Angelico, was the creator of all the paintings in the
convent. The frescoes in the corridor were certainly
painted after those in the Niccolina (ills. 109–116), in
which the pictorial narrative has a different status from
that in the earlier frescoes in San Marco.

In any case a very extensive picture cycle of the story
of the Passion can be identified, even if the sequence
differs greatly in its arrangement from the chronology
of the biblical story and iconographic tradition. It leads
from *The Sermon on the Mount*, in cell 32, to the *Entry
into Jerusalem*, in cell 33b, to the *Institution of
the Eucharist*, in cell 35 (ill. 101), to the *Agony in
the Garden*, in cell 34 (ill. 102), to the *Arrest of Christ*,

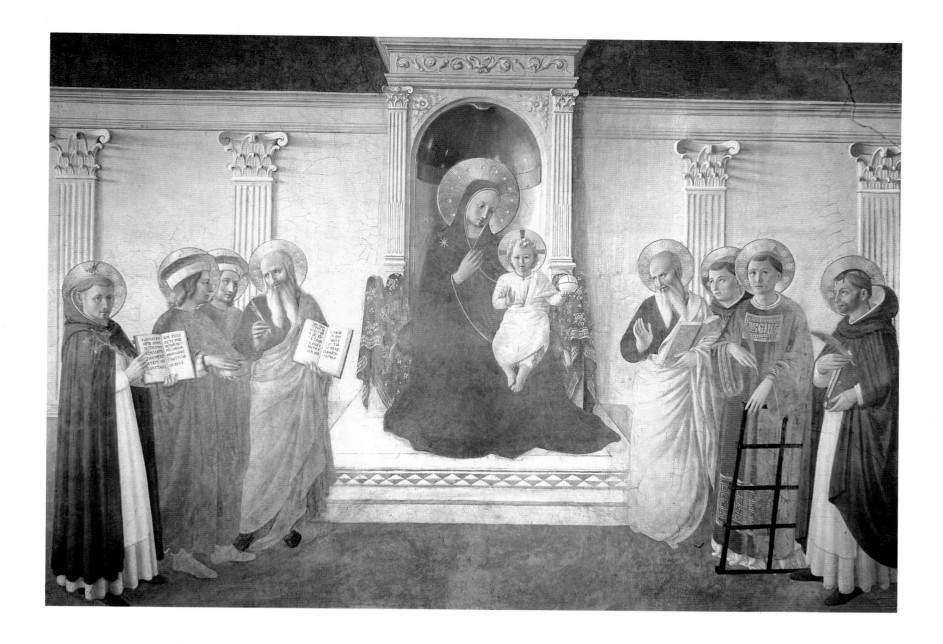

in cell 33 (ill. 103), to *Christ being Nailed to the Cross*, in an unusual setting, in cell 36 (ill. 104), to several Crucifixions, in cells 4, 13, 25, 37, 42 (ill. 105), until one arrives finally at *Christ in Limbo*, in cell 31 (ill. 107).

Only the subject matter of the fresco of the *Adoration of the Magi*, in cell 39 (ill. 108) is taken from a different iconographic context, and this was not meant for the friars but for Cosimo de' Medici, as patron, and for other important guests. Most of the scenes are without Dominican saints but the presence of the Virgin is most conspicuous and she is often accompanied by Martha and Mary Magdalene, who, both in the frescoes in the north corridor as well as in cell 1 (ill. 97), is wearing an orange garment – perhaps an indication that this picture is of a later date.

The Virgin Mary's presence could be connected with the use of the prayers from Books of Hours, such as the "Lamentationes" of the Holy Virgin. These prayers followed the Passion through the eyes of a figure from the story of the life of Christ, who interceded between the person praying and Christ himself. They can be found in many French Books of Hours with a Dominican, and sometimes a Franciscan, influence. Two familiar examples are the "Petites Heures" of the Duc de Berry, and the Turin-Milan "Book of Hours" for which Jan van Eyck painted an introductory miniature. Fra Angelico however, places the Virgin with Mary Magdalene and Martha: a different sort of text would be required if these pictures were to be used with such prayers.

99 *Madonna delle ombre (Madonna of the Shadows),* ca. 1450
Fresco and tempera, 193 x 273 cm
Museo di San Marco, Florence

Situated in the corridor on the first floor, this fresco was reserved for the inmates of the convent. The saints who were of importance to the Medici family appear here as in the *San Marco Altarpiece*; they are Lawrence, John the Baptist, Cosmas and Damian, the patron saint of the church, St. Mark, and the Dominicans, Dominic, Peter Martyr and Thomas Aquinas. The Virgin's throne is set into a shell niche in a pale stone wall. The capitals of the pilasters cast shadows to emphasize the sole source of light. This has led to the name of the *Madonna of the Shadows*.

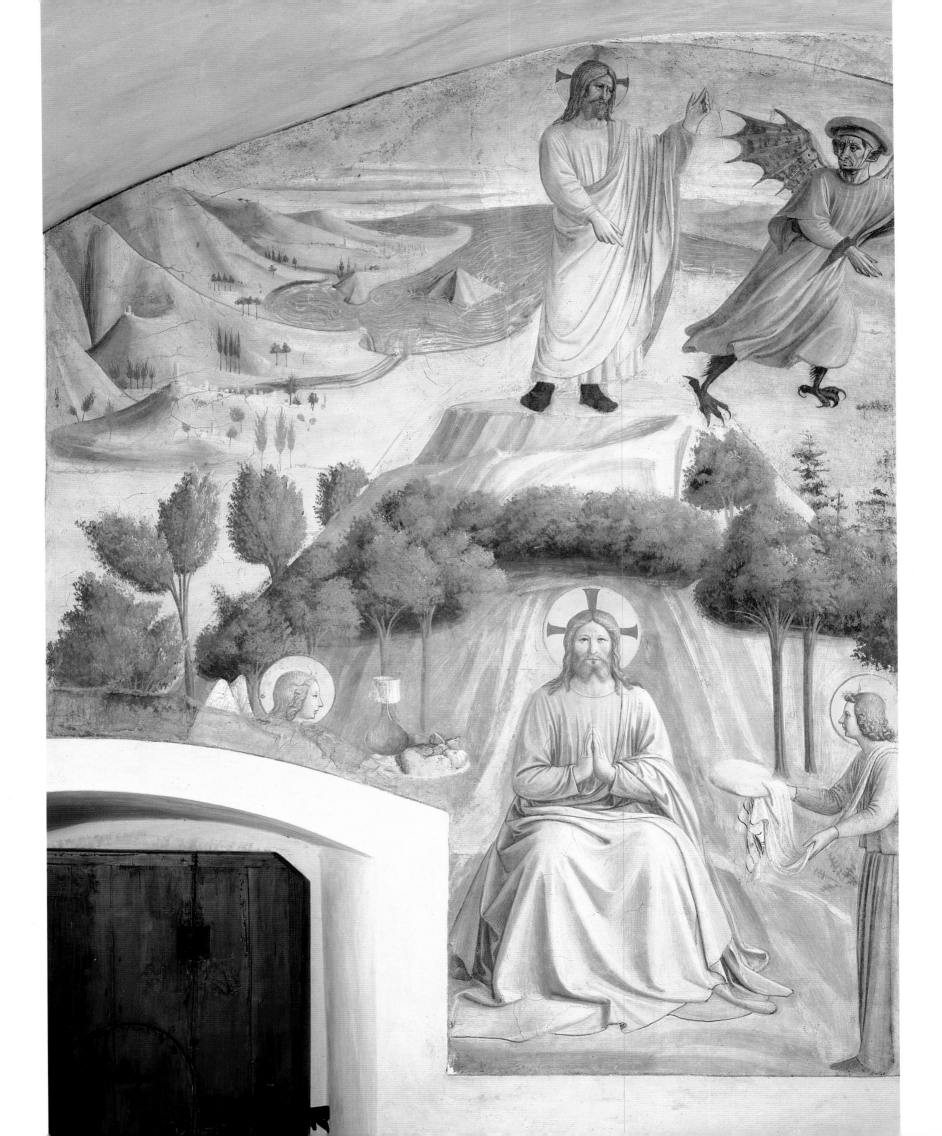

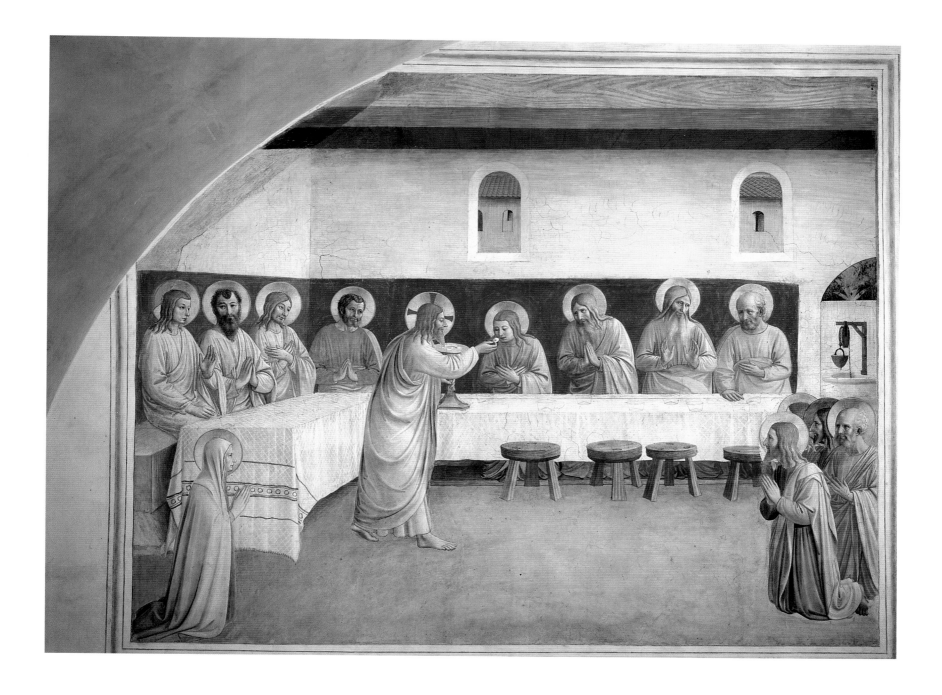

100 (opposite) *Temptation of Christ*, after 1450
Fresco (fragment), 174 x 137 cm
Museo di San Marco, cell 32a, Florence

The frescoes in the north corridor (cells 32–38) have a
different character from the previous ones. They have a
wealth of figures and are full of excitement. Studio
assistants, chiefly Benozzo Gozzoli, collaborated in both
the design and execution of these. Two windows have
since been made in the walls thus destroying the fresco.
The Feeding by the Angels, which followed the
Temptation in the gospels was also depicted in this fresco,
with the kind of attention to detail that one might find in
a still life.

101 (above) *The Institution of the Eucharist*, ca. 1450
Fresco, 186 x 234 cm
Museo di San Marco, cell 35, Florence

The number of the Twelve Apostles is introduced into the
picture in an unexpected way. Eight of them are sitting at
two tables set together at right angles and four have risen
from their stools to kneel in front. Among them is Judas
who is marked by a dark halo about his head. The faces of
those seated can be seen in full, including the standing
Christ who fits into the line of their heads. The presence
of the Virgin is unusual. The open door gives onto a
courtyard with a well. The windows reflect the real view
through the cell window onto the cloister opposite.

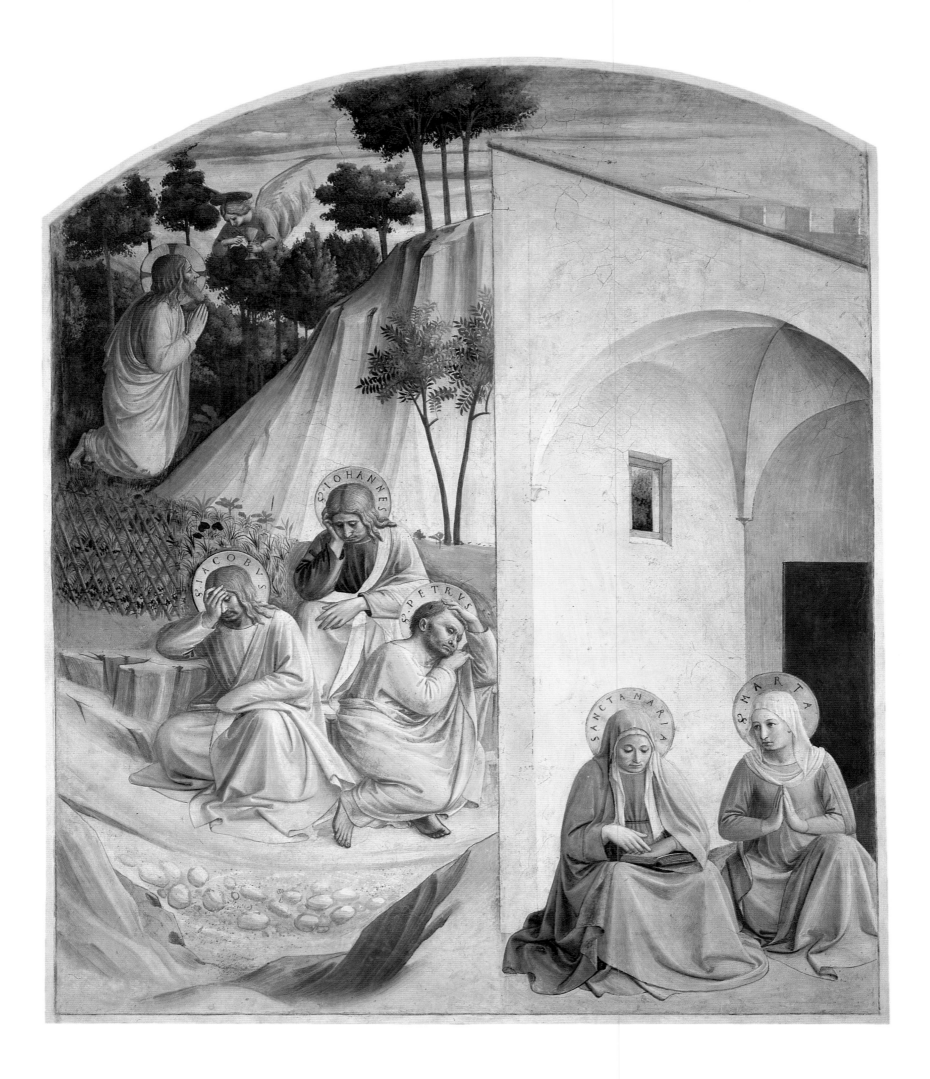

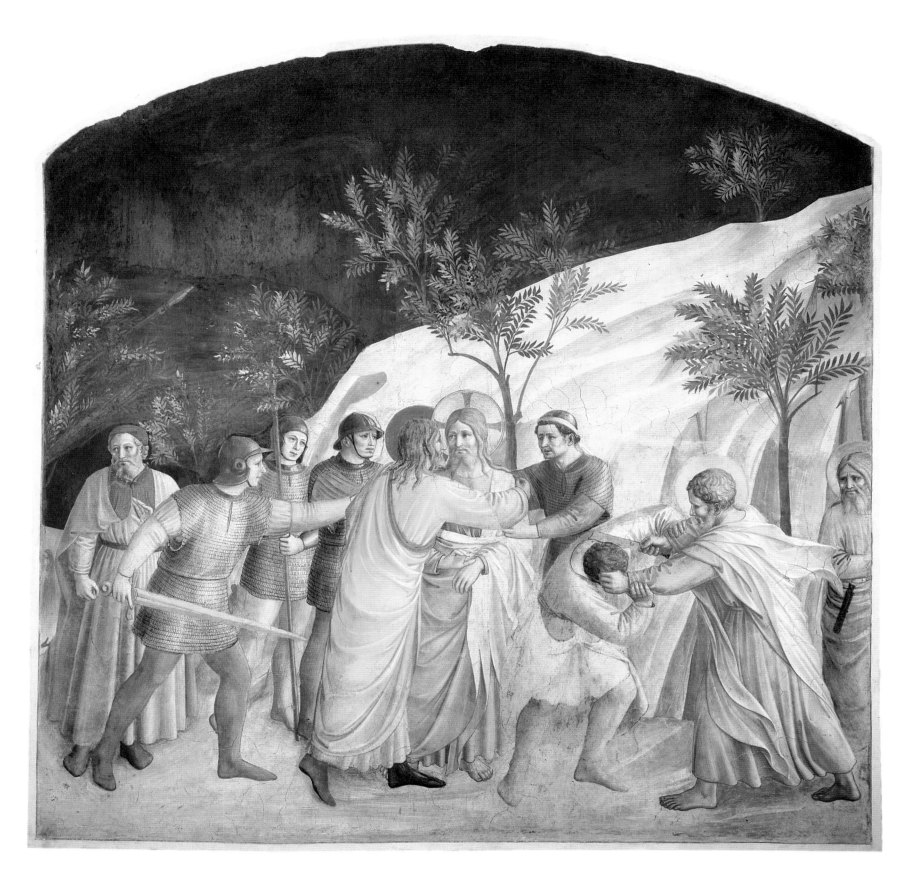

102 (opposite) *Agony in the Garden*, ca. 1450
Fresco, 177 x 147 cm
Museo di San Marco, cell 34, Florence

Smaller scenes within the picture, such as the Apostles sleeping
at the foot of the Mount of Olives, the two Marys praying,
unusual in the iconography of this scene, and Martha or Mary
Magdalene, whose house takes up half the picture, leave Christ
and the angel in the background. The colorfulness and volume
of the figures suggest Benozzo Gozzoli's hand.

103 (above) *Arrest of Christ*, ca. 1450
Fresco, 182 x 181 cm
Museo di San Marco, cell 33, Florence

Judas is characterized by a dark halo as in the *Institution of the
Eucharist* (ill. 101). When he kisses Christ, the soldiers seize
him. Their faces show more pity than violence. Peter cuts off
Malchus' ear. He is dressed as in the *Agony in the Garden* scene
(ill. 102). Movement is shown in the clothes, caught by the

wind, and the way Malchus has hold of Peter as he tries to fend
him off. On the left, a figure with his left hand raised, who is
probably the High Priest, is looking out beyond the picture. At
the edge, there is a torch and a lance which are only partly
visible as if the fresco were originally wider.

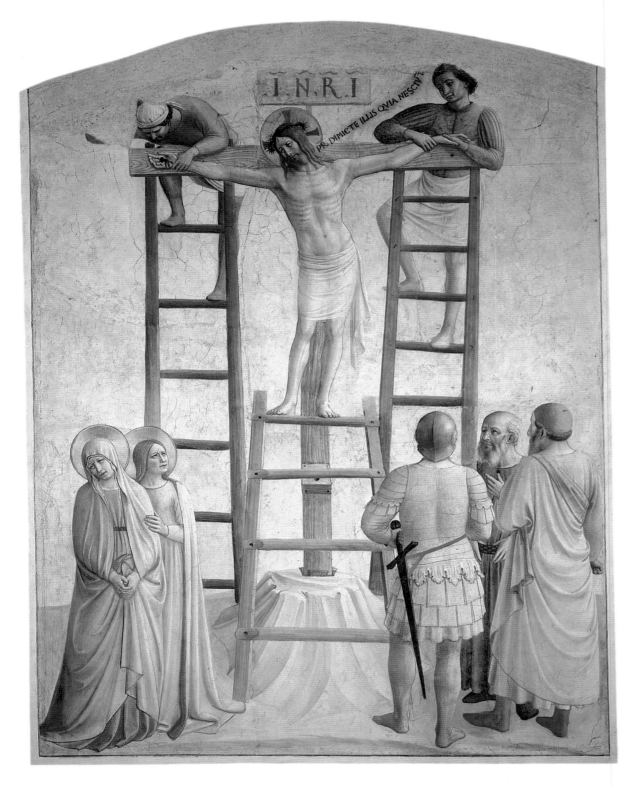

104 (left) *Christ being Nailed to the Cross*, ca. 1450
Fresco, 169 x 134 cm
Museo di San Marco, cell 36, Florence

It is rare in monumental cycles of the Passion to show Christ being nailed to the cross. It is especially unusual for the cross to be already in place. Mention of it is made in texts like the prayer from the Book of Hours of the "Lamentationes beatae virginis". Christ's head is inclined towards his mother who here is supported by Martha. The beautiful figure shown in rear view of the soldier in leather armor has an almost exact counterpart in a figure in the Niccolina frescoes in the Vatican (ill. 115). This is an important indication for the dating of the frescoes in the third corridor, which must therefore be after Fra Angelico's return from Rome.

105 (opposite) *Crucifixion with Thieves, Mary, St. John, St. Dominic and St. Thomas Aquinas*, ca 1450
Fresco, 233 x 183 cm
Museo di San Marco, cell 37, Florence

The spatial arrangement of cell 37 at the end of the north corridor differs from the other cells. The depiction is a repetition of the scene with Christ and the thieves in the large *Crucifixion* in the chapterhouse (ill. 85), where Christ is depicted with his eyes already closed; in the *Crucifixion with Thieves, Mary, St. John, St. Dominic and St. Thomas Aquinas*, he is still speaking to the Good Thief. The words which promise that the thief, who is even distinguished by a halo, will be in paradise that day are written in mirror writing.
This painting was probably mainly carried out by Fra Angelico's workshop, and this is confirmed by the use of models: in the picture, St. Cosmas is standing in a position normally adopted by St. John; St. Thomas Aquinas is similar to St. Dominic depicted on the ground floor, right down to the folds of the habit which falls right onto the ground.

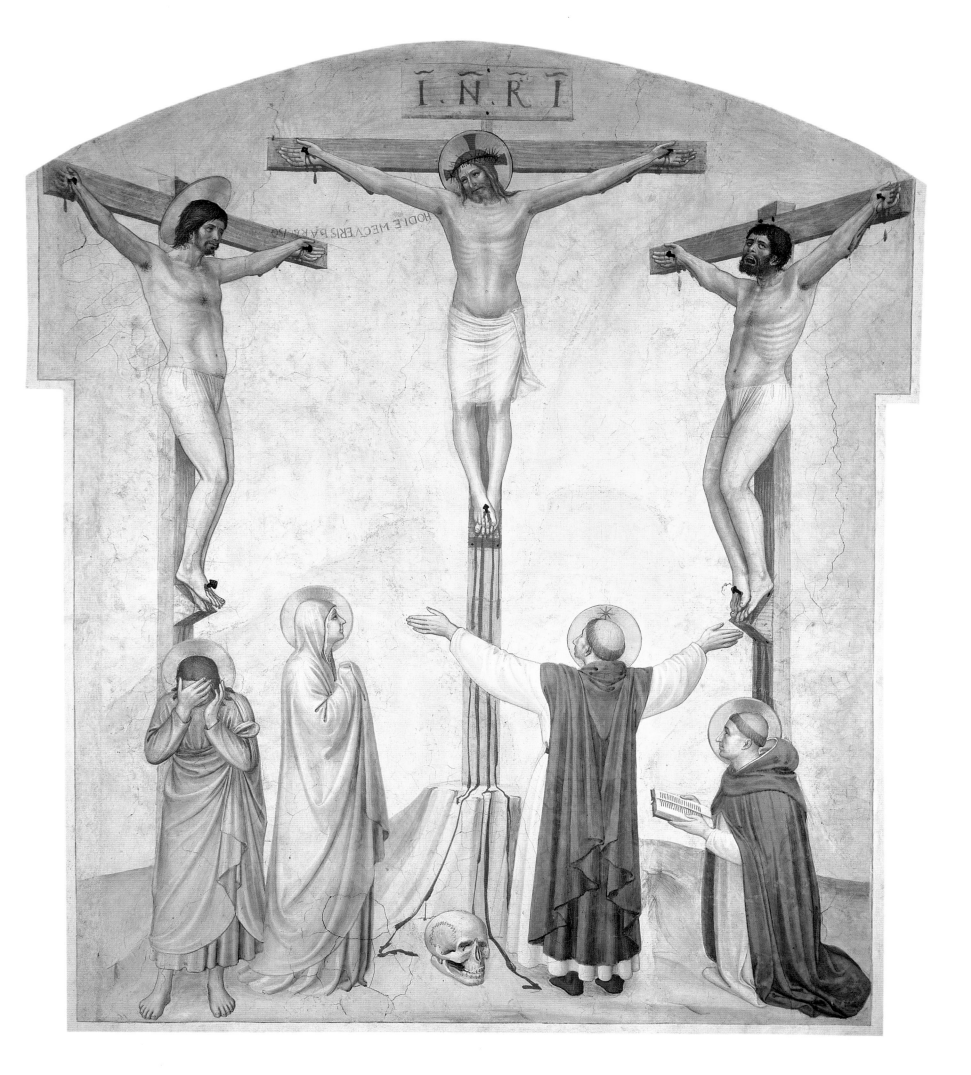

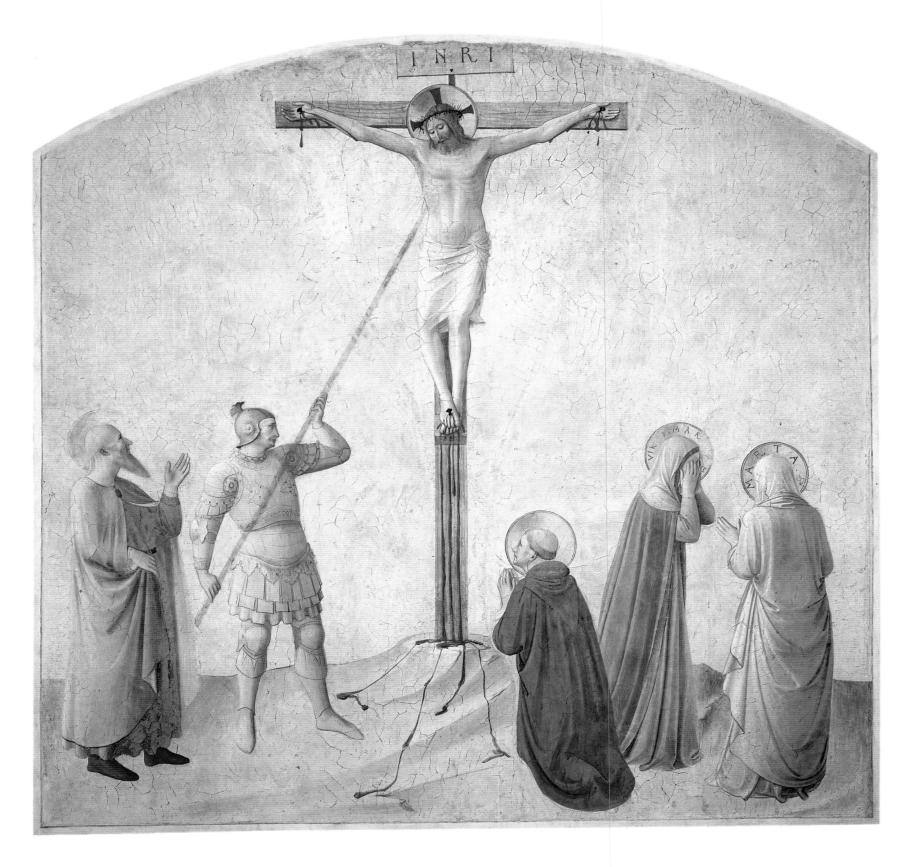

106 *St. Dominic with the Crucifix – the Piercing of Christ's side,*
ca. 1450
Fresco, 196 x 199 cm
Museo di San Marco, cell 42, Florence

The Crucifixion with St. Dominic as an observer has many
variations in the cell decorations. This is one which portrays an
event from the gospels and has a most impressive design. St.
Mark, possibly, is looking up at the cross from the left. The
Virgin turns away from the Crucifixion of Christ, overcome
with anguish. Martha is hurrying towards her full of concern,
which is the reason that her back is turned to the onlooker.

107 (opposite) *Christ in Limbo*, ca. 1450
Fresco, 183 x 166 cm
Museo di San Marco, cell 31, Florence

According to legend this cell was occupied by St. Antoninus, the
Prior of Fiesole and San Marco, and Bishop of Florence from
1446, who was probably instrumental in the development of the
programme of the frescoes. Even if Fra Angelico is not
responsible for the execution, the design is delightful because of
its use of light. Countless haloes shine out from the dark depths
of Hell, but the real light emanates from the figure of Christ
who glides in on clouds. The demons hide in fear in the clefts of
the rocks.

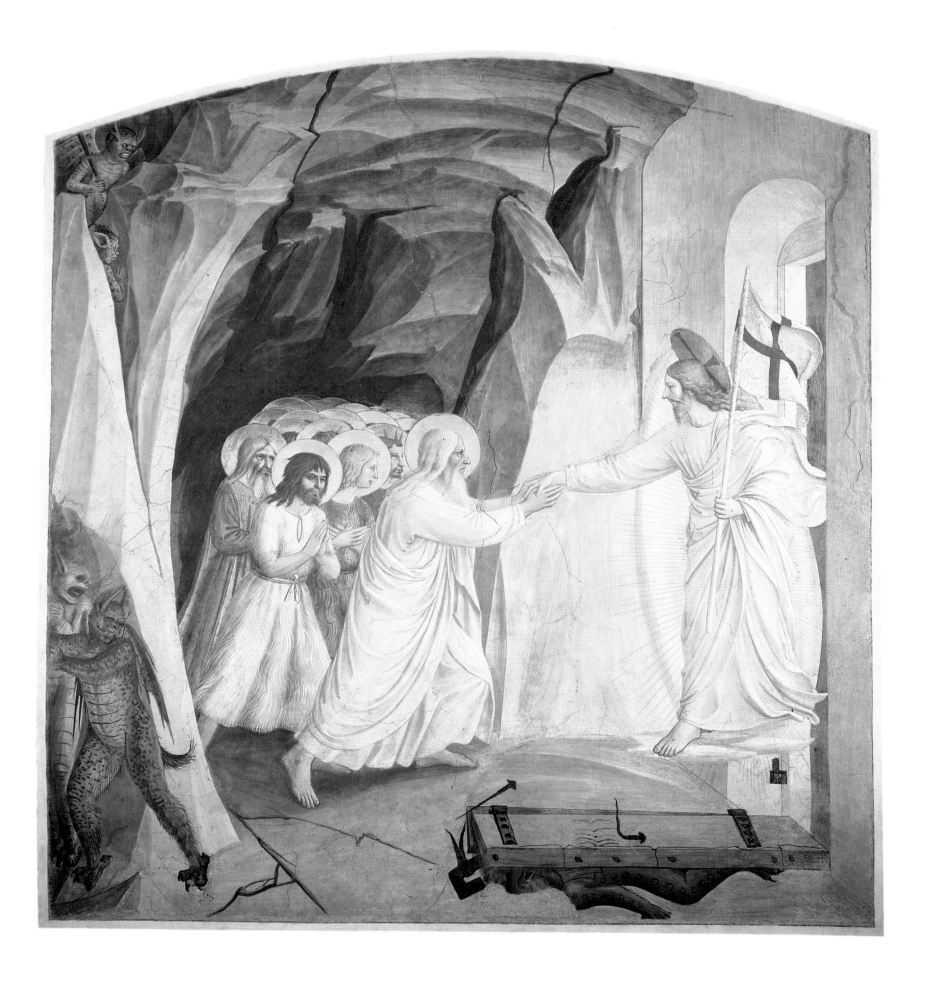

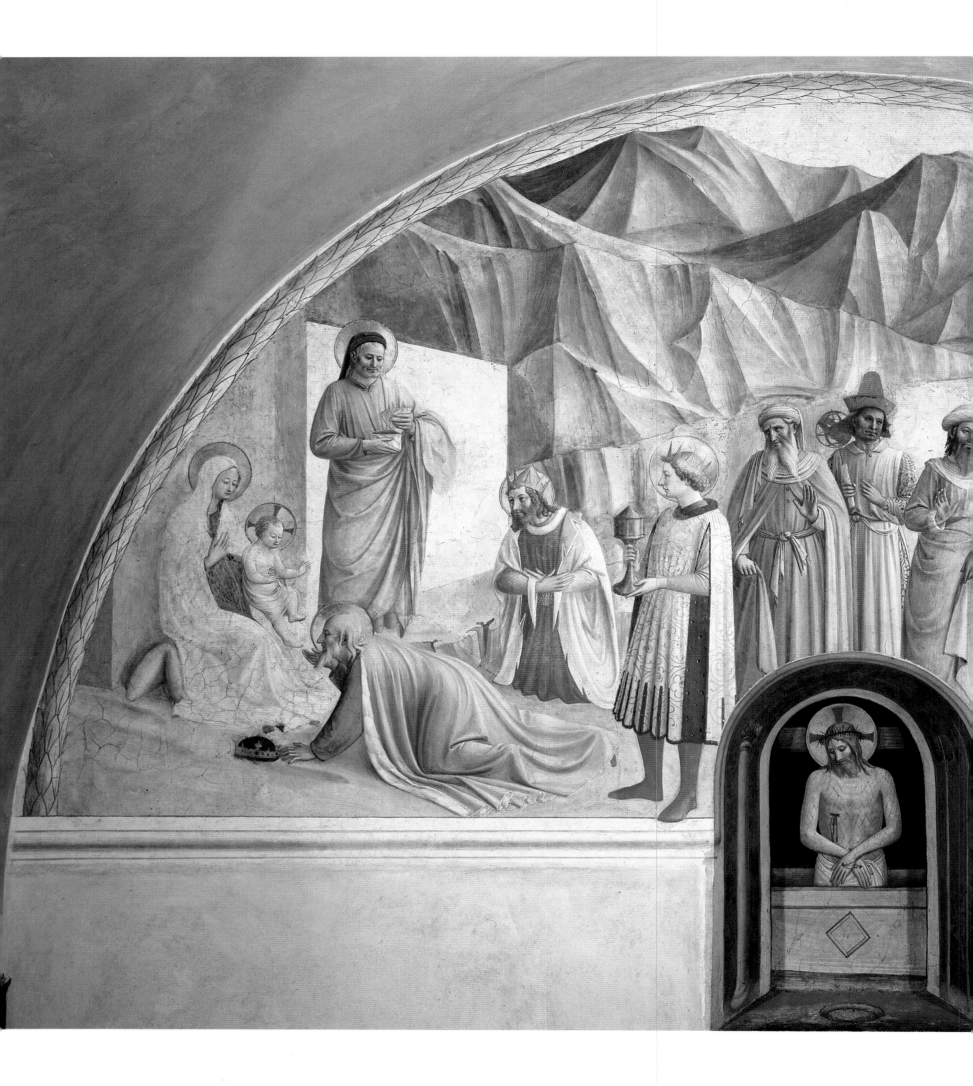

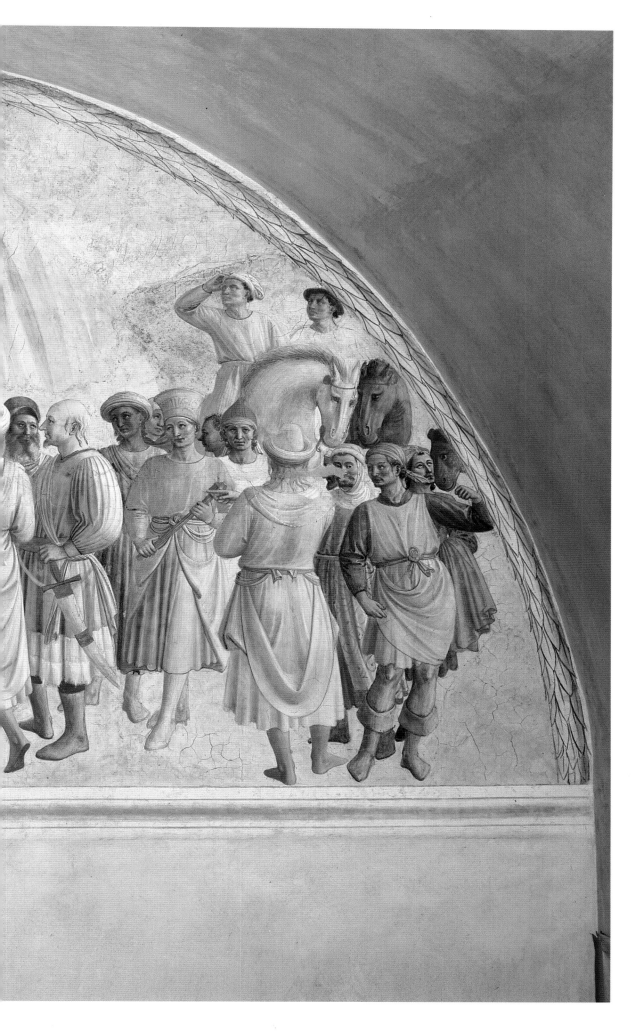

108 *Adoration of the Magi*, ca. 1450
Fresco, 175 x 357 cm and 86 x 60 cm (tabernacle)
Museo di San Marco, cell 39, Florence

This room which is reached through an antechamber was
intended for Cosimo de' Medici. The size of the room
and the subject of the painting are marks of respect for
him, the patron. He, too, is paying homage to Jesus with
the Three Wise Men from the East. The Virgin is sitting
on the saddle of an ass; the bare stable wall is strangely
touching. The magnificence of the procession has led art
historians to the conclusion that the hand of Benozzo
Gozzoli was at work on this fresco.

CAPPELLA NICCOLINA FOR NICHOLAS V

Soon after his election Pope Nicholas V commissioned Fra Angelico to decorate the chapel dedicated to the Archdeacons Lawrence and Stephen. After the Schism, the Roman papacy began to regain its power. Nicholas V identified himself by these frescoes, with the early Popes who survived divisions within the Church and were often persecuted. Fra Angelico probably painted these frescoes with the help of studio assistants from San Marco.

Pope Eugenius IV knew Fra Angelico from his sojourn in Florence which lasted many years. The Pope was present at the consecration of the church and stayed at the convent of San Marco. It is not surprising then, that he summoned Fra Angelico to Rome in 1445. In the time of his successor Nicholas V, who was Pope from 1447, there is mention in the records of the decoration of a private chapel in the Vatican dedicated to St. Stephen and St. Lawrence. Fra Angelico was to start work in Orvieto (ill. 10) during the summer months when the papal court moved to the Alban hills. In 1449 the artist was ready to decorate a study for the Pope, so at this point the Niccolina frescoes, the only remaining Roman work, must have been finished.

Unlike the San Marco frescoes, which were designed for devotional purposes for the friars, these works in the Vatican portray narrative scenes from the lives of the Archdeacons of Rome and Jerusalem, St. Stephen and St. Lawrence. As he had done before in the smaller narrative predellas, Fra Angelico turned his artistry to the decorative portrayal here of large, detailed, historically accurate, narrative scenes.

On the ceiling there are portraits of the *Four Evangelists* (ill. 109), the lunettes depict three episodes from the life of St. Stephen, the rectangular frescoes illustrate stories about St. Lawrence, and on the lateral walls there are eight full length figures of Fathers of the Church in painted niches, in pairs, one above the other. Beneath the frescoes there was a painted textile design. The altar wall had no frescoes but there was an altarpiece by Fra Angelico of the Deposition that has since disappeared.

The subjects of the frescoes were important events in the Lives of the Saints, namely their ordination, distribution of alms and their condemnation and martyrdom, which are depicted in parallel scenes. In the *Ordination of St. Stephen by St. Peter* (ill. 110), Fra Angelico uses the device of an interior space without a roof so that the contiguous scene is not too starkly divided from it, as it had been in the Perugia predella (ill. 38). But the architectonic structure is not clarified; the eye moves from the outside scene to the inside alternately, and comes to rest on the left, in the ecclesiastical setting which is flooded with light. Even if the execution is not completely successful, the impetus for its attempt must have come from the inspiring atmosphere of the papal court. The *Distributing of Alms* shows Stephen on the church steps (ill. 110), which follow through from the previous scene. The poor carry flasks and bags or a stick and hat, the emblems of the pilgrim.

Fra Angelico's artistry seems not to have been well adapted to painting large spaces. The scene of *St. Stephen Preaching* (ill. 111) is surrounded by a high palace, which nonetheless is much too small in relation to the figures. As in the scene of *St. Peter Preaching* in the *Linaiuoli Tabernacle* (ill. 27), women are sitting attentively at his feet. In the Tabernacle scene the artist displayed varying hairstyles and head-dresses on the figures but he opts for a simple veil in the Vatican fresco. Each face is reacting differently to the sermon. In *St. Stephen Addressing the Council*, the artist uses the traditional device of enclosing the scene through the creation of a cell-like room with a highly ornate pilaster.

The division of the picture between the *Expulsion* and the *Stoning of St. Stephen* (ill. 112) is very successful. The city wall, which, stretching into the distance, ends on the frontal plane of the picture, is rounded off with columns and a balcony above. It permits the division between the city and the open country where his tormentors are leading the condemned Saint Stephen. The Saint is shown here in full face whereas in the other frescoes he is shown only in profile.

The design and execution of the Lawrence frescoes in the lower rectangles are more impressive, partly because they are easier to observe. The *Ordination of St. Lawrence by St. Sixtus* (ill. 113) between the chapel windows shows a view into a low basilica with columns. The two main figures, Sixtus and Lawrence, are not placed centrally in the architecture; the altar is on their left. The priests surrounding them, however, create a convincing area of action. The light comes from the left, and subtly graded shadows are introduced which can be observed particularly well in the priest holding the cloth. The side of his head is in full light while his face falls into shadow. Pope Sixtus with his jewelled tiara has the features of Nicholas V, as he does also in the next scene.

St. Lawrence Receiving the Treasures of the Church

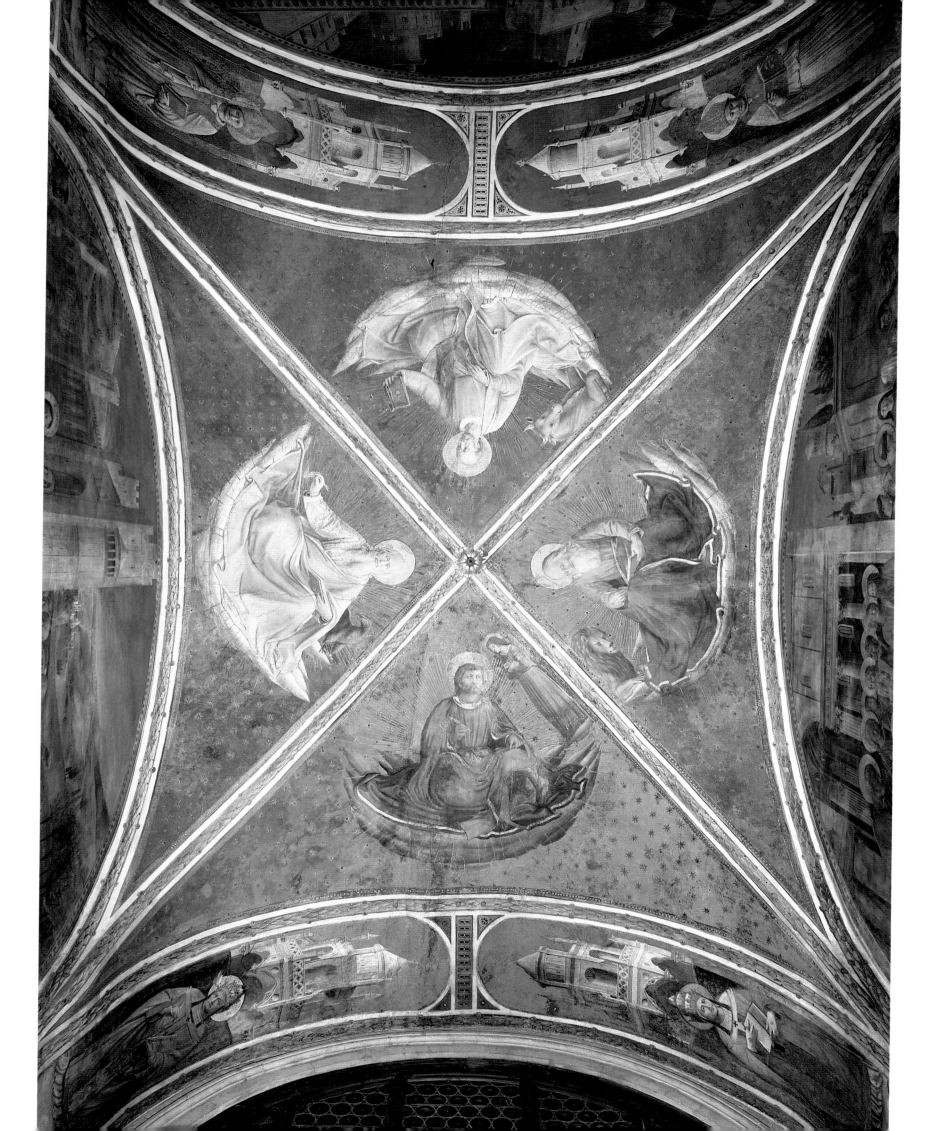

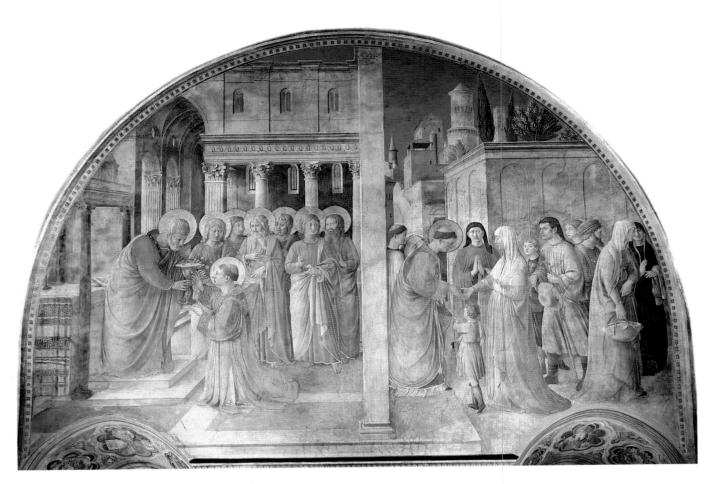

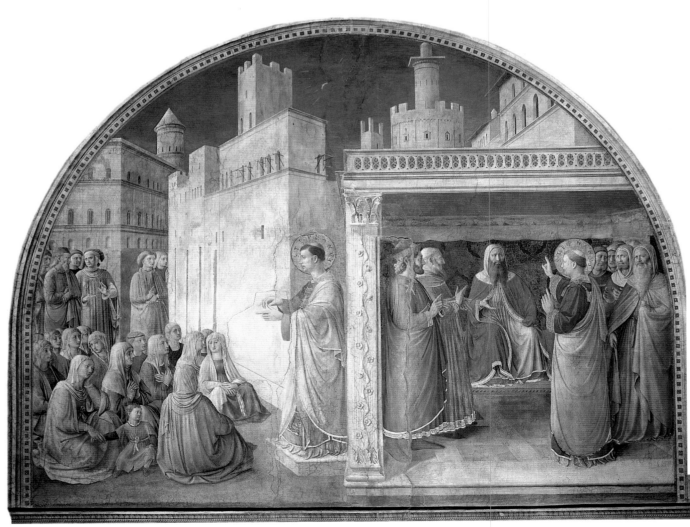

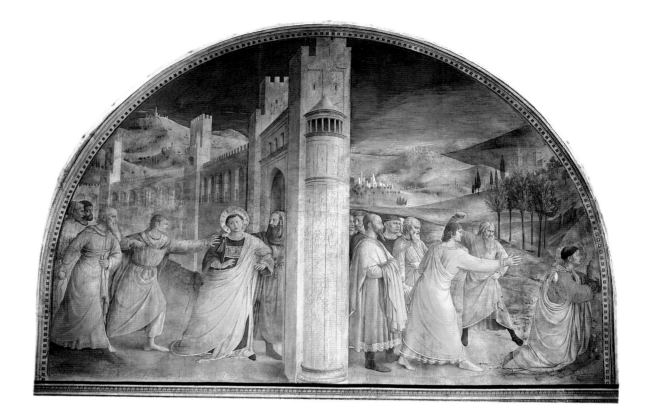

from St. Sixtus has a division between indoors and out
(ill. 114). The soldiers shown in rear view with their
colorful leather armour are trying to break down the
door from outside in the street while the priest under
the arch is looking round at the noise. There is a strange
contrast between the massive columns on the left and
the slender ones in the middle distance; the view into
the cloister with its tall cypresses allows the introduction
of varying shades of brightness into the picture.

For narrative reasons this next scene (ill. 116) is not
connected to the one before, since this is a church scene
as well: the two scenes are sharply divided by a line down
the middle. The interplay of architecture and figures is
particularly successful in the *Distributing of Alms* by
Saint Lawrence, which is a central composition in front
of a church. The view through a square door into the
church catches Lawrence in such a way that the Choir
seems like a niche surrounding him. Light is caught
between the columns, which stand close together,
providing a strong focus on the holy deacon. It is
different from the same episode in the life of Stephen
(ill. 110), where passers-by seem to have come upon the
alms by chance. Here they are truly needy – mothers,
children, cripples. The blind man on the right in the
foreground is particularly striking.

Fra Angelico used architectural motifs from other
pictures in the scenes with *St. Lawrence before Valerianus
and the Martyrdom of St. Lawrence* (ill. 115). The wall
with its brocade curtain and niche comes from the
Annalena Altarpiece (ill. 39) and the background with
its pots of flowers seen from below, and trees towering
above, affords an idea of how the upper part of the
altarpiece must have looked originally.

Lawrence refuses to sacrifice to pagan gods even in the
face of the instruments of torture at which the Emperor
Valerian with his laurel wreath is pointing. Two figures
are seen from behind frame the scene on the right, while
the young man looking out of the picture leads the eye
to the cell with the scene of the conversion of the jailer
(ill. 115). The fresco of the *Martydom of St. Lawrence*
who, as legend has it, asked to be turned over while being
roasted because he was already cooked on one side, is
unfortunately badly damaged.

The frescoes for the Niccolina transform convincing
narratives from early Christianity into a pictorial
arrangement in perfect perspective. Fra Angelico's wall
paintings are a successful attempt to link narrative
pictures compositionally, as he had done in the narrative
predella scenes. His ability to adapt to the challenges
that this important commission set is quite evident. He
weighed artistic considerations when deciding on the
historical accuracy of clothing in the pictures, above all
in the architecture, where his choices were based on the
remnants from Antiquity all around him in Rome, and
the architecture of his own time.

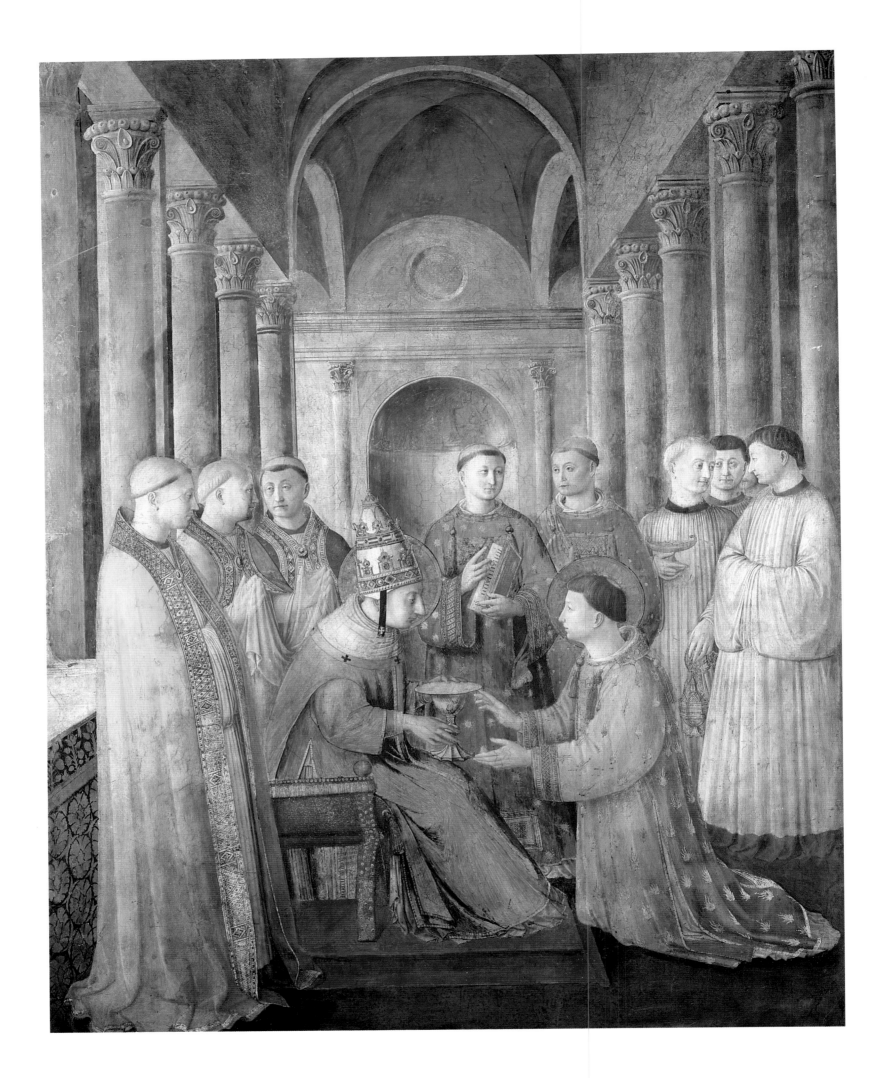

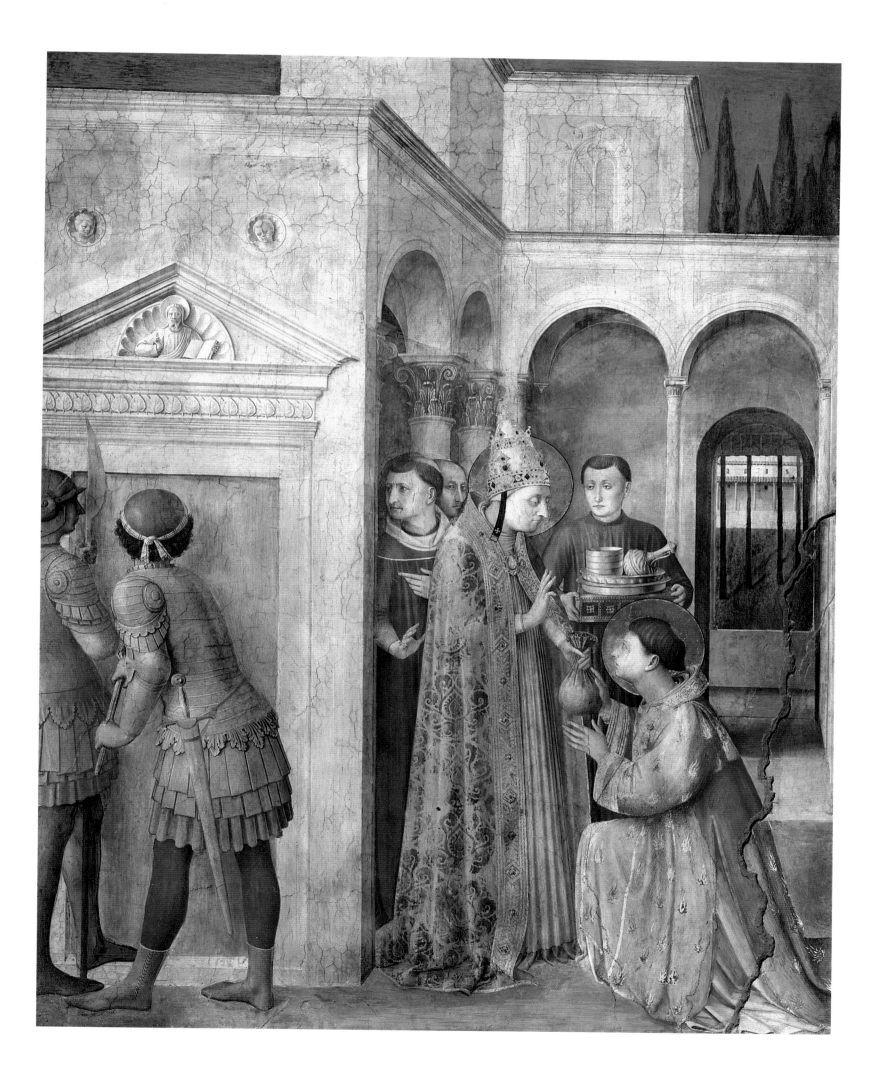

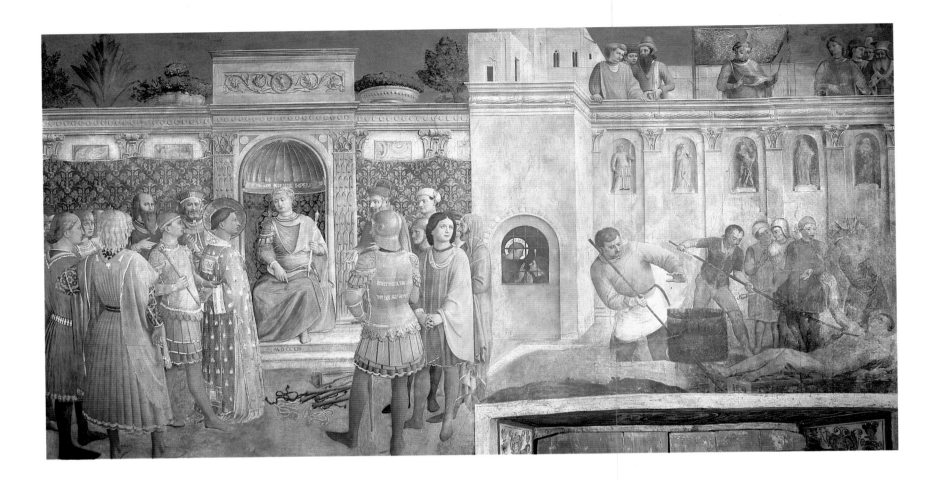

113 (previous double page, left) *Ordination of St. Lawrence by St. Sixtus*, 1447–1449
Fresco, 271 x 197 cm
Vaticano, Cappella Niccolina, Rome

There was room only for the *Ordination of St. Lawrence by St. Sixtus* between the chapel windows, under the fresco of the *Ordination of St. Stephen and his Distributing of Alms*. It takes place in a basilica with Corinthian columns. Stephen's ordination took place much earlier so the clothing in that fresco is not historically accurate. The clerics around Sixtus II in the later scene are wearing liturgical vestments and are tonsured. The figure of the Pope has the features of Nicholas V, the patron. This portrait set the precedent for immortalizing the incumbent Pope in contemporary Vatican frescoes.

114 (previous double page, right) *St. Lawrence Receiving the Treasures of the Church from St. Sixtus*, 1447–1449
Fresco, 271 x 205 cm
Vaticano, Cappella Niccolina, Rome

Fra Angelico decided here against a design connecting the two scenes of *St. Lawrence Receiving the Treasures of the Church from St. Sixtus* and the *Distributing of Alms* (ill. 116). Instead they are separated by a colored line. The complex setting for the action is a convent with a glimpse of the cloister as a backdrop. The church door is so small that the soldiers trying to break in have to bend down to fit into the entrance.

115 (above) *St. Lawrence before Valerianus and Martyrdom of St. Lawrence*, 1447–1449
Fresco, 271 x 473 cm
Vaticano, Cappella Niccolina, Rome

The scenes are differentiated only by the colors in the architecture though the smaller figures in the second scene are intended to imply a greater distance from the onlooker. Fra Angelico took care to indicate accurate historical detail in this fresco. There is an inscription with the date CCLIII on the step below Valerian's niche. The two scenes are hinged by a third scene which takes place centrally, through the round hole in the wall. The long drawn-out martyrdom finally ends with the roasting on the grille, which is again linked to the conversion of the jailer.

116 (opposite) *Distributing of Alms*, 1447–1449
Fresco, 271 x 205 cm
Vaticano, Cappella Niccolina, Rome

The church architecture with its central view in to the apse serves only as a background for the *Distributing of Alms* which takes place in front of the church. Lawrence, again in his ceremonial vestments, distributes money from the bag he received in the previous scene (ill. 114). The poor have individual features; the neediness on the faces of the old, sick and of the mothers is made clear and life-like. The sight of the two children sharing their gift is very touching.

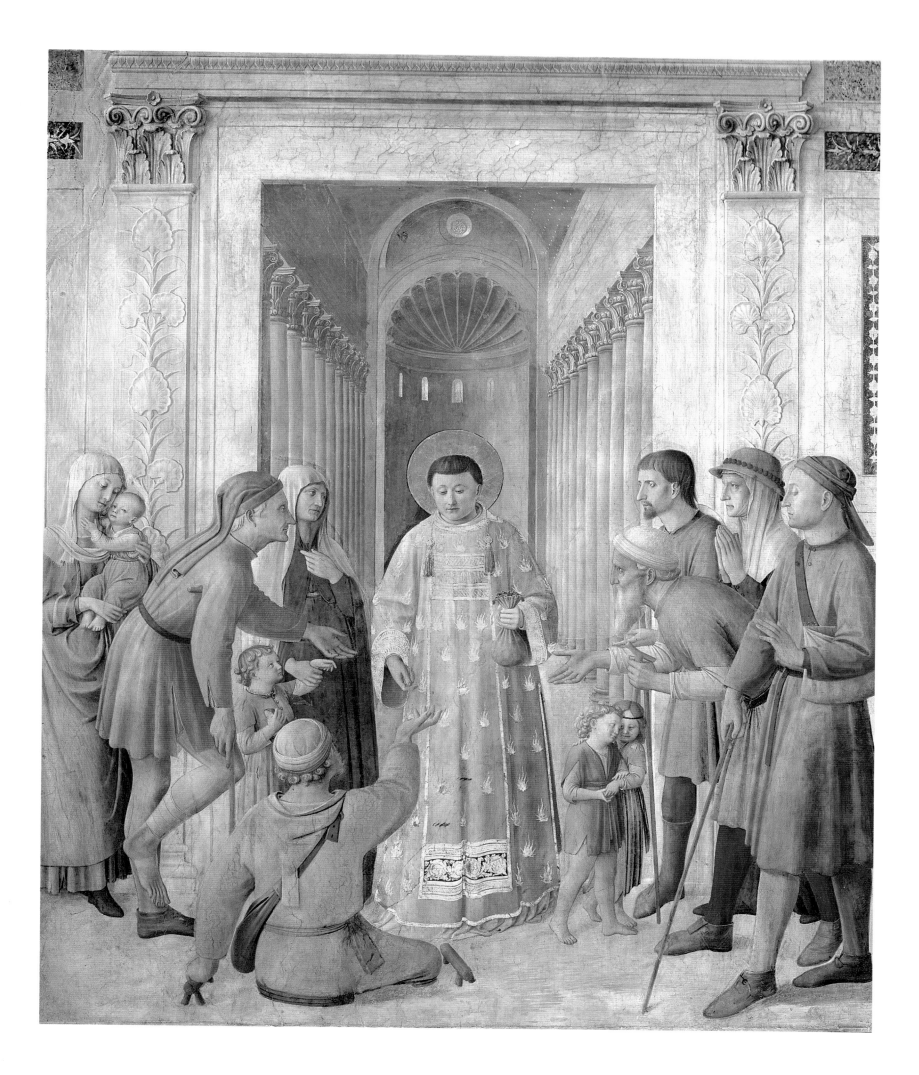

THE ARMADIO DEGLI ARGENTI: NARRATION IN MINIATURE

The original construction of the silver cabinet for
Santissima Annunziata in Florence – the *Armadio degli
Argenti* –, probably commissioned by Piero de' Medici
in 1448, can only be guessed at now. When it was first
planned, two doors which opened outwards were to be
decorated by Fra Angelico, and payment was made for
this in 1453. In 1461–1463, though, the doors were
made into a single shutter to be drawn upwards. The
panels were probably painted at the same time as the
frescoes in the north corridor in San Marco (ills.
100–108) after Fra Angelico returned from Rome, so
it is debatable whether he was responsible for their
creation. Three of the panels differ from the others and
were carried out by Alesso Baldovinetti. Fra Angelico
himself would have accepted the commission, but as
always, in undertakings involving so much work, studio
assistants would have been entrusted with it.

The story of the life of Christ is portrayed between
Ezekiel's Vision of the Mystic Wheel (ill. 118) and the
Coronation of the Virgin and Lex Amoris (ill. 133). These,
the last known panel paintings by Fra Angelico, reveal
once more the great variety of his artistic talents and give
the viewer the same pleasure as his early works, especially
the small predella scenes. In the little panels of the silver
cabinet also, the artist takes the opportunity to conjure
up scenes linked to a particular place and a narrative
climax.

The *Annunciation* (ill. 119) has a composition which,
unusually for Fra Angelico, plays with symmetry. The
Nativity (ill. 120) is comparable with the fresco in cell
5 in San Marco (ill. 121). Each of the paintings was
carried out by a different assistant. The same design is
used in the much smaller panel of the silver cabinet to
bring to the fore the luminescent effects which are easier
to achieve in tempera. Christ, the Light of the World, is
encircled in brightness while the angels above the roof
kneel and pray in a circle around the light. Black, which
was only used in the frescoes in coloring the friars'
habits, is used here to contrast with paler colors and
enhance their luminescence. This can be seen both in
St. Joseph's hat and in the angel's black garments at the
top right.

The *Adoration of the Magi* (ill. 123) places the Virgin
in the center of the picture, but shows the middle King
kissing the Child's feet as in the predella scenes of the
Linaiuoli Triptych (ill. 27) and the Annunciation
predellas (ill. 66), while in San Marco (ill. 108) the
oldest King is paying homage. The explanatory scrolls
quote texts of varying length. Thus, in the case of the
Nativity (ill. 120), the passage from Isaiah has many
abbreviations.

In the case of panels depicting the childhood of
Christ, the artist has not thought in terms of landscape
or architectural links between individual scenes (ill.
117). Each picture reveals a new insight into the Bible
stories. In terms of color, too, each picture is given
an independent composition. In this context, the
Circumcision of Christ is particularly impressive. It
depicts the relevant architecture in blue and grey tones,
and ends in an apse flooded with light (ill. 122). The
Massacre of the Innocents is a rare attempt in Fra
Angelico's œuvre to present a dramatic depiction of
cruelty (ill. 124). In contrast to the soldiers marching
forward in their dark armor, the artist has painted the
group of women in lively colors – with light red and
vivid yellow predominating. In the scenes depicting the
Passion, the artist has sought to achieve maximum
consistency by painting in a very high horizon. This is
particularly well executed in the *Agony in the Garden* (ill.
125) and the *Betrayal with a Kiss* (ill.126).

A detailed cycle of pictures tells the story of the
Passion, which is certainly based on Fra Angelico's
own design like the *Mockery of Christ* in the San Marco
fresco (ill. 90). Unlike the cell frescoes, here in the
cabinet panels it is the portrayal of action that is more
important, as are the details relating to place. In the
Lamentation over the Dead Christ (ill. 129), there is a
view of Jerusalem in the distance through the fence
which separates the garden from the landscape. The
stone of the tomb is leaning up against it. In the Easter
Sunday picture of Three Marys at the Sepulchre (the
Resurrection), the stone will be placed in the grass (ill.
130). Christ is laid out on the shroud used when he was
taken down from the cross; either Nicodemus or Joseph
of Arimathia is holding the winding sheet ready to wrap
the body in.

The *Last Judgement* fills two panels because of the
importance of the subject and the impossibility of fitting

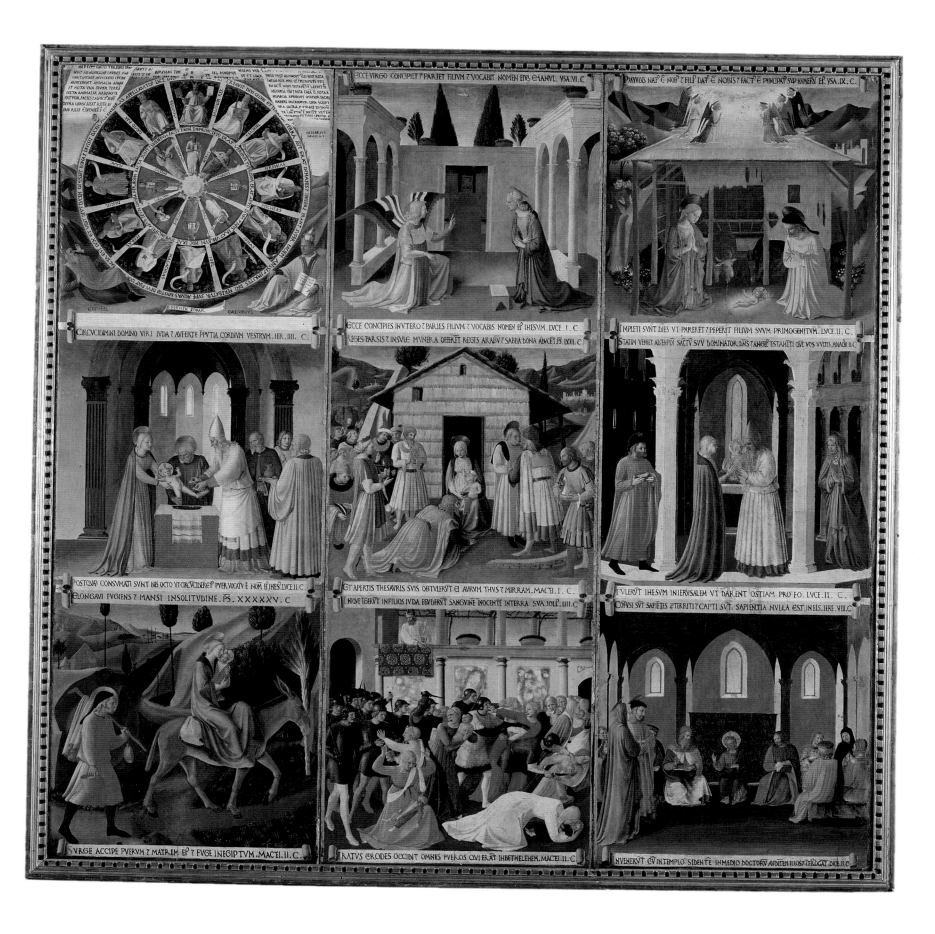

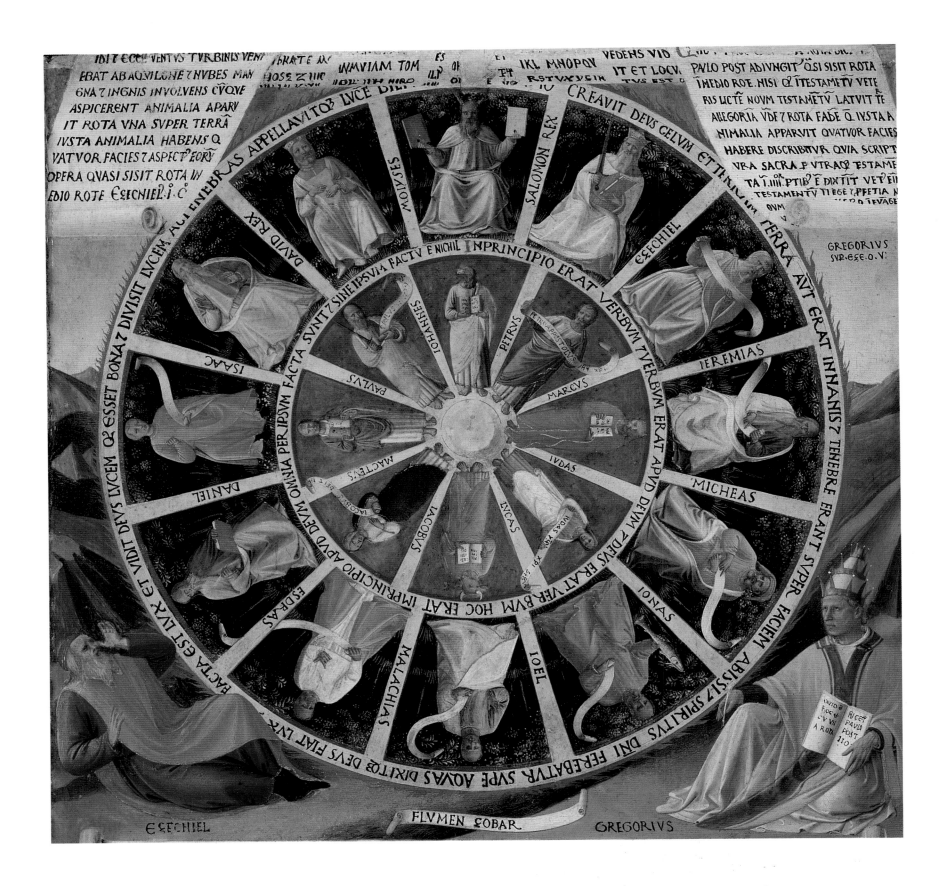

118 (above) *Armadio degli Argenti: Ezekiel's Vision of the Mystic Wheel* (detail ill. 117), ca. 1450
Tempera on panel, 38.5 x 37 cm
Museo di San Marco, Florence

The allegorical portrait begins with *Ezekiel's Vision of the Mystic Wheel* in which the outer ring has portraits of prophets, and the inner ring those of the Evangelists and Saints Peter, Paul, James and Judas Thaddeus. At the tops of the panels are ribbons of text with quotations from the Old Testament and below, from the New Testament.

119 (opposite) *Armadio degli Argenti: Annunciation* (detail ill. 117), ca. 1450
Tempera on panel, 38.5 x 37 cm
Museo di San Marco, Florence

The design for the panel, playing with symmetry and perspective, as it does, is unusual for Fra Angelico but it is a successful achievement. Behind each figure there is a deeply receding arcade. A garden can be seen through a central opening in which there are two palm trees and two cypresses flanking the central axis.

ECCE VIRGO CONCIPIET 7 PARIET FILIVM 7 VOCABIT NOMEN EIVS EMANVL. YSA.VI.C

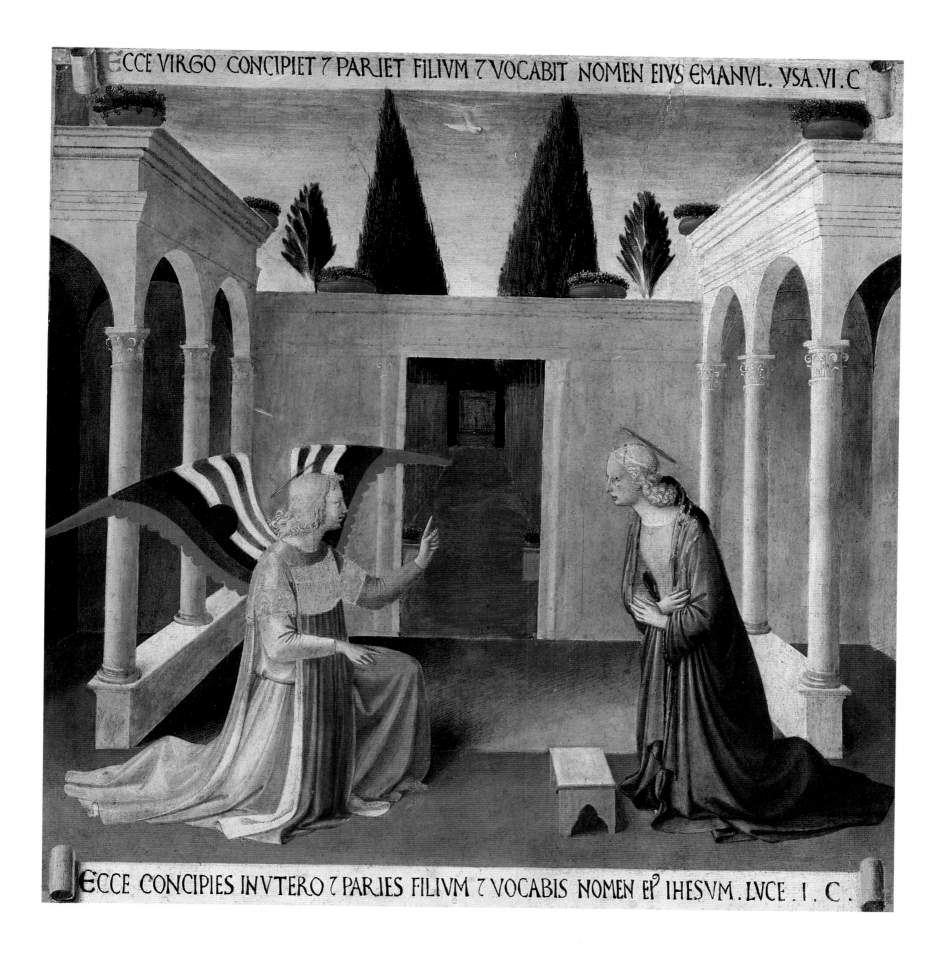

ECCE CONCIPIES INVTERO 7 PARIES FILIVM 7 VOCABIS NOMEN EI' IHESVM. LVCE . I . C .

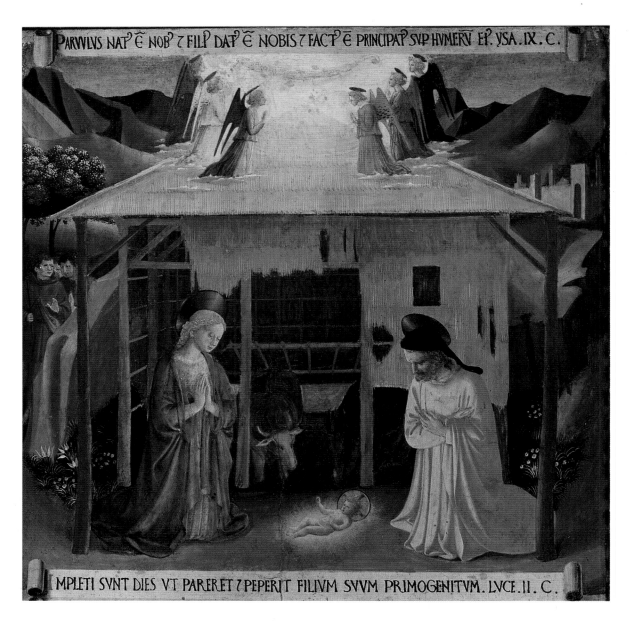

PARVVLVS NAT⁹ Ē NOB⁹ Z FILI⁹ DAT⁹ Ē NOBIS Z FACT⁹ Ē PRINCIPAT⁹ SVP HVMERV EI⁹ YSA .IX . C.

IMPLETI SVNT DIES VT PARERET Z PEPERIT FILIVM SVVM PRIMOGENITVM. LVCE . II . C.

120 (left) *Armadio degli Argenti: Nativity* (detail ill. 117), ca. 1450
Tempera on panel, 38.5 x 37 cm (panel)
Museo di San Marco, Florence

The doll-like Child is lying on the bare ground. Light radiates from him onto his parents and the ox in the dilapidated stable. The scene is cloaked in nocturnal gloom. The shepherds are approaching on the left, and the angels are kneeling on the roof round the light of the Star of Bethlehem. This motif is unusual for Fra Angelico and has been attributed to Benozzo Gozzoli by many experts.

the broad design into one square (ill. 132). Even so, the angels leading the Blessed into Paradise, and the scenes of Hell which appeared in the *Last Judgement* for Santa Maria degli Angeli (ill. 76), are left out.

The *Armadio degli Argenti* is to some extent the summing up of Fra Angelico's work. After the paintings in the Niccolina in the Vatican, where the narrative scenes had demanded pictorial intimations of time and place, Fra Angelico had changed his approach when painting the frescoes in San Marco. These quasi-didactic paintings allowed him to increase his artistry while drawing on the experience he had gained in Rome. The panels for the silver cabinet, with their pictures of the different stages of the life of Christ, provided

an opportunity to combine the two – a mystical expectation of salvation and a proper portrayal of detail. Together with the miniature work on the predellas, the panels of the *Armadio degli Argenti* offer an abundance of narrative and joyous life-like detail. The lyrical Madonna figures, the captivating angels and the intense piety of the cell pictures in San Marco may well be what stays most in our minds of the artist's work, but it must not be forgotten that he made remarkable attempts at portraying landscape, natural events, such as the storm at sea and the hail storm, and also emotive interior scenes. Fra Angelico stands out for us as both a pious Observant Dominican and a Renaissance artist with original talent.

121 (opposite) *Nativity*, ca. 1441
Fresco, 177 x 148 cm
Museo di San Marco, cell 5, Florence

There is no doubt that the execution of this fresco is not by Fra Angelico, but Benozzo Gozzoli's hand is not evident either. Little has been changed though of Fra Angelico's model for this scene. On the painting of the silver cabinet there are a few plants added, but the birth place is the same as this one in the cell fresco. Peter Martyr and Catherine of Siena are present at the adoration.

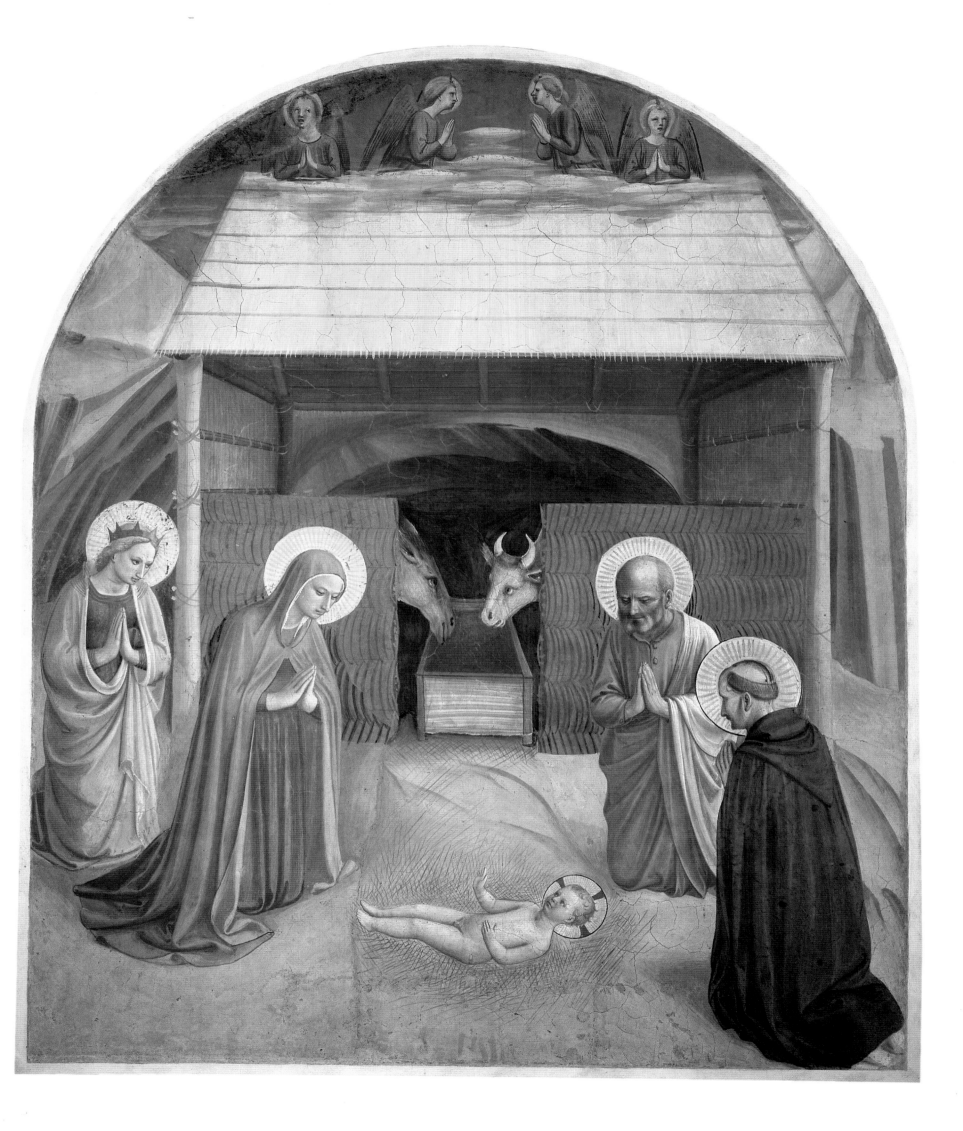

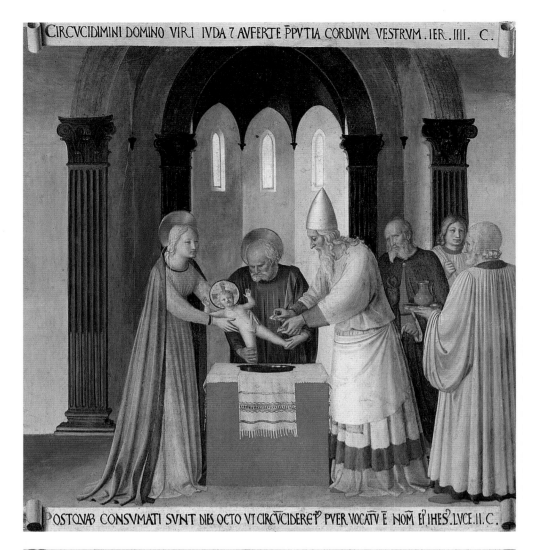

CIRCVCIDIMINI DOMINO VIRI IVDA 7 AVFERTE PPVTIA CORDIVM VESTRVM. IER. IIII. C.

POSTQVAB CONSVMATI SVNT DIES OCTO VT CIRCVCIDERET PVER VOCATV E NOM EI IHES. LVCE. II. C.

122 *Armadio degli Argenti: Circumcision* (detail ill. 117), ca. 1450
Tempera on panel, 38.5 x 37 cm
Museo di San Marco, Florence

The central view is of a Choir with two rood arches supported by blue pilasters with Corinthian capitals, a feature that would not be found in that period of architecture. The foreground is a separate stage where the circumcision is being performed. The Child's pose is almost like the Cross of St. Andrew.

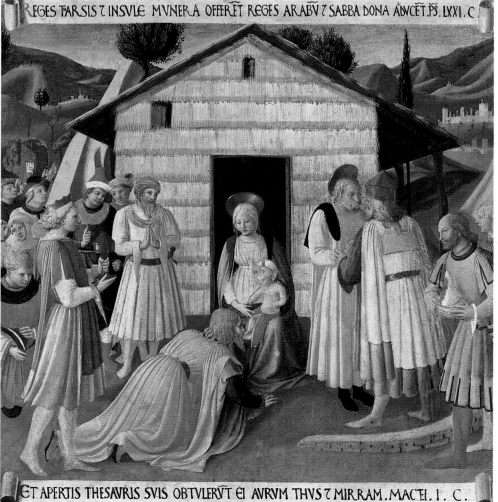

REGES TARSIS 7 INSVLE MVNERA OFFERET REGES ARABV 7 SABBA DONA ADVCET. PS. LXXI. C.

ET APERTIS THESAVRIS SVIS OBTVLERVT EI AVRVM THVS 7 MIRRAM. MACEI. I. C.

123 *Armadio degli Argenti: Adoration of the Magi* (detail ill. 117), ca. 1450
Tempera on panel, 38.5 x 37 cm
Museo di San Marco, Florence

The central composition is unusual for Fra Angelico. The darkness of the stable door behind the Virgin provides a background which recalls the cloths over the altarpiece thrones. Joseph's yellow robe and black hat are repeated on all the cabinet panels where he appears. The cap is lying over his shoulder here. The landscape is far off, which can be deduced from the small outlines of the buildings of the town that lies in the middle distance.

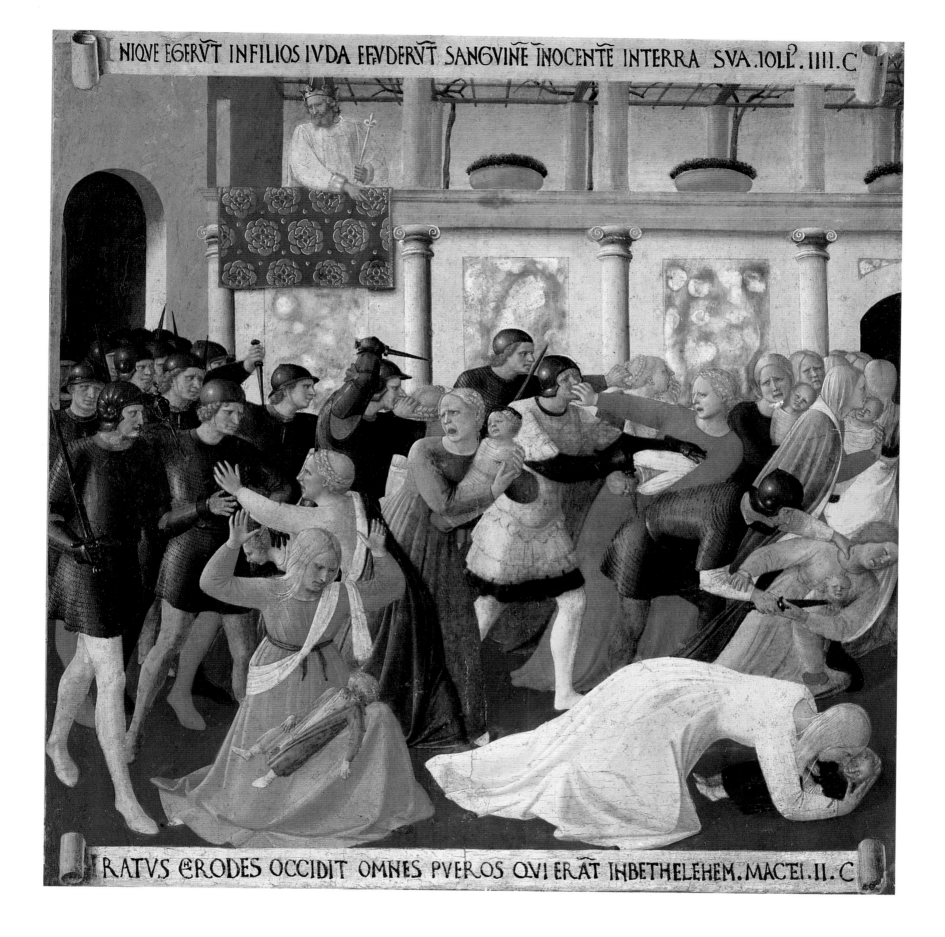

NIQVE EGERVT INFILIOS IVDA EFVDERVT SANGVINE INOCENTE INTERRA SVA.IOLL.IIII.C

RATVS ERODES OCCIDIT OMNES PVEROS QVI ERAT INBETHELEHEM.MACEI.II.C

124 *Armadio degli Argenti: The Massacre of the Innocents*
(detail ill. 117), ca. 1450
Tempera on panel, 38.5 x 37 cm
Museo di San Marco, Florence

The subject here demands the portrayal of violent
emotions and the murder of the children of Bethlehem is
set at a place that can be construed as Herod's palace. The
soldiers are rushing out of the gate to the slaughter, and
the women are fleeing with their children through
another gate on the right, so that the whole looks like a
procession. The mothers' faces are full of anguish and
grief, bereft of any lyrical element. The Feast of the Holy
Innocents is on 4 January, and the bare, leafless vines on
Herod's terrace can be taken as a mark of the season.

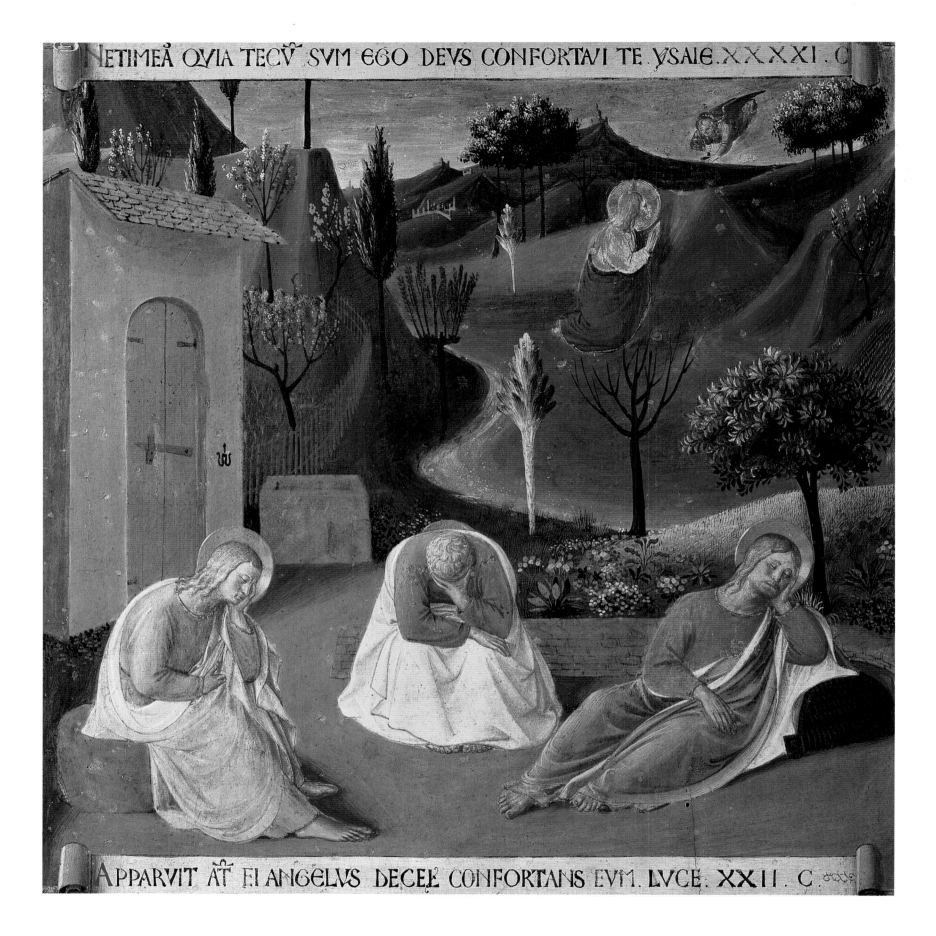

125 *Armadio degli Argenti: Agony in the Garden*
Tempera on panel, 38.5 x 37 cm
Museo di San Marco, Florence

In an enlightening variant on the fresco in San Marco, the
sleeping apostles appear, but not the women. Unusual
care for a painting of this kind was taken in the depiction
of the garden which, in keeping with Spring, the season of
Passiontide, has some trees in bloom and some not.

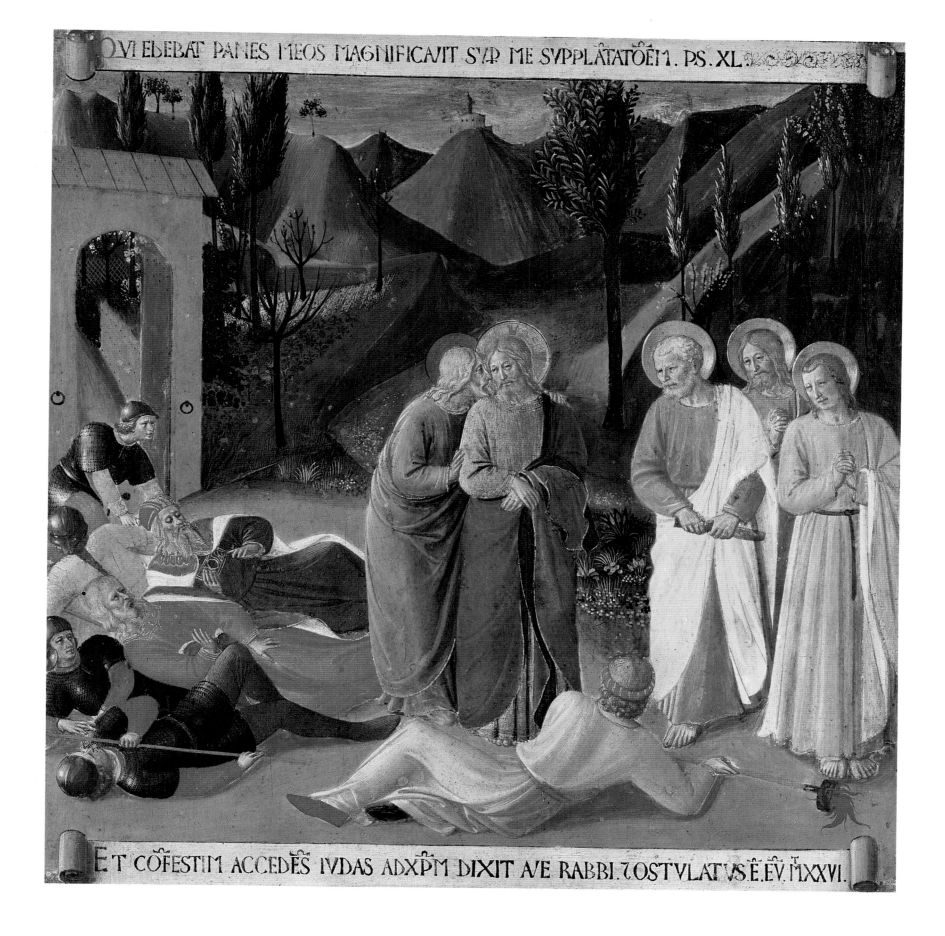

126 *Armadio degli Argenti: Betrayal with a Kiss*
Tempera on panel, 38.5 x 37 cm
Museo di San Marco, Florence

In a version similar to the *Agony in the Garden* only three apostles are present when Judas betrays Christ with a kiss. Judas is marked by a dark halo. As in the Gospel according to St. John, chapter 18, 3–6, the soldiers appear with torches and weapons, but fall down in worship before Christ when they come face to face. This gives the painter the opportunity to portray a figure lying prone in the foreground.

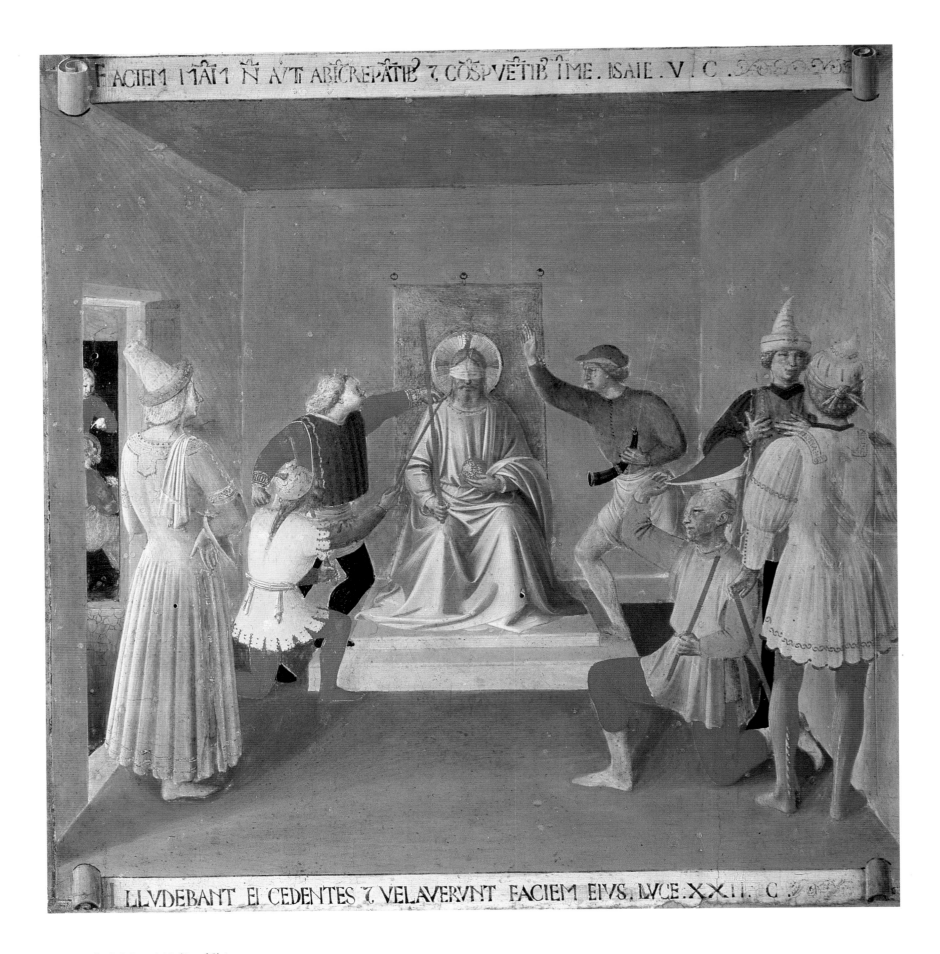

127 *Armadio degli Argenti: Mocking of Christ*
Tempera on panel, 38.5 x 37 cm
Museo di San Marco, Florence

This picture is like a narrative version of the fresco in
cell 7 in San Marco (ill. 90). Christ as the mocked ruler
sits in a room with a central perspective. The spitting
head and slapping hands belong to figures who are
involved in an active event.

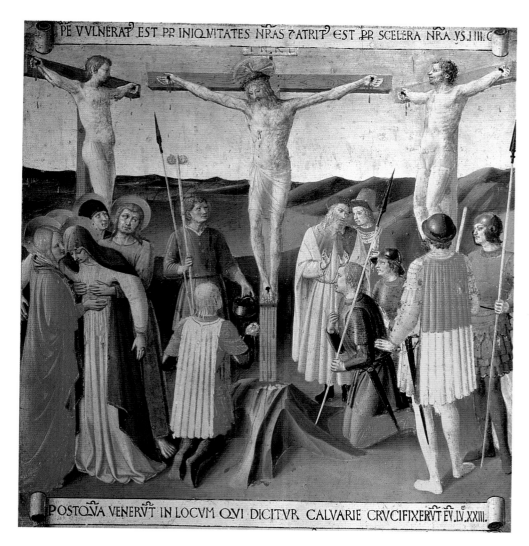

128 *Armadio degli Argenti: Crucifixion*
Tempera on panel, 38.5 x 37 cm
Museo di San Marco, Florence

The only known Crucifixion by Fra Angelico which illustrates the biblical narration does not show any specific landscape elements, but groups the participants in an extended area around the cross.

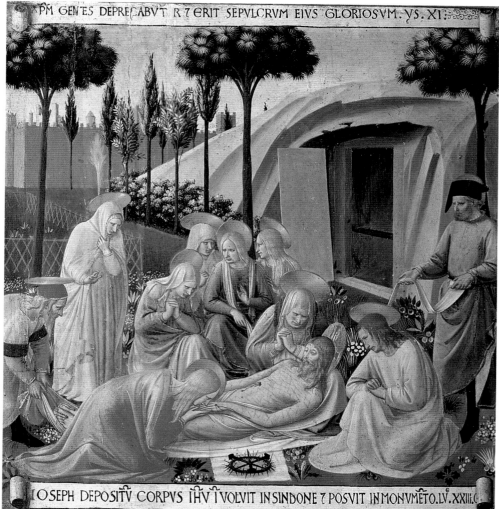

129 *Armadio degli Argenti: Lamentation over the Dead Christ*
Tempera on panel, 38.5 x 37 cm
Museo di San Marco, Florence

Christ is lying on the winding-sheet which has been laid out for Him. St. Mary Magdalene and St. John are close to Him, with the mourning women standing in the background. This results in a triangular composition with flanking figures. Joseph of Arimathia is holding Christ's shroud in his hand, just as is written in the Gospel text beneath. In the foreground center, the crown of thorns and the nails lying on a piece of cloth are also presented as important reliquaries.

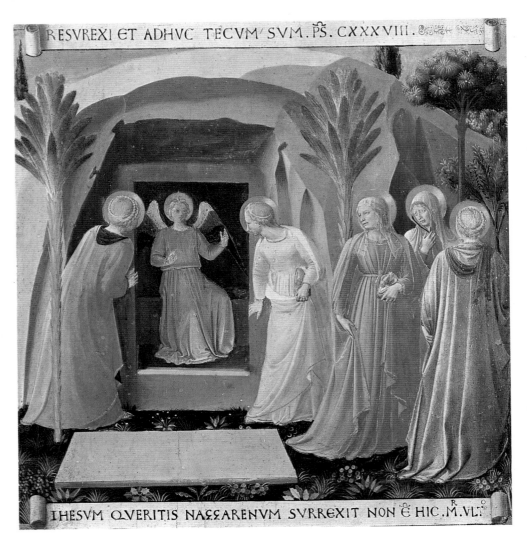

RESVREXI ET ADHVC TECVM SVM.PS.CXXXVIII.

IHESVM QVERITIS NAZZARENVM SVRREXIT NON Ē HIC .M.VLI

130 (left) *Armadio degli Argenti: Resurrection*
Tempera on panel, 38.5 x 37 cm
Museo di San Marco, Florence

This is a particularly satisfying version of the Easter event. The women come to anoint the body of Christ and find the sepulchre empty. Fra Angelico leaves out the guards but shows the heavy stone lying on the ground. The women's agitated movements express their surprise and confusion. The entrance of the tomb is flanked by palm trees.

132 (opposite) *Armadio degli Argenti: Last Judgement*
Tempera on panel, 38.5 x 74 cm
Museo di San Marco, Florence

The composition is much smaller than the one on the back of the Priest's seat but the basic features are derived from it (ill. 76). The distance between the attendant saints with the Virgin and John and Mary as the most important intercedents in the center, and the action of the *Last Judgement*, is so small that the relation in size between the saints and the Blessed and the Damned is out of balance. In an imaginative, dramatic touch, a pleading sinner is sent to Hell from the side of the Just.

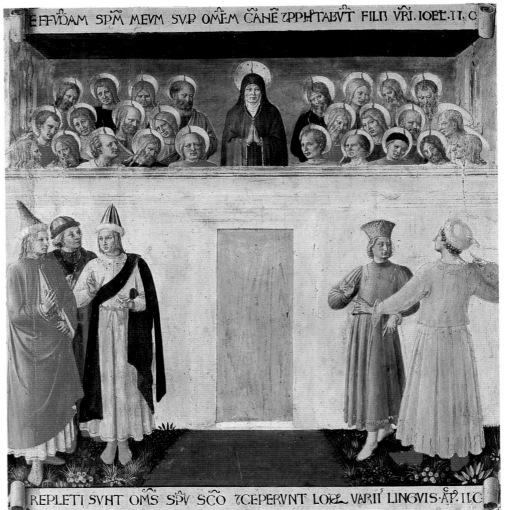

EFFVDAM SPM MEVM SVP OMEM CANĒ ZPPHTABVT FILII VRI.IOEL.II.C

REPLETI SVNT OMS SPV SCO ZCEPERVNT LOEL VARII LINGVIS.AP.IIC

131 (left) *Armadio degli Argenti: Pentecost*
Tempera on panel, 38.5 x 37 cm
Museo di San Marco, Florence

The miracle of Pentecost presents the artist with the problem of showing the onlooker a scene in a closed interior room without relinquishing the closed element. He chooses a view from the roof which restricts the view of the apostles and the other followers to their heads. The impression is further reduced by the presentation of the Virgin as a waist-length figure in the center of the composition. Jews from different lands gather outside and suddenly share in the miracle of Pentecost by being able to understand each other's languages.

133 (opposite) *Armadio degli Argenti: Coronation of the Virgin and Lex Amoris*
Tempera on panel, 38.5 x 74 cm
Museo di San Marco, Florence

The central group with the Madonna and Child in an aureole of light corresponds to the panel in the Uffizi (ill. 71), on which it is based. But there is not enough space in the only cabinet panel with a gold ground to arrange the surrounding saints in a proper circle. *Ezekiel's Vision of the Wheel* was a symbolic portrayal at the beginning of the sequence (ill. 118) which is completed with a scene quite overloaded with texts from the Old and New Testaments. Only the authors' heads appear on the ribbons of text but the one allegorical embodiment of the Church is shown as a complete figure and it bears a sign with the legend *"Lex Amoris"*.

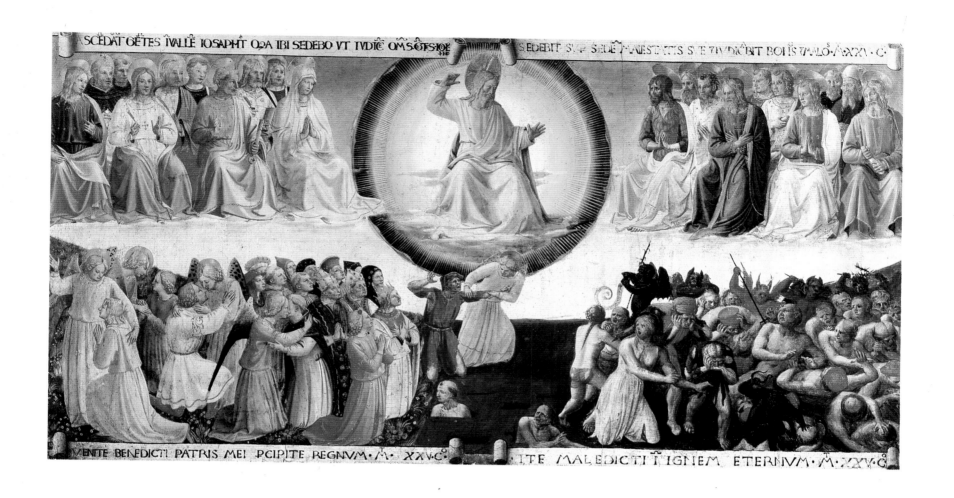

GLOSSARY

altarpiece, a picture or sculpture that stands on or is set up behind an altar. Many altarpieces were very simple (a single panel painting), though some were huge and complex works, a few combining both painting and sculpture within a carved framework. From the 14th to 16th century, the altarpiece was one of the most important commissions in European art; it was through the altarpiece that some of the most decisive developments in painting and sculpture came about.

Annunciation, in art, a depiction of the Virgin Mary being visited by the angel Gabriel who announces that she is to be the mother of Christ (Luke: 1:26–38).

arcade (Lat. *arcus,* "arch"), a series of arches supported by columns, piers or pillars.

architectonic (Gk. *arkhitektonikos,* "architectural"), relating to structure, design, or organization.

aureole (Lat. [*corona*] *aureola,* "golden [crown]"), a circle of light shown surrounding a holy person, a halo.

basilica (Gk. *basilike stoa,* "king's hall"), in Roman architecture a long colonnaded hall used as a court, a market or as a place for assemblies. The early Christians adopted this form of building for their churches, the first Christian basilicas being long halls with a nave flanked by colonnaded side aisles, and with an apse at the eastern end. With the addition of other features, in particular the transept, the basilica became the traditional Christian church.

Book of Hours, a book of the prayers to be said at specific hours of the day. Books of Hours were usually for a lay person's private devotions, and many of them were richly illuminated.

Camaldolensi, in the Roman Catholic Church, a religious order founded in the early 11th century by St. Romuald at Camaldoli, near Arezzo in Italy.

capital (Lat. *capitellum,* "little head"), the head or crowning feature of a column or pillar. Structurally, capitals broaden the area of a column so that it can more easily bear the weight of the arch or entablature it supports. They also provide an opportunity for decoration: medieval capitals, for example, were often richly decorated with sculptures of plants, animals, demons, faces or figures.

Carmelites (Lat. *Ordo Fratrum Beatae Mariae Virginis de Monte Carmelo,* Brothers of Our Blessed Lady of Mount Carmel), a Roman Catholic order of contemplative mendicant friars. Founded in Palestine in the 12th century, the Carmelites were originally a group of hermits. In the 13th century the order was refounded as an order resembling the Dominicans and Franciscans. An order of Carmelite Sisters was founded in the 15th century, and reforms introduced by St. Teresa of Ávila in the 16th century led to the creation of the Barefoot (Discalced) Carmelites.

ciborium (Gk. *kiborion,* "cup"), a chalice holding the host consecrated for Holy Communion; a vaulted canopy over an altar, usually supported by four pillars.

classical, relating to the culture of ancient Greece and Rome (**classical Antiquity**). The classical world played a profoundly important role in the Renaissance, with Italian scholars, writers, and artists seeing their own period as the rebirth (the "renaissance") of classical values after the Middle Ages. The classical world was considered the golden age for the arts, literature, philosophy, and politics. Concepts of the classical, however, changed greatly from one period to the next. Roman literature provided the starting point in the 14th century, scholars patiently finding, editing and translating a wide range of texts. In the 15th century Greek literature, philosophy and art – together with the close study of the remains of Roman buildings and sculptures – expanded the concept of the classical and ensured it remained a vital source of ideas and inspiration.

cloister (Lat. *claustrum,* "an enclosed place"), a covered walk, with an open colonnade along one side, usually running along all four walls of the quadrangle of a monastery or cathedral.

Corinthian, one of the three orders of classical architecture. See: **orders**

cornice, in architecture, a projecting molding that runs around the top of a building or the wall of room.

Deposition, a representation of the body of Christ being taken down from the Cross.

Dominicans (Lat. *Ordo Praedicatorum,* Order of Preachers), a Roman Catholic order of mendicant friars founded by St. Dominic in 1216 to spread the faith through preaching and teaching. The Dominicans were one of the most influential religious orders in the later Middle Ages, their intellectual authority being established by such figures as Albertus Magnus and St. Thomas Aquinas. The Dominicans played the leading role in the Inquisition.

finial (Lat. *finis,* "end"), in architecture, a carved ornament crowning a gable, buttress, or pointed arch. They are characteristic of Gothic architecture.

fresco (It. "fresh"), wall painting technique in which pigments are applied to wet (fresh) plaster (*intonaco*). Painting in this way is known as painting *al fresco.* The pigments bind with the drying plaster to form a very durable image. Only a small area can be painted in a day, and these areas, drying to a slightly different tint, can in time be seen. Small amounts of retouching and detail work could be carried out on the dry plaster, a technique known as *a secco* fresco.

frieze (Lat. *frisium,* "fringe, embroidered cloth"), in classical architecture, the horizontal band of the entablature between the cornice and the architrave, often decorated with relief sculptures; a decorated band running along the upper part of an internal wall.

gable, in architecture, the triangular section at the end of a pitched roof.

Gothic (Ital. *gotico,* "barbaric, not classical"), the style of European art and architecture during the Middle Ages, following Romanesque and preceding the Renaissance. Originating in northern France about 1150, the Gothic style gradually spread to England, Spain, Germany and Italy. In Italy Gothic art came to an end as early as 1400, whilst elsewhere it continued until the 16th century. The cathedral is the crowning achievement of Gothic architecture, its hallmarks being the pointed arch (as opposed to the Romanesque round arch), the ribbed vault, large windows, and exterior flying buttresses. The development of Gothic sculpture was made possible by Gothic architecture, most sculptures being an integral part of church architecture. Its slender, stylized figures express a deeply spiritual approach to the world, though its details are often closely observed features of this world. Gothic painting included illuminated manuscripts, panel pictures, and stained glass windows. In painting and sculpture elegant style known as **International Gothic** – combining realism and courtly refinement – flourish from the 1370s to the 1420s.

historia (Lat. "story"), in Renaissance art theory, the story or incident to be painted or sculpted. It was thought the subjects depicted should be morally, intellectually, and spiritually uplifting, so the two main sources of subjects for artists were the Bible and Christian stories on the one hand, and classical literature and mythology on the other.

Hortus Conclusus (Lat. "enclosed garden"), a representation of the Virgin and Child in a walled garden, sometimes accompanied by female saints, angels and tame animals. The garden, set off from the rest of the world, symbolizes her purity.

iconography (Gk. "description of images"), the systematic study and identification of the subject-matter and symbolism of art works, as opposed to their style; the set of symbolic forms on which a given work is based. Originally, the study and identification of classical portraits. Renaissance art drew heavily on two **iconographical** traditions: Christianity, and ancient Greek and Roman art, thought and literature.

illumination, manuscript decorations consisting of small, finely painted pictures (**miniatures**) or elaborately designed letters, painted in rich colors and sometimes with gold. Illumination flourished during the Middle Ages, dying out with the advent of printing.

"Legenda Aurea" (Lat. "golden legend"), a collection of saints' legends, published in Latin in the 13th century by the Dominical Jacobus da Voragine, Archbishop of Genoa. These were particularly important as a source for Christian art from the Middle Ages onwards.

liturgy (Gk. *leitourgia,* "a service performed by a priest"), the public rituals and services of the Christian Churches; in particular, the sacrament of Holy Communion.

loggia (It.), a gallery or room open on one or more sides, its roof supported by columns. Loggias in Italian Renaissance buildings were generally on the upper levels. Renaissance loggias were also separate structures, often standing in markets and town squares, that could be used for public ceremonies.

lunette (Fr. "little moon"), in architecture, a semi-circular space, such as that over a door or window or in a vaulted roof, that may contain a window, painting or sculptural decoration.

mandorla (It. "almond"), an almond-shaped radiance surrounding a holy person, often seen in images of the Resurrection of Christ or the Assumption of the Virgin.

Man of Sorrows, a depiction of Christ during his Passion, bound, marked by flagellation, and crowned with thorns.

medallion, in architecture, a large ornamental plaque or disc.

missal (Lat. *missalis,* "relating to the Mass"), the book containing the prayers and responses for the Roman Catholic Mass; a book of prayers.

nave (Lat, *navis,* "ship"), the central part of a church stretching from the main doorway to the chancel and usually flanked by aisles.

orders of architecture, in classical architecture, the three basic styles of design. They are seen in the form of the columns, capital, and entablatures. The earliest, the **Doric** order, was the simplest, with a sturdy, fluted column and a plain capital. The **Ionic** order had a slenderer column, a more elaborate base, and a capital formed by a pair of spiral scrolls. The **Corinthian** order was the most ornate, having a very slender column and a capital formed of ornately carved leaves (acanthus).

panel painting, a portable painting on a rigid support (usually wooden boards) rather than canvas. It was not until the 15th century that canvas began to replace wooden panels.

perspective (Lat. *perspicere,* "to see through, see clearly"), the method of representing three-dimensional objects on a flat surface. Perspective gives a picture a sense of

depth. The most important form of perspective in the Renaissance was **linear perspective** (first formulated by the architect Brunelleschi in the early 15th century), in which the real or suggested lines of objects converge on a vanishing point on the horizon, often in the middle of the composition (**centralized perspective**). The first artist to make a systematic use of linear perspective was Masaccio, and its principles were set out by the architect Alberti in a book published in 1436. The use of linear perspective had a profound effect on the development of Western art and remained unchallenged until the 20th century.

pilaster (Lat. *pilastrum*, "pillar"), a rectangular column set into a wall, usually as a decorative feature.

plasticity (Gk. *plastikos*, "able to be molded, malleable"), in painting, the apparent three-dimensionality of objects, a sculptural fullness of form.

plinth (Gk. *plinthos*, "stone block"), in architecture, the block or slab on which a column, pedestal, or statue rests.

polyptych (Gk. *poluptukhos*, "folded many times"), a painting (usually an altarpiece) made up of a number of panels fastened together. Some polyptychs were very elaborate, the panels being housed in richly carved and decorated wooden frameworks. Duccio's *Maestà* (1308–1311) is a well-known example.

pouncing, the technique of transferring a design from a drawing to a painting surface by pricking holes along the outlines and then powdering the drawing with charcoal or chalk so that a dotted impression is left on the painting surface; the technique of decorating metal ornaments with patterns of tiny indentations.

predella (It. "altar step"), a painting or carving placed beneath the main scenes or panels of an altarpiece, forming a kind of plinth. Long and narrow, painted predellas usually depicted several scenes from a narrative.

provenance (Lat. *provenir*, "originate"), the origins of an art work; the history of a work's ownership since its creation. The study of a work's provenance is important in establishing authenticity.

reliquary (Lat. *reliquiae*, "remains"), a container for the sacred remains of a saint, widely used during the Middle Ages. They were often made of precious materials and richly decorated.

Sacra Conversazione (It. "holy conversation"), a representation of the Virgin and Child attended by saints. There is seldom a literal conversation depicted, though as the theme developed the interaction between the participants – expressed through gesture, glance and movement – greatly increased. The saints depicted are usually the saint the church or altar is dedicated to, local saints, or those chosen by the patron who commissioned the work.

sarcophagus, pl. **sarcophagi** (Gk. "flesh eating"), a coffin or tomb, made of stone, wood or terracotta, and sometimes (especially among the Greeks and Romans) carved with inscriptions and reliefs.

sibyls, in antiquity, women who could prophesy. In Christian legend, Sibyls foretold the Birth, Passion and Resurrection of Christ, just as the male prophets of the Bible did.

sinopia, the preparatory drawing for a fresco drawn on the wall where the painting is to appear; the red chalk used to make such a drawing.

Sylvestrine Brothers, in the Roman Catholic Church, a small religious order founded in the early 13th century by the Italian saint Sylvester Gozzolini. The rule they followed was close to that of the Benedictines.

tabernacle (Lat. "tent, hut"), in a church, a container for the consecrated host or relics, usually placed in the middle of an altar. Also, a small niche for statues.

tempera (Lat. *temperare*, "to mix in due proportion"), a method of painting in which the pigments are mixed with an emulsion of water and egg yolks or whole eggs (sometimes glue or milk). Tempera was widely used in Italian art in the 14th and 15th centuries, both for panel painting and fresco, then being replaced by oil paint. Tempera colors are bright and translucent, though because the paint dried very quickly there is little time to blend them, graduated tones being created by adding lighter or darker dots or lines of color to an area of dried paint.

terminus post quem (Lat. "the end after which"), the earliest possible date to which an event or work can be dated.

Trecento (It. "three hundred"), the 14th century in Italian art. This period is often considered the "proto-Renaissance", when writers and artists laid the foundation for the development of the early Renaissance in the next century (the **Quattrocento**). Outstanding figures of the Trecento include Giotto, Duccio, Simone Martini, the Lorenzetti brothers, and the Pisano family of sculptors.

triptych (Gk. *triptukhos*, "threefold"), a painting in three sections, usually an altarpiece, consisting of a central panel and two outer panels, or wings. In many medieval triptychs the two outer wings were hinged so that could be closed over the center panel. Early triptychs were often portable.

vault, a roof or ceiling whose structure is based on the arch. There are a wide range of forms, including: the **barrel** (or **tunnel**) vault, formed by a continuous semi-circular arch; the **groin** vault, formed when two barrel vaults intersect; and the **rib** vault, consisting of a framework of diagonal ribs supporting interlocking arches. The development of the various forms was of great structural and aesthetic importance in the development of church architecture during the Middle Ages.

SELECTED BIBLIOGRAPHY

Alberti, Leon Battista: Della Pittura (1436), Milan, Naples 1955

Argan, Giulio: Fra Angelico, Geneva 1955

Baldini, Umberto and Elsa Morante: Fra Angelico (Klassiker der Kunst), Lucerne, Freudenstadt, Vienna 1970

Baxandall, Michael: Die Wirklichkeit der Bilder, Frankfurt 1984

Berenson, Bernard: Italian Pictures of the Renaissance: Florentine School, London 1963

Bering, Kunibert: Fra Angelico, Essen 1984

Berti, Luciano, Bianca Vellardoni and Eugenio Battisti: Angelico a San Marco, Florence 1965

Bonsanti, Giorgio: Il Museo di San Marco, Milan 1985

Boskovits, Miklós: Pittura fiorentina alla vigilia del Rinascimento, Florence 1975

Boskovits, Miklós: Un ' adorazione dei magi e gli inizi dell'Angelico, Berne 1976.

Castelfranchi Vegas, Liana: Italien und Flandern, Stuttgart and Zürich 1984.

Diea: L'Angelico e l'Umanesimo (Arte Storia Archeologia), Milan 1989.

Cole-Ahl, Diane: Fra Angelico: A new Chronology for the 1420's, in: *Zeitschrift für Kunstgeschichte* 43, 1980, pp. 360–381

Cole-Ahl, Diane: Fra Angelico: A new Chronology for the 1430's, in: *Zeitschrift für Kunstgeschichte* 44, 1981, pp. 133–158

Didi-Hubermann, Georges: Fra Angelico. Unähnlichkeit und Figuratio, München 1995

Dini, Daniela and Magnolia Scudieri: Gli affresci di S. Marco nella storia del Restauro, Florence 1990

Gilbert, Creighton: Fra Angelico's Fresco Cycles in Rome: Their Number and Dates, in: *Zeitschrift für Kunstgeschichte* 38, 1975, pp 245–65

Gombrich, Ernst H: Norm and Form, London 1966

Greco, Antonella: La Cappella di Niccolò V del Beato Angelico, Rome 1980

Hood, William: Fra Angelico at San Marco, New Haven and London 1993

Jacobus da Voragine: Legenda aurea, Gerlingen 1993 (11th Edition)

Kanter, Laurence B., et. al.: Painting and Illumination in early Renaissance Florence 1300–1450, New York 1994

Marchese, Vincenzo, Memorie dei più insigni Pittori, Scultori ed Architetti Domenicani, Florence 1854

Middeldorf, Ulrich: L'Angelico e la scultura, in: *Rinascimento* 6, 1955 pp. 179–194

Orlandi, Stefano: Beato Angelico, Florence 1964

Pope-Hennessy, John: Fra Angelico, London 1952

Salmi, Mario (ed.): Mostra delle opere del beato Angelico, Florence 1955

Schottmüller, Frida: Fra Angelico: Des Meisters Gemälde, Stuttgart 1924

Scudieri, Magnolia: San Marco, Florence 1996.

Ullmann, Bertold L. and Philip A. Stadter: The Public Library of Renaissance Florence, Padua 1972

Vasari, Giorgio: Vita de' più eccellenti architetti, pittori et scultori italiani (1550 and 1558), ed. by R. Bettarini and P. Barocchi, Florence 1971

Verdon, Timothy and John Henderson (eds.): Christianity and the Renaissance, Syracuse (New Jersey) 1990

PHOTOGRAPHIC CREDITS

The publishers would like to thank the museums, collectors, archives and photographers for permission to reproduce the works in this book. Particular thanks go to the Scala photographic archives for their productive cooperation.

Artothek, Peissenberg – Foto: Blauel/Gnamm (20); Samuel H. Kress Collection, © 1997 Board of Trustees, National Gallery of Art, Washington, District of Columbia (42 above, left); Su concessione del Ministero per i Beni Culturali e Ambientali, Roma (7);

Reproduced by courtesy of the National Gallery of Ireland, Dublin (42 below, left); © Nicolò Orsi Battaglini, Firenze (48); Scala, Istituto Fotografico Editoriale, Antella/Firenze (8, 9, 10, 11, 13, 15, 16, 17, 19, 21, 22/23, 24, 25, 26, 27, 28, 29, 30, 31, 32, 33, 34/35, 36, 37, 38, 40, 42 above, right, 42 below right, 43, 44, 46, 47, 49, 50, 51, 52, 53, 54, 55, 56, 57, 58, 59, 60/61, 64, 66, 67, 68, 70/71, 73, 74, 75, 76, 77, 78, 79, 80, 81, 82, 83, 84, 85, 86, 87, 88, 89, 90, 91, 92/93, 95, 96, 97, 98, 99, 100, 101, 103, 104, 105, 106, 107, 108, 109, 110, 111, 112, 113, 114, 115).